# THE WINEMAKER'S MARSH

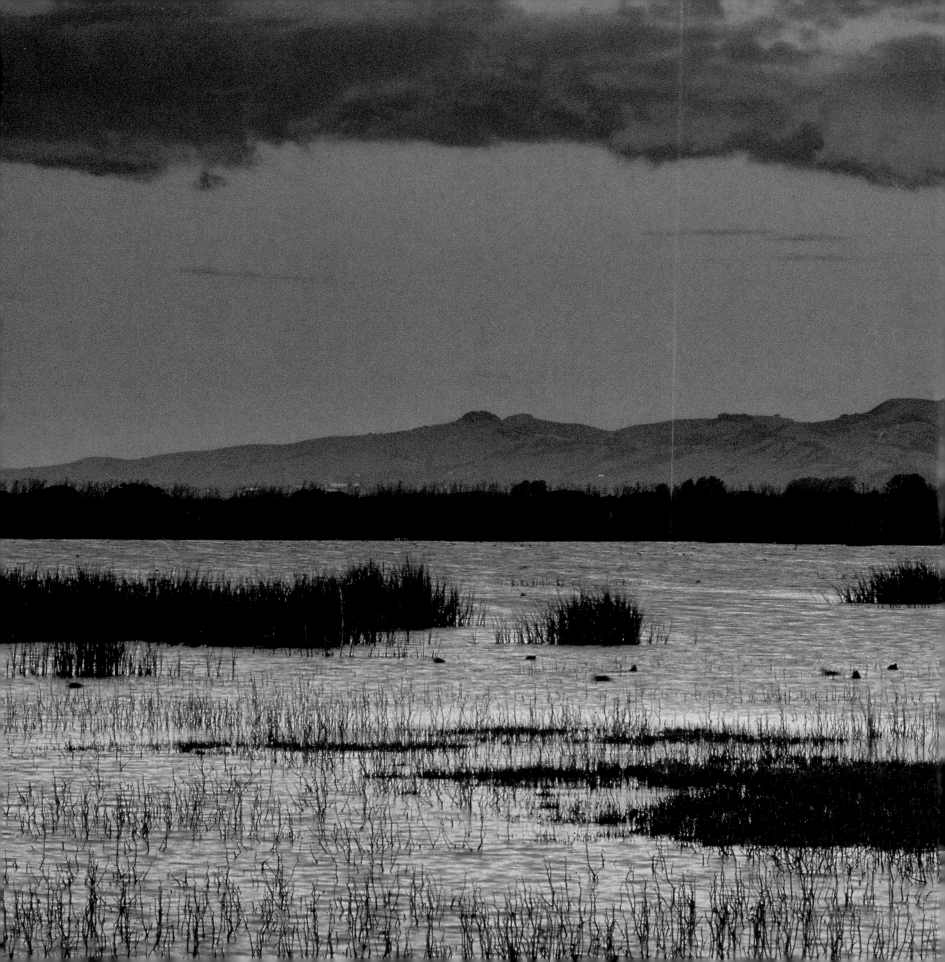

# THE WINEMAKER'S MARSH

## FOUR SEASONS IN A RESTORED WETLAND

*Text by*
Kenneth Brower

*Photographs by*
Michael Sewell

*Foreword by*
David R. Brower

## SIERRA CLUB BOOKS

*San Francisco*

ACKNOWLEDGMENTS  Special thanks to the following individuals and businesses: Gary "Doc" Beeman; Carol Coyle; Charles Kennard; Ken Luther; Galen Rowell; Joe Sebastiani; Sam Sebastiani; John Shoemaker; Adolph Gasser, Inc., San Francisco; Nikon Professional Services, Los Angeles; and Seawood Photo, Inc., San Anselmo.

The Sierra Club, founded in 1892 by John Muir, has devoted itself to the study and protection of the earth's scenic and ecological resources — mountains, wetlands, woodlands, wild shores and rivers, deserts and plains. The publishing program of the Sierra Club offers books to the public as a nonprofit educational service in the hope that they may enlarge the public's understanding of the Club's basic concerns. The point of view expressed in each book, however, does not necessarily represent that of the Club. The Sierra Club has some sixty chapters throughout the United States and Canada. For information about how you may participate in its programs to preserve wilderness and the quality of life, please address inquiries to Sierra Club, 85 Second Street, San Francisco, CA 94105.

www.sierraclub.org/books

Published by Sierra Club Books in conjunction with Crown Publishers, New York, New York.
Member of the Crown Publishing Group.
Random House, Inc. New York, Toronto, London, Sydney, Auckland
www.randomhouse.com

SIERRA CLUB, SIERRA CLUB BOOKS,
and the Sierra Club design logos are registered trademarks of the Sierra Club.

"Call of the Coot" originally appeared, in a somewhat different form, in *Smithsonian,* December 1998.

D.L. TO: 782–2001

Printed in Spain

Design by Doug Offenbacher

Library of Congress Cataloging-in-Publication Data
Brower, Kenneth, 1944–
    The winemaker's marsh: four seasons in a restored wetland / text by Kenneth Brower; photographs by Michael Sewell; foreword by David R. Brower.
        p. cm.
    1. Marsh ecology — California — San Francisco Bay Area. 2. Wetland conservation — California — San Francisco Bay Area. 1. Sewell, Michael, 1960– II. Title.
QH105.C2 B665 2001
577.68'09794'6 — dc21
                                                                    00-067049
ISBN 1-57805-058-8
10 9 8 7 6 5 4 3 2 1
First Edition

*To the two David Browers, my father and my son*

*K.B.*

*To my wife, Denise, who has changed my life*
*with her trust, patience, and dedication,*
*and to our sons, Dylan and Austen*

*M.S.*

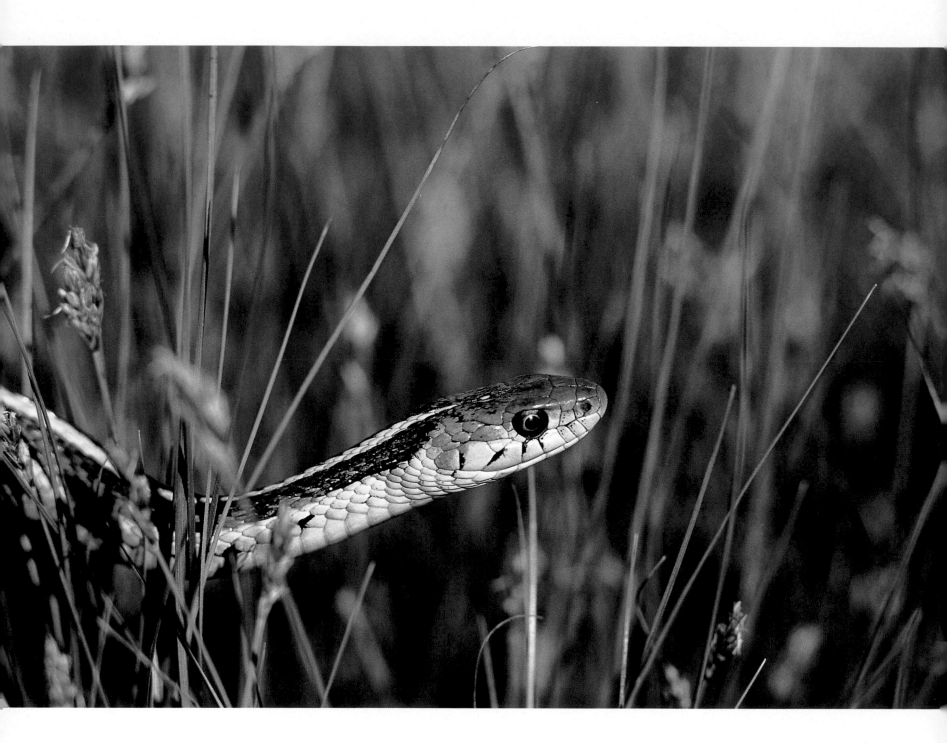

# FOREWORD
*9*

# RESURRECTION
*13*

*Mirage    Sea of Reeds    Levee    Fathers and Sons*

# WINTER
*43*

*Rain    El Niño    Muskrats    Uta-Napishtim's Ark    Eclipse*

# SPRING
*77*

*Equinox    Tragedy of the Carp    Wild Radish*

*Reedsong    Wrenovation    Perizoon and Aufwuchs*

*Call of the Coot    Prince of Darkness*

# SUMMER
*147*

*Zugunruhe    Otter    Balsa    Bedlam*

# AUTUMN
*169*

*Angel of the Marsh    Archipelago    Albatross*

*Red-sided garter snake*

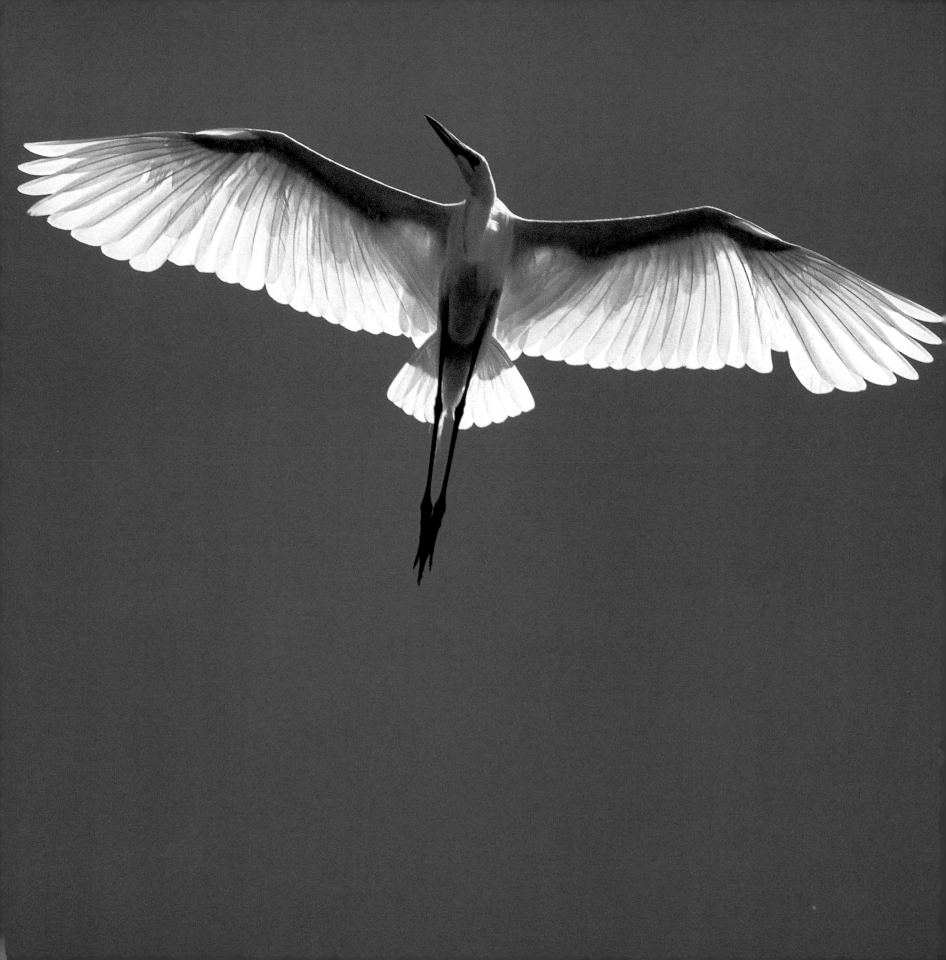

# FOREWORD

### By David R. Brower

Twenty-five years ago, my son Ken and I, midway through the thirty volumes of the "Exhibit-Format Series" that we produced at the Sierra Club and Friends of the Earth, put together an oversized photo book called *Guale, the Golden Coast of Georgia.* This work, with photographs by James Valentine, text by Robert Hanie, and introduction by the great marsh ecologist Eugene Odum, was a celebration of the beaches and salt marshes of the sea islands of Georgia. It has taken my son a quarter century to turn his attention finally to the other sort of marsh, the freshwater kind. Better late than never. It is good to be collaborating on a marsh book again.

"If a quarter acre of marsh could be lifted up and shaken in the air, anchovies would fall out, and crabs, menhaden, croakers, butterfish, flounders, tonguefish, squid," John McPhee wrote of Georgia's salt marsh. "Bigger things eat the things that eat the marsh, and thus the marsh is the broad base of a marine-food pyramid that ultimately breaks the surface to feed the appetite of man." So it is in a sweetwater marsh. If a quarter acre of California's cattails could be lifted and shaken, catfish, carp, crabs, frogs, water beetles, dragonfly nymphs, and baby coots would fall out. Bigger things — ducks, herons, shorebirds, hawks, owls, muskrats, coyotes — eat the things that eat the marsh, and eventually feed the appetite of man, both gustatory and aesthetic.

Appetite is one thing, gluttony another. Since the Industrial Revolution, we humans have been on a binge that has ransacked most of the Earth for resources. We are living now off the natural capital of the planet, the principal, and not the interest. The solution is simple. We must go back to the world's ravaged places and bind up the wounds we have inflicted. The Earth is in urgent need of CPR. Conservation. Preservation. Restoration. As the new millennium grows older, the last of these duties will become first and foremost. Restoration means putting the Earth's life-support systems back in working order: rivers, forests, wetlands, deserts, soil, endangered species. We must do our best to restore the natural world to something like it was 200 years ago, before our gluttony got out of hand. If we are to succeed at this, environmental conscience will have to intrude on world trade and corporate thinking. Everyone will have to impart eco-spin to his job description, or to hers: Carry on with your work, but carry on too with the best interests of the Earth.

The winemaker Sam Sebastiani did not need any lecture by me to incorporate environmental conscience in his vineyard. He seems to have taken to the idea naturally, as a duckling takes to water. In restoring ninety acres of his land to marsh, he has brought back a piece of natural California of 200 years ago, when the margins of San Francisco Bay were green with reeds. In the following pages, Kenneth Brower and Michael Sewell document the small miracle that happens when a man follows his conscience.

*Great egret*

*"Whatever you can do,*

*or dream you can,*

*begin it.*

*Boldness has genius,*

*power and magic in it."*

*— Goethe*

*Black-necked stilt nest, sunrise*

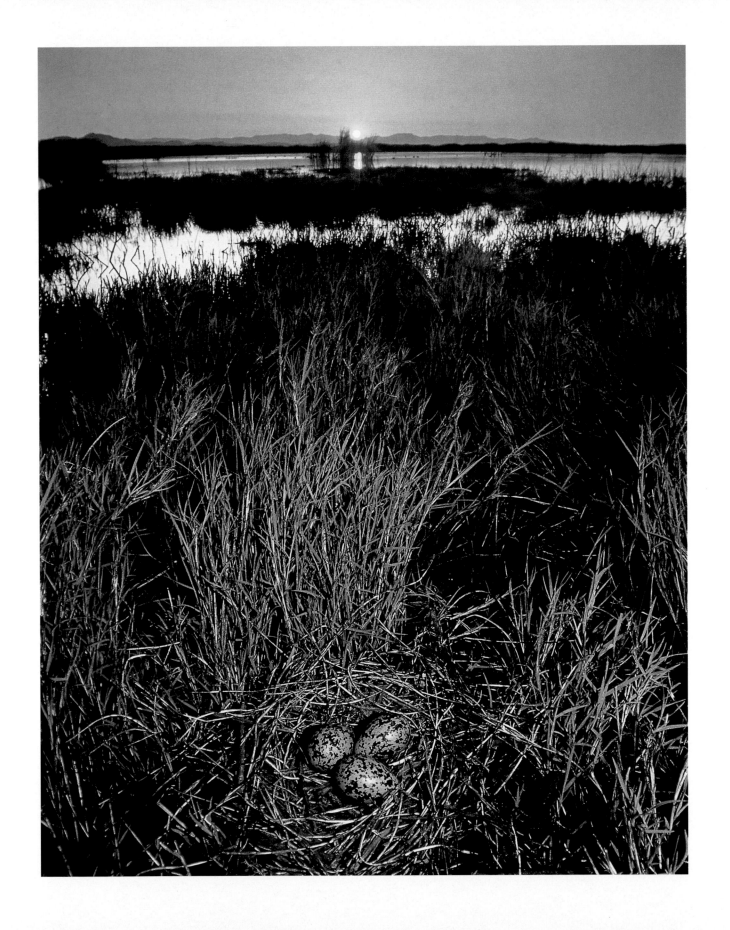

RESURRECTION

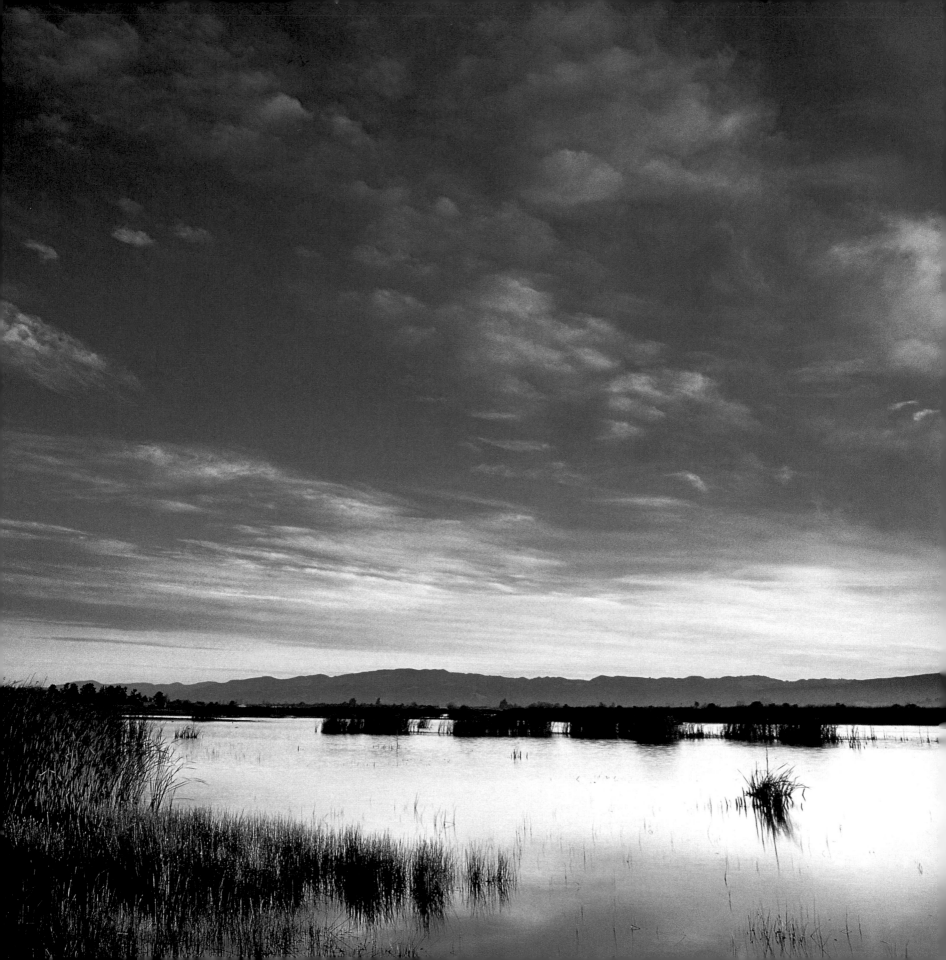

## Mirage

In summer of 1988, Sam Sebastiani climbed a Sonoma hill, the last prominence before the floodplain. He trudged up preoccupied, like Moses on his way up Pisgah. On top the winemaker looked about him for a new beginning. Westward were the Carneros hills. The Spaniards had run *carneros*, sheep, on those rounded summits early in the nineteenth century. The flocks were long gone. The lower slopes were planted now to grapes. Eastward was Sonoma Creek. Beyond the creek's meandering levee lay the Sonoma floodplain, an expanse of diked and drained marsh, with tidal creeks and sloughs shining in the distance. Directly beneath the hilltop was the poor stubble of a very marginal hayfield.

The hayfield was a fossil marsh. It had the hydric soil characteristic of former wetlands. If Sebastiani had descended to the field, and dropped to his knees and dug up a handful, he would have smelled the telltale sulfidic odor and seen the histosol, the high organic content of the surface layer, the organic streaking, and the gleyed, low-chroma, blue-gray color: all characteristics that testify to a water regime. Digging deeper, he would have found long-dormant seeds of marsh sedges and the sleeping rhizomes of tules and cattails. The geomorphology of the field — a flat embayment at the bottom of a long slope draining an amphitheater in the hills — testified to its former life as marsh bottom. This had been a northern cove in the plain of reeds that bordered San Francisco Bay before the Gold Rush, in the days of the Miwok Indians, when the bay itself was twice its present size.

But Sam Sebastiani scarcely noticed the hayfield. He saw no ghost of former marsh there, no mirage of future water glinting in the hayfield's stubble. He had more pressing concerns. He was worried about survival. Until three years before, he had run Sebastiani Vineyards, one of the largest wine producers in the nation. Founded in 1904 by his grandfather and namesake, Samuele Sebastiani, the company had expanded into a hundred-million-dollar operation. Samuele had grown up in Tuscany, sleeping with the cows for warmth. Sam, just two generations later, had grown up on the vast estate of a family-owned agribusiness. Then came one of those temblors that periodically shake the grape dynasties of California. There arose a family disagreement over the direction the business should take. In a campaign to gentrify his company's jug-wine image and modernize the Sebastiani plant, Sam had invested in expensive new equipment in France, and in so doing had run afoul of Sebastiani Vineyards' sixty-nine-year-old chairwoman. On New Year's Day of 1986, the chairwoman, Sylvia Sebastiani, his mother, had fired him. Sam was sleeping with the cows again.

"I was looking around the valley for a place to reestablish myself, after I left the family," he says. "I had three possible sites. One was on the border of Napa and Sonoma counties. It looked pretty good. There was a canyon back in there that was beautiful. But that border site was a problem immediately, because there would be a left turn across traffic for the people going to Napa. More cars go toward Napa than the other way."

That left turn might seem an insignificant detail, but it was fraught with difficulties for Sebastiani. The balance he was seeking in the vineyard of his resurrection was complex, as in

the blending of some difficult cabernet. Proper soil, slope, exposure, and drainage were not his only requirements. The migration patterns of automobiles figured, too. He did not simply intend to grow grapes, but to build a facsimile Tuscan hill town in which to house a winery and tasting room. The thick stucco walls, red-tile roofs, and pavilions would shelter a *caffé* and Italian market run by his wife, Vicki. The border site was lovely, but that left-turn exit across the traffic from San Francisco was poison. "I would have ended up having to buy a highway sign," he says. "A stop sign. It can take you *years* to get one of those."

The second site was around a corner in the same canyon, a meander that Sebastiani had discovered one day while hiking. The canyon was pretty, but it was confined, with insufficient bottomland for building. In the end he had to give up on it.

"And then we had this third site, the hilltop. When you looked up at it, it was pretty stark. But I went up on it, and I turned around, and boy, the reverse is true. Looking *at* it was nothing. Looking *from* it was great. It had the right-hand-exit potential. It had the red soil, which is what I want for vines. Red soil is unique in Carneros. There's a little run of it here, and I got a piece of it. So now I got my right-hand access, and I got my red soil. The other thing I was looking for was potential to build caves. I wanted to dig in under the hill and age barrels.

"There's a whole phenomenon that occurs in a cave. In a cave you make better wine, because you have the humidity, which keeps the barrel tighter. With the tight barrel, what you lose in the aging process is alcohol. The alcohol goes up — they call it 'the angel of wine' — and as it goes away, you're dropping

the alcohol level in the barrel. That softens the wine and makes it better. If you're in a dry environment, you don't get rid of the alcohol. If you get real dry, you get rid of water and you get concentration. That's how they make sherry. Well, anyway, underneath the hill was tuff — volanic ash — which is perfect for digging caves. So I had my right turn, and I had all the things I needed for winemaking."

Sebastiani visited the hilltop again and again, first as prospective buyer, then as owner. In winter of 1988, with the deed in pocket, he drove a rototiller up the hillside.

"I rototilled it, a patch maybe twenty by forty, and I seeded it with wildflowers. I wasn't going to be able to get onto it until the next spring, and I wanted to see what color would do. I put a big V on it, with calcium. The V was to provide scale, for when I started drawing buildings on it. As soon as you put something on your land, it changes it."

Painting with wildflowers and calcium, Sebastiani put his stamp on the hilltop. The Tuscan villa that he and Vicki had dreamed became real for him, in some metaphysical way. As it did, the hayfield changed, too. "I looked out the door," he recalls. "And thought, *It's not right to keep making hay out there.*"

The doorway was still only imaginary, but the winemaker could see through it clearly. The ghostly lintel and jambs framed the hayfield in a new way. The field was not suitable land for grapes, Sebastiani could see. Renting to some farmer for haying or grazing would bring a negligible return. *I can do something out there,* he thought. It was then that he saw a kind of mirage. The field flooded in his imagination, its stubble greening and lengthening into stands of cattails and the twenty-foot culms of bulrushes, with mallards and pintails swimming underneath.

*Bullfrog in rushes*

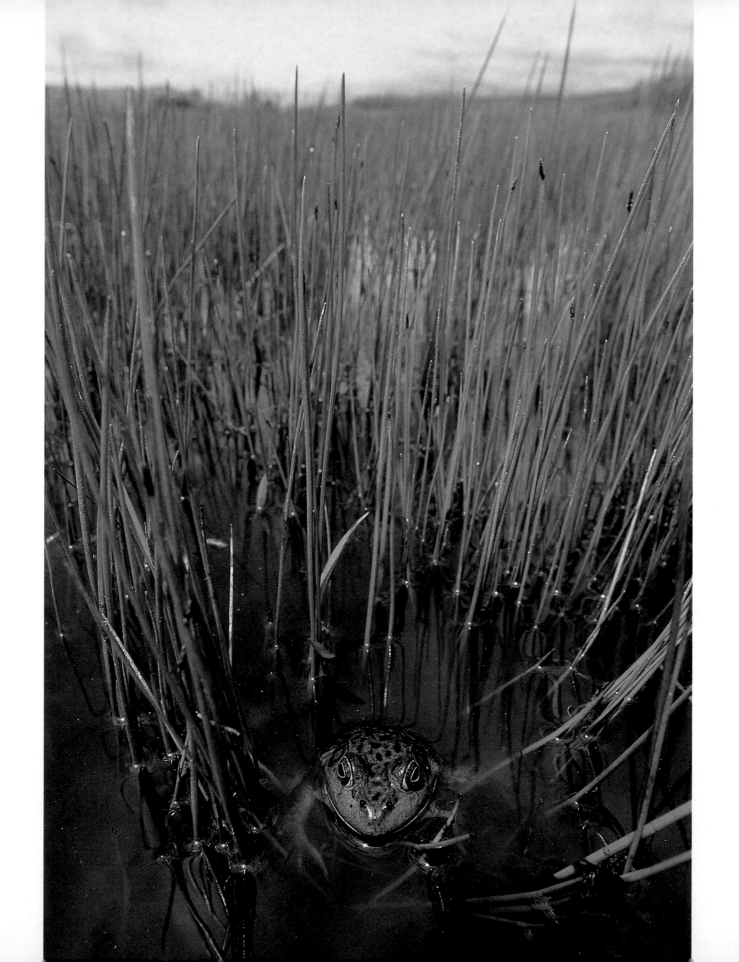

## Sea of Reeds

Sitting in flowering wild radish on the levee, I pulled off my jeans and tugged on my chest waders, first one leg, then the other. I laced up the oversized tennis shoes that I wore over the waders, hung my binoculars about my neck, and waded out into Sam Sebastiani's marsh.

The cattails closed in behind and overhead. With a single step, the horizontal world of levee and slough narrowed to the vertical, intimate, almost claustrophobic world of marsh reeds. I forced my way through the thick, pale-green plantation of cattails. The faint fragrance of wild radish was gone. The shade of the cattails smelled entirely now of that clean yet faintly mucky odor of marsh. Close by, from the darker, taller green of bulrushes, a marsh wren sang. It had a big, bold voice for such a small bird. It drowned out the distant babble of red-winged blackbirds.

When the water reached mid-thigh, its pressure constricted the neoprene of the waders. The sudden tightening of my legs felt tonic and agreeable. A brisk wind stirred in the tips of the cattails, causing them all to dip one way, then sway and dip the other. The world was all cattails. The levee had vanished behind. There was nothing to see but reeds, nothing to hear but the declarations of wrens and the muttering of coots, nothing to smell but the fecund fragrance of marsh.

To wade into a marsh is to step back in time. No feature of this close green universe — not the nest of coot or grebe, nor the spiky inflorescense at the tip of the bulrush, nor the V of geese glimpsed through a bulrush screen — was any different from what a Miwok fisherman would have seen,

poling his reed canoe through these same bulrushes centuries before Columbus.

Much of central California was once a sea of reeds. From the Sierra to the east, the Coast Range to the west, the Klamath and Trinity Mountains to the north, rivers of reeds ran down to that green sea. In the deserts of southeast California, green tributaries of reeds poked inland from the Colorado. The extent of this vast, vanished marsh is hard to grasp today, but in poking around the archives, one pieces together some small sense of it.

There are hints in the journals of Pedro Fages. Fages, who arrived in 1772, was probably the first Spaniard to see California's central valley in the wet season. He was a lieutenant of Catalonian volunteers, a leader of the Portolá expedition, and eventually governor of the Californias. He named the valley Llano de San Francisco, from the Spanish word *llano*, or seasonal marsh. He described the vast plain of the valley as "a labyrinth of lakes and tulares."

*Tule* and *tular* were new Spanish coinages that Fages and his countrymen had brought north from Mexico, having pilfered them from the hieroglyphic dictionary of the Aztecs. *Tule* applies narrowly to the bulrush and broadly to all rushes, cattails, and similar reeds, even including, in Texas, several species of yucca. A *tular* is a place where tules grow. The root word is the Uto-Aztecan *tullin* or *tollin*. There are those who insist that tule refers only to the bulrush, but there is no such specificity at the source. The Aztec hieroglyph for the term — a very small tular of four spiky, stylized reeds in a row — could have

*Cattails and sun*

represented almost any rush. "Tule" and "tulare" and the diminutive "tularcitos" occur in more than fifty California place-names. The Spaniards after Fages called the central valley Valle de los Tulares or Llano del Tular before settling on San Joaquin Valley. The city of Stockton was originally Tuleburg. There is Tule River, Tule Lake, Tularcitos Creek, and the city and county of Tulare. There is the tule fog, the tule wren, the tule elk, and the disease called tularemia, all features of the vast, vague realm that Westerners call the Toolies.

Tules reproduce prolifically as clones from rhizomes, and so it is with all the words that have sprouted from the old Aztec root *tullin*. The ubiquity of "tule," the term, hints at the former ubiquity of tule, the reed.

The English-speaking explorers who followed the Spaniards described their ordeals in getting their horses across the endless marshlands of the Central Valley. One of them, Thomas Coulter, an Irish physician and botanist, reported that despite his troubles in the reeds, the two "tule lakes" described by trappers who preceded him were a disappointment. They were not nearly so large as the trappers had claimed. "Neither was over one hundred miles long," Coulter complained.

Today, of course, nothing like a hundred-mile tule lake survives. Nearly 90 percent of California's marsh has been destroyed by European agriculture and urbanization in the past century and a half. The four million acres of wetlands that once covered the Central Valley have been reduced to 300,000, and less than 5 percent of the state's coastal wetlands remain.

"There is not any country in the world which more abounds in game of every description," the eighteenth-century French sea captain Jean La Pérouse wrote of coastal California. La Pérouse described geese and ducks rising "in dense clouds with a noise like that of a hurricane" over a landscape of "inexpressible fertility."

With the disappearance of marshes, those hurricanes of geese and ducks thinned radically, becoming gales at best. The inexpressible fertility became expressible. In 1988, the year Sam Sebastiani first ascended his hilltop, the fall-flight index of North American ducks was 66 million, down from 74 million the year before. The 1989 midwinter survey of Pacific Flyway ducks would total just 3.4 million, a record low. The seasonal wetlands, mudflats, and tidal marshes of San Francisco Bay — the wet world in which his hill once stood as an island — were in retreat. Nine plant and animal species dwelling in the bay's wetlands had been listed as endangered under the Endangered Species Act, and 28 more as candidates for listing.

Sebastiani, as he looked down that day from his hilltop on the stubble of his hayfield, was a candidate for listing himself. He was full of doubts about his own survival. Beyond the once-and-future tular of the hayfield, in the shrunken vestige of Llano de San Francisco, that great, vanished inland sea of reeds, he had a host of fellow-spirits — the salt-marsh harvest mouse, the salt-marsh wandering shrew, the Suisun shrew, the clapper rail, the western snowy plover, the American white pelican, the burrowing owl, and various other threatened creatures. He was a winemaker without vineyard. He was an endangered species of one.

*Coot on nest*

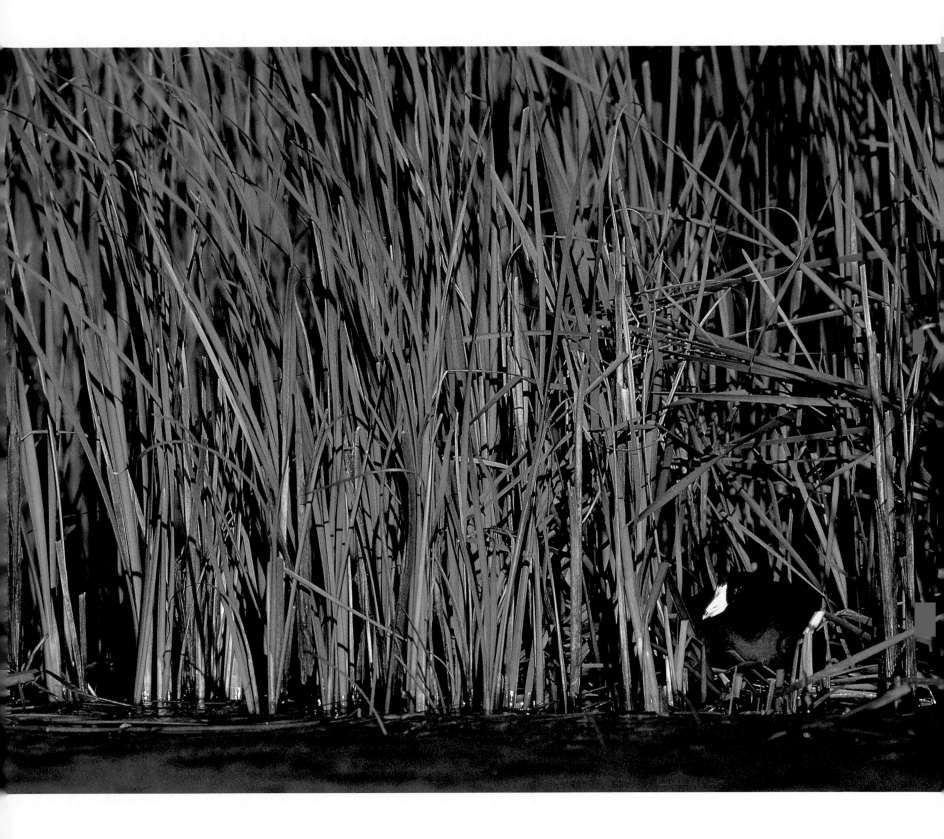

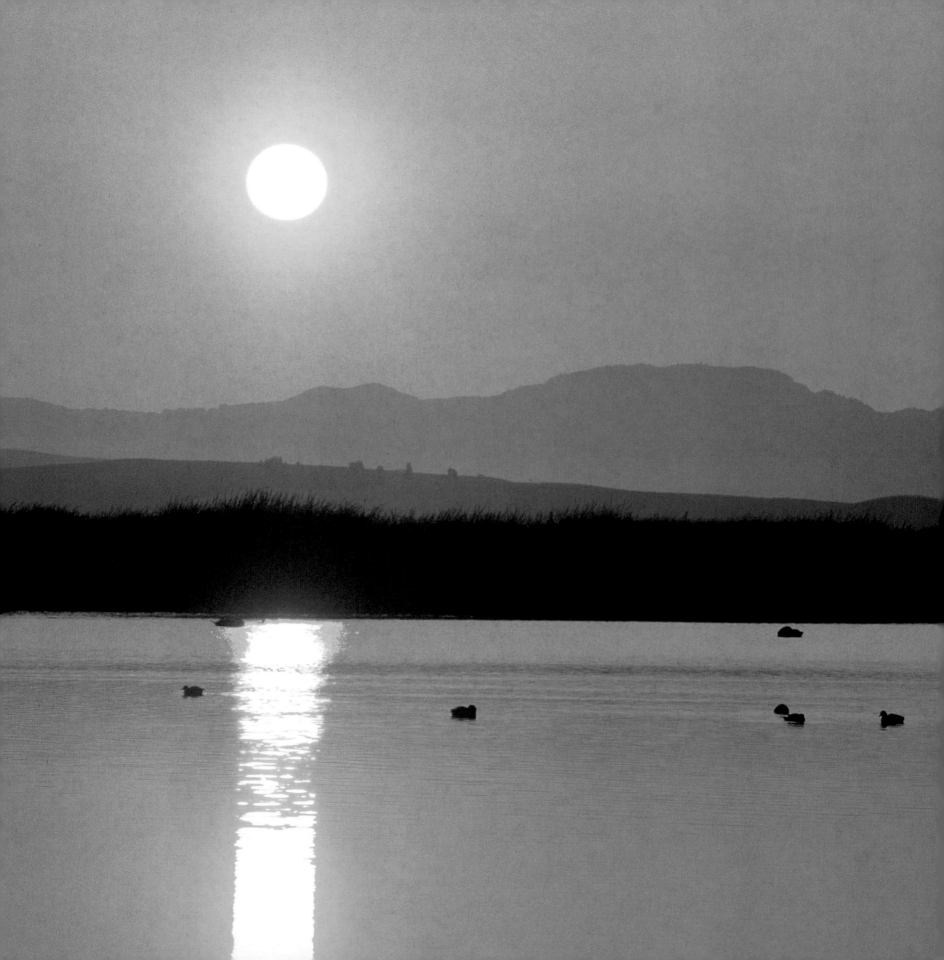

## Levee

"The moment one definitely commits onself, then Providence moves too," the mountaineer William Murray once wrote. "All sorts of things occur to help one that would never otherwise have occurred. A whole stream of events issues from the decision, raising in one's favour all manner of unforeseen incidents and meetings and material asssistance, which no man could have dreamt would have come his way."

Murray's commitment was to Himalayan peaks, but the same elevated truths apply at lower altitudes. It worked on Sam Sebastiani's little hilltop, on the day he had his vision of marsh.

"It looked pretty bad," Sebastiani remembers of the hay-field below. "It was half of a culture. Not even a monoculture. It was a meso-culture. Couple of jackrabbits. And once in a while something would land in there, a duck or something. Yes, there was water. But they were just little puddles. It was apparent that if you added some real water, you'd get more."

Sebastiani decided to do that, add water, and Providence promptly moved for the winemaker. It sent an angel, an unlikely looking specimen, six feet four and 260 pounds, bespectacled and balding — an old family friend, the waterfowl lover and Ducks Unlimited volunteer Dave Hillendahl. Hillendahl strolled up, on cue, and joined Sebastiani on the hilltop.

"You know how God helps you?" Sam asks today. "I started talking to Dave. I told him I really wanted to do a bird pond out here. He told me that Ducks Unlimited would help me right now."

Ducks Unlimited was founded in 1937, in response to a prolonged drought in the prairie states and provinces. Its founders understood, before almost anyone else, that marsh is not a bad thing, but indispensable for waterfowl and good for humanity in numerous ways. Ducks Unlimited has raised more than a billion dollars toward conservation of more than 8.6 million acres of wildlife habitat in the United States, Canada, and Mexico. Ducks Unlimited of Canada manages 5 million acres of wetlands in the prairies where its work began. Ducks Unlimited de México has protected, restored, or enhanced 1.6 million acres of wetlands and uplands. Ducks Unlimited Australia is at work along the floodplain of the River Murray, and in rehabilitating shorebird habitat along Lake Alexandrina, and in controlling carp in Loveday Wetland. Ducks Unlimited New Zealand owns wetlands in Otago, Wairarapa, Manawatu, and the Bay of Plenty. And so on, all around the world.

Dave Hillendahl, who had worked with Ducks Unlimited in California, believed that Sam Sebastiani's bird pond would fit as a piece in this wide-scattered mosaic. He contacted the Western Regional Office of Ducks Unlimited in Sacramento and set about convincing the outfit that a wetlands here would be a good project.

"Next thing I know, I get a phone call from somebody," Sebastiani recalls. "They asked me did I still want to do it? I said yes. So here come these DU guys, and they bring an attorney from Chicago. What they wanted to see was if I was nuts. I picked up on it right away. It's common business sense. If you're going to come and put money on my property, you want to make sure I'm not a wacko. I finally had to tell them, 'Look, I know you're trying to psychoanalyze me and see if I'm nuts. I

may be nuts, but I'm really just trying to do this. I'm not going to run with the money. I really want to create a wetlands."

In spring of 1988, atop Sam's preliminary sketches with wildflowers and calcium on his hill, he and Vicki began construction of their winery. Over the next two years they built their little piece of Tuscany on the hilltop. They named the place Viansa — not some Tuscan term, just a melding of their names. They planted a good part of their 175 acres with neglected Italian grape varieties: Sangiovese, Pinot Grigio, Vernaccia, Teroldego, and Primitovo, and in 1990, Viansa opened. Business was slow. At the worst possible time, a white-collar recession had cut into the disposable income of their clientele, and northern California's tourist industry still wobbled in cultural aftershocks of the Loma Prieta Earthquake of 1989. Investors grew nervous. Occasionally Sam would pull ten dollars from his wallet and slip it in the till to make two hundred dollars in proceeds for the day. But Viansa was one of the first wineries that travelers from San Francisco encountered in the wine country. The Tuscan architecture on the hilltop and the white tents of the pavilions caught the eye. The right turn of the highway was inviting. The exit immediately forked again, right to Viansa, then left to the Sonoma Valley Visitors Bureau, next to which Sam and Vicki had strategically located. It drew the uninformed at first, then repeat visitors. Viansa turned the corner economically. The trickle of cars making that right turn off the highway swelled and soon became a stream driving up to the hilltop.

By 1992, Sam was able to turn some of his attention to the hayfield. From its offices in Sacramento, Ducks Unlimited dispatched two of its specialists to oversee the marsh restoration: Andy Engelis, a biologist, and Jim Wells, an engineer.

These two shepherded Sebastiani through the bureaucratic labyrinth that had to be negotiated.

"The task of developing marshlands presents no serious problems," Herbert Mason writes in his A Flora of the Marshes of California. "Given adequate water of proper depth, a marsh is inevitable."

Inevitable in nature, perhaps, but not in the affairs of men. Herbert Mason clearly never had to deal with the U.S. Army Corps of Engineers, U.S. Environmental Protection Agency, U.S. Fish and Wildlife Service, and U.S. Department of Justice; the California Department of Fish and Game, California Department of Transportation, California Regional Water Quality Control Board, and California State Lands Commission; Sonoma County's Board of Supervisors, its Water Agency, Reclamation District, and Planning Department; the Marin-Sonoma County Mosquito Abatement District; the San Francisco Bay Conservation and Development Commission — all agencies to which Sebastiani had to apply in his two-year quest for the 404 permits he needed for the marsh.

Andy Engelis and Jim Wells knew the steps in the dance; Sam Sebastiani did not, and was continually astounded by all the pliés, splits, contortions, and curtsies required of him. The winemaker gave speeches at town meetings, persuaded college students to circulate petitions, solicited letters of support from hunters, fishermen, birders, the Audubon Society, the Nature Conservancy, and letters of approval from the farmers of the surrounding 13,000 acres, to assuage concerns over ducks eating crops.

The Schellville Airport to the north worried that Sebastiani's marsh might flood one of its runways. Sebastiani made presentations at the airport and before groups of airplane

*Wildflowers at dusk, Viansa hilltop*

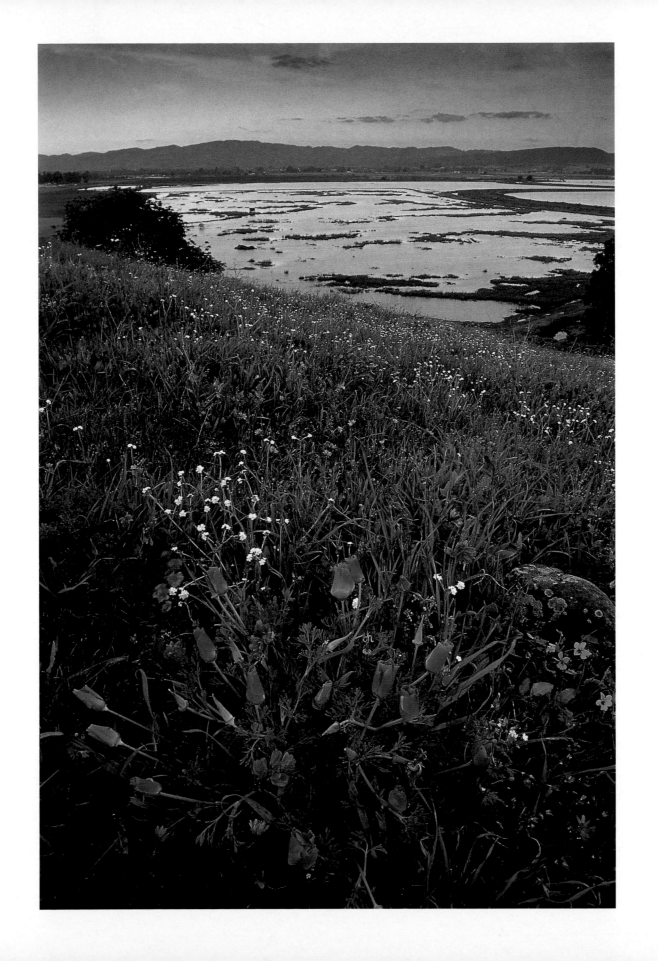

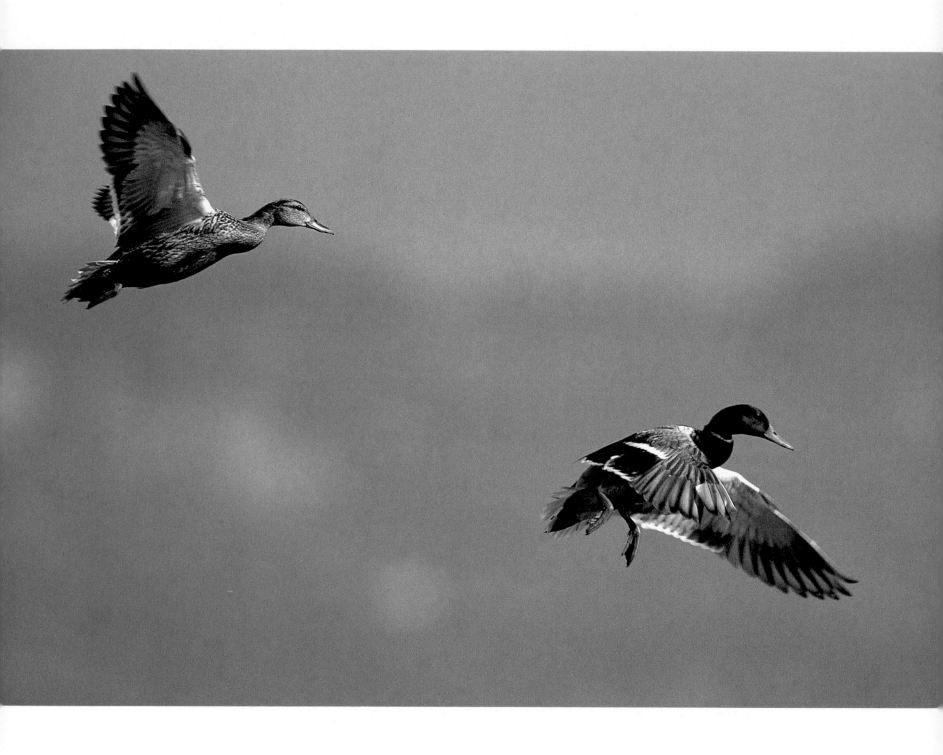

owners. The Bisso brothers to the east were uneasy. Sebastiani did his best to reassure them. Fred and Nancy Cline, Sebastiani's immediate neighbors to the north, were adamantly opposed to his project. The Clines had bought the 350-acre Haddon Salt Ranch just upstream of Viansa in 1989, just months after Sam and Vicki bought their hilltop. They intended to plant grapes and build a winery on the uplands to the west and continue grazing and planting hay on the seasonally wet lowlands that bordered Sebastiani's proposed marsh. The Clines wanted to decrease ponding time on their land, Sebastiani to increase ponding time on his. A bitter feud over these conflicting goals led to meeting after meeting before the Sonoma County Board of Zoning Adjustments, and it stretched the county permit process out to a year and a half. Finally, in February of 1992, the zoning permits were approved, but they came encumbered with conditions. Viansa Wetlands would have to be monitored, with annual reports submitted for five years.

Sebastiani spent days at the county seat in negotiations with various other agencies. He guided dozens of permit verifiers around the property. He was forced to redefine his property lines because the State Lands Commission had not kept track of property sales for the past century and a half.

The most absurd moment in his Laocoönian struggles with red tape came when the Army Corps of Engineers ruled that the levee that would impound his proposed marsh, in covering an acre of the seasonally wet hayfield, amounted to a *destruction* of wetlands.

"When we had designed it, the government came back and told us we had to provide four more acres," says Sam. "I asked, 'Why? I just gave you eighty-six.' They said the levee needed to be mitigated, because I had destroyed wetlands by the volume of the levee. We create a live and verdant and active wetlands, and now we're the bad guys."

Recalling this twist in the plot, Sebastiani goes glassy-eyed and bewildered, like Kafka's hero, Joseph, trying to make sense of his ordeal in *The Trial*.

The Corps of Engineers settled on a four-to-one mitigation ratio, which required Sebastiani and Ducks Unlimited to create 4.1 acres of mitigation wetlands elsewhere. The winemaker had to sacrifice four acres of productive vineyard, dug out at the base of the hill, to pay for his crimes. "The extra four acres cost Ducks Unlimited $50,000," he says. "That's $12,500 an acre. For a thousand dollars, Ducks Unlimited can go to the San Joaquin Valley and create an acre of wetlands. If they could have kept their fifty grand, the universe would have gained fifty acres of marsh."

After two years in the quest, Sebastiani had his permits. With funding and advice from Ducks Unlimited, he built a 1,700-foot levee on the northern border of his land. The levee was necessary to lengthen ponding time in the new wetlands and prevent flooding of the Cline Cellars land to the north. The levee was thirty feet wide at the base, four or five feet high, and the crown was ten feet across. His crews reshaped the hayfield with earthmovers, excavating deep areas for diving ducks, shallow areas for dabblers. They installed gates in the Sonoma Creek levee to help regulate water levels in the marsh. The rains came. Rainwater ponded behind the levee. Cattails, bulrushes, and sedges sprang from the dormant seed bank. Waterfowl, taking notice, began setting down.

To date, 156 species of birds have been recorded in or around the marsh. On a single winter day, 10,000 waterfowl were counted on its 90 acres. Nearly every North American

*Mated pair of mallards*

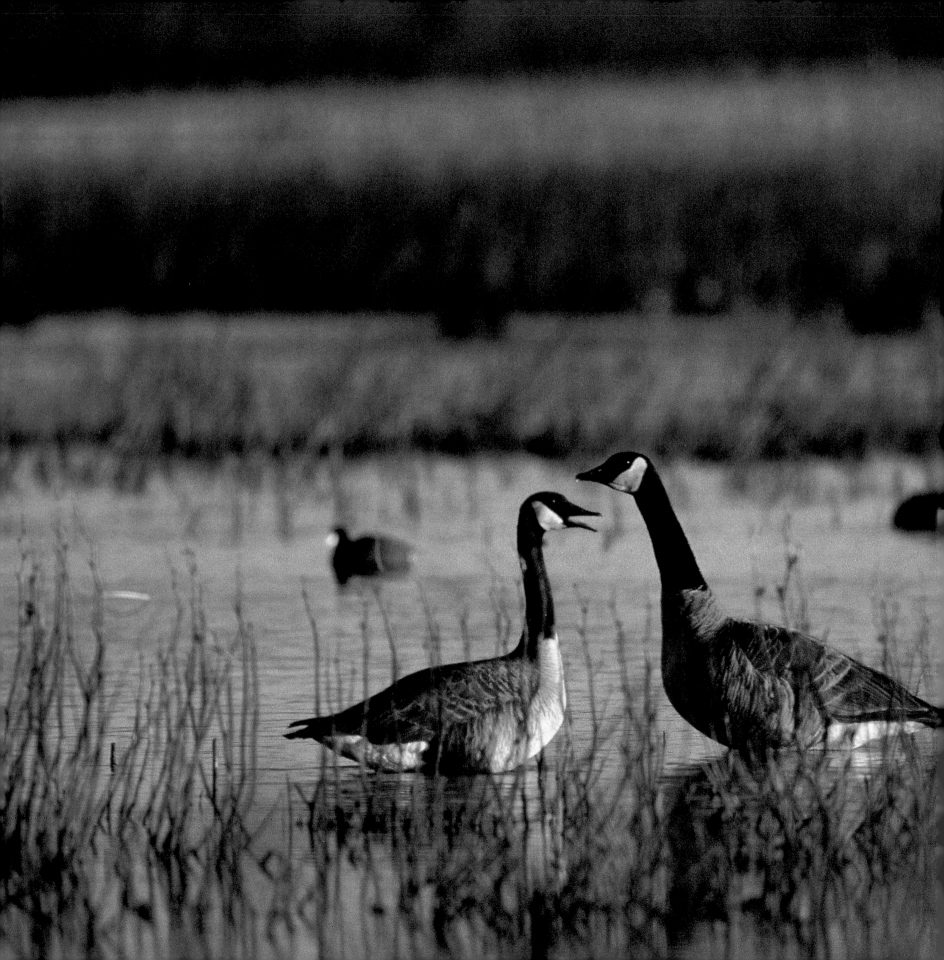

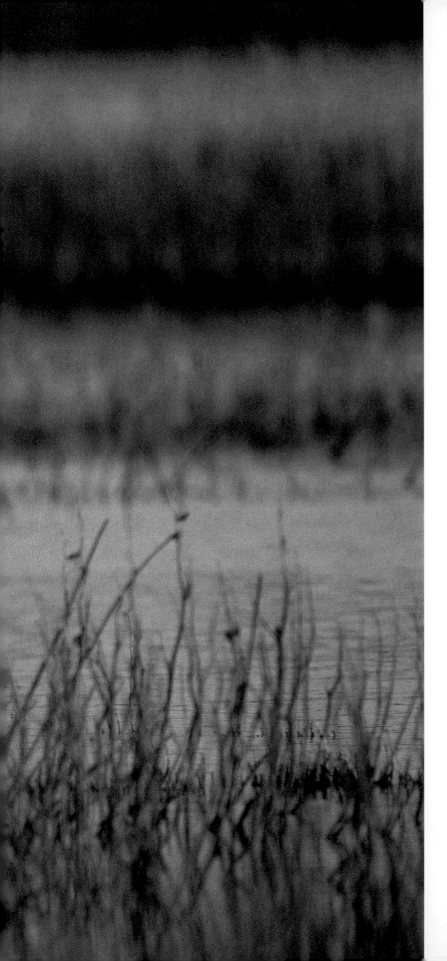

duck has paid a visit: two species each of goldeneye, scaup, and wigeon; three each of merganser and teal. Tundra swans. Shovelers. Canada geese. Brant. Of the 35,000 canvasbacks that winter on San Francisco Bay annually, about 10 percent spend time in Viansa Wetlands. Red-tailed hawks and three species of owl nest here. Eight species of hawks, four species of falcon, and one kind of eagle — the golden — hunt here. The marsh has recorded one kind of starling, two of dove, three wrens, four grebes, five flycatchers, six gulls, seven sparrows. No partridge, yet, on any of Sam's transplanted willow trees, but its cousin, the quail, does run in file down the levees, and another cousin, the ring-necked pheasant, occasionally flushes from the leveeside reeds.

"If there is magic on this planet, it is contained in water," Loren Eiseley once wrote. Water has certainly worked its magic in Sam Sebastiani's hayfield. Water was the potion that resurrected the cattails; the glint that caught the eyes of migrating waterfowl; the highway that brought in turtles, muskrats, carp, and frogs.

William Murray, the mountaineer, in concluding his observation on commitment and Providence, quoted a couplet by Goethe: "Whatever you can do, or dream you can, begin it. Boldness has genius, power, and magic in it."

There are several sorts of magic, then, at work in Sam Sebastiani's marsh.

*Mated pair of Canada geese*
*Overleaf: Sunrise, Viansa Wetlands*

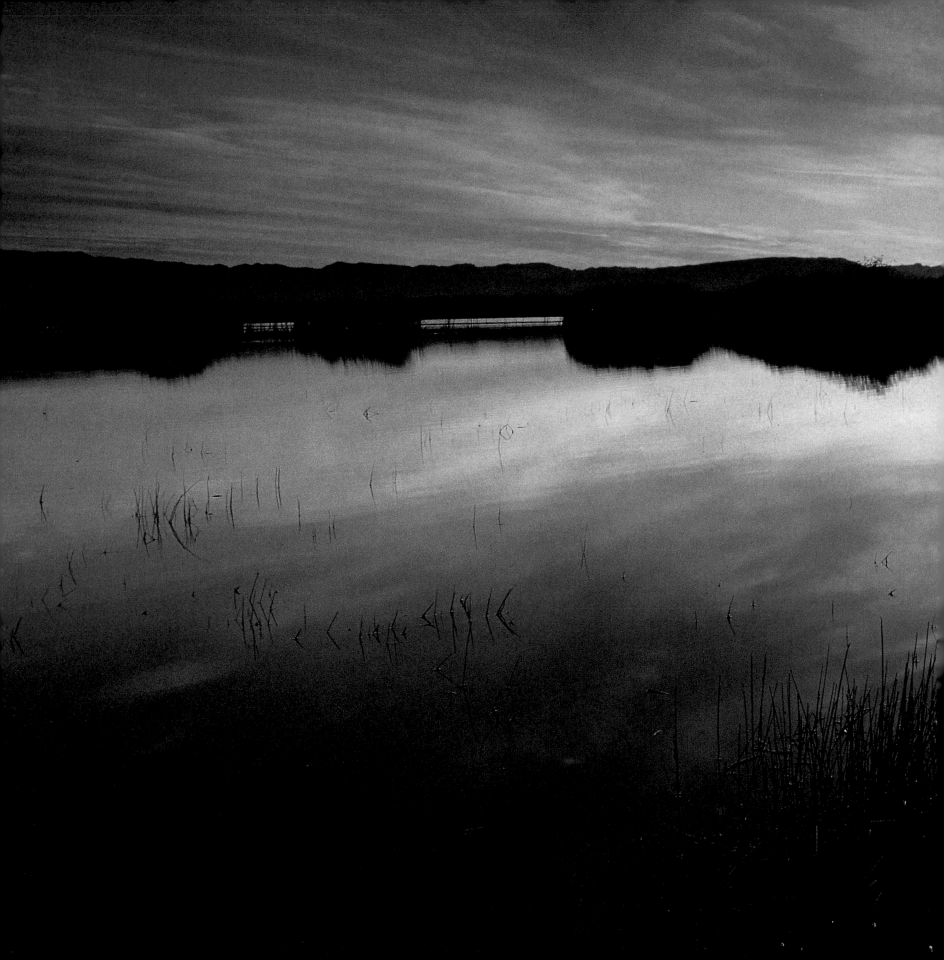

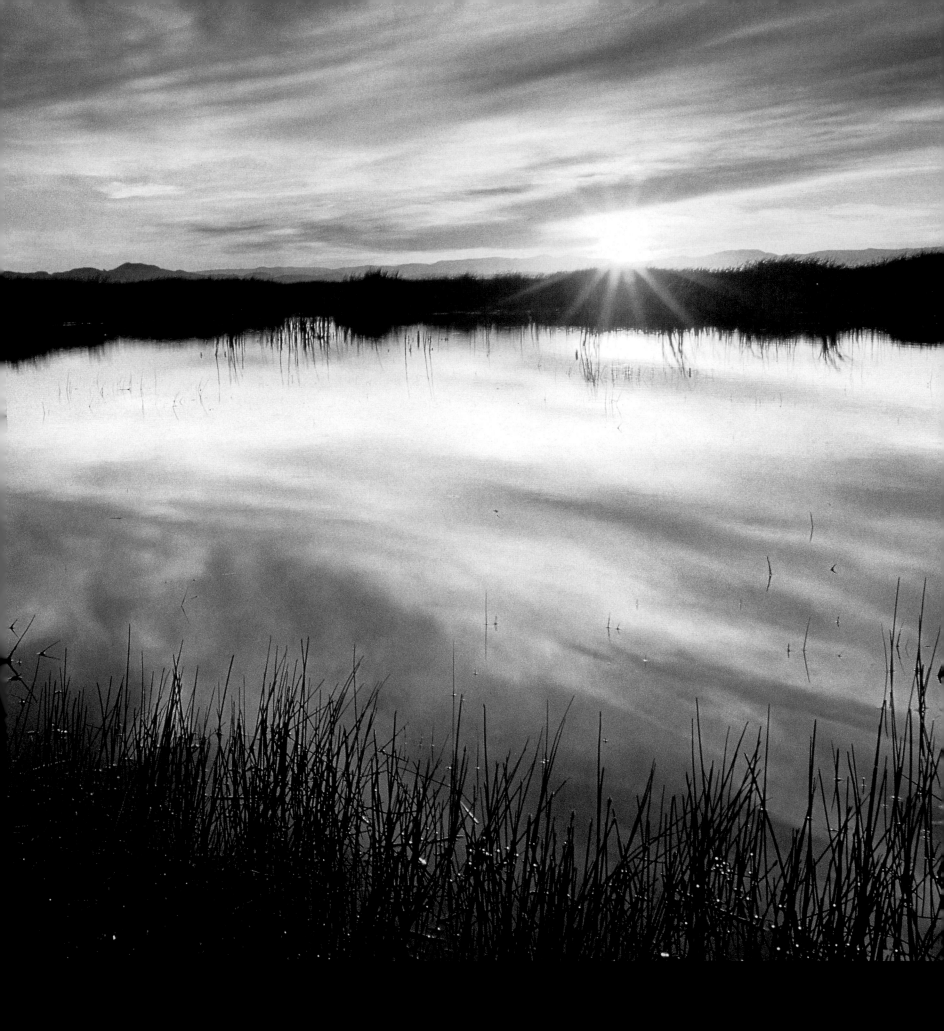

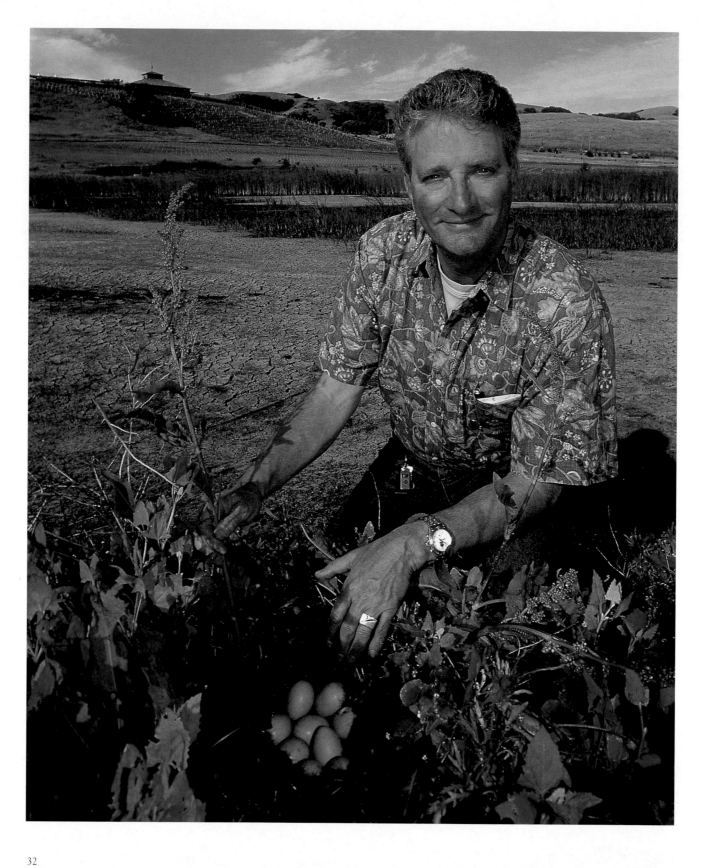

## Fathers and Sons

The mirage of water and ducks Sam Sebastiani glimpsed from his Sonoma hilltop was refracted light from his childhood. Sam's growing up had been equal parts vines and birds, for those had been the passions of August Sebastiani, his father.

"You either have an affinity for animals, or you don't," Sam told me at his winery one day. "My father had it. Especially for birds. When he was little, he would put glue on a stick and catch birds. He would trap them with box-drops, raise them for a while, and let them go. When he was fifteen or sixteen, he read about the passenger pigeon going extinct. To have millions and millions of birds that darken the sky go to zero! It focused his feeling for birds."

In the marshes of August Sebastiani's childhood — those along the Pacific Flyway — the horizon sometimes seems to lift off in a long cloud as waterfowl take wing, but never in numbers sufficient to eclipse the day, as the passenger pigeon did. *Ectopistes migratorius,* a pretty, slim, noisy, long-tailed bird with a pinkish breast and a slate-blue back, was likely the most abundant bird ever to exist. Audubon once watched a flock of them pass over for three days, at a rate, he estimated, of about 300 million birds an hour. Alexander Wilson saw one flock he estimated at 2 billion birds. The passenger pigeon shares with the dodo the unhappy distinction of being the most famous species extinguished by man. The exit of *Ectopistes migratorius* and the entrance of August Sebastiani were nearly simultaneous. The last passenger pigeon, Martha, died in the Cincinnati Zoo in 1914, the year after August's birth.

August Sebastiani became a savior of birds, starting with the species at hand. Sonoma Valley's thousands of acres of farmland were harvested when many of the duck nests hidden in the grain were still occupied. When Sonoma farmers came across nests, they would set them aside for August, who took the eggs home for incubation in pens of his own design. Sam Sebastiani remembers his father's duck enclosures, for it became his chore to clean them.

"He had about five or six of them. They were about eight feet long, with wooden sides and a double screen on top to keep out predators. And then he had a chicken, and a light, and the chicken would incubate the eggs. He used plastic eggs. He'd take the chicken's real eggs and substitute plastic to keep her thinking she had eggs, while he waited for the farmers to call him. When he got word about a nest, he'd replace the plastic eggs with duck eggs."

When the ducklings reared by the surrogate mother chickens had fledged, August released them to the wild.

"A problem," said Sam. "Once the baby chicks hatch, and they're ducks, they want to jump in water. So he used to get old sinks, and bury them halfway in the ground. At the nest end, where the light and mother chicken were, there was a board door. You could lift it up and check the nest, then close it back down. I'll always remember one part. When a baby duck — which the mother thinks is a chicken — jumps in the water, the mothers go crazy. They run in circles. That was common until some chickens had a few years of experience and got to know the game."

Sam came to understand the game himself.

"One thing that I learned, in spending all this time with

*Sam Sebastiani at mallard nest*

birds, feeding them every day after school, was that they were pretty smart. 'Birdbrain' is a compliment, not a knock. I just saw that firsthand. And I got to see personalities. You'd have a bunch of nervous Nellies over here, and over there you'd have a tough little guy. I think I began to develop an appreciation for them, and a fondness. By the time I was sixteen, I took a job driving tractor for a harvester in the summer, and I was personally bringing nests to my dad. I got familiar with the area, and learned where the sloughs are, and learned to watch for the birds. You'll see the nest from the tractor unless you're sleeping. The hen will take off. You have to be quick. When she takes off, you got to shut down right away, because she holds to the nest pretty tightly.

"My dad taught me about not scaring wild birds. Every time you go, you wear the same clothes. I used to carry a red jacket in the back of my truck. I'd put on my red jacket for waterfowl. I got out of the truck, and I always drove a white truck. I'm still able now, when the geese are out on my levee, I'll take my white truck and start calling 'em, and drive right up to them. They think I'm a big goose, or a big swan, or I don't know what the heck they think."

With the draining of central California's wetlands, the demographics of Canada geese had changed along with the landscape. With their sloughs and flooded oxbows dried up, they had taken to golf courses. August Sebastiani now followed them, making the rounds of the greens himself. He commenced raising golf-course geese and from those branched into swans.

"When he was raising swans," said Sam, "he'd get a pair and stick them on your pond. The deal he'd make with you is this: the swans in your pond are yours, but he gets the eggs. He knew that otherwise the eggs would just get depredated. When the nesting season came, he'd go around to all these little ponds and pick up the swan eggs and do it again."

August's waterfowl brought him into the ornithological community. Game wardens, captive breeders, hobbyists, academics, and assorted other bird folk would drop by to see his ducks. From these acquaintances the winemaker learned that the story of Martha, the last passenger pigeon, was being repeated again and again on the Pacific islands, in the rainforests of Asia, in the African veldt, as one dove species after another veered toward extinction. August's attention returned to where it had begun: the Columbidae, the family of the doves and pigeons. Where before August had sent the word out to Sonoma tractor drivers to bring him nests, now he sent a similar message out across the world. Endangered doves from all over Oceania and Asia, after forty-five days of quarantine in Hawaii, would stream in from Honolulu to the Sebastiani vineyards in Sonoma, and there August would breed them.

"He still had ducks and pheasants and everything, but he focused on the doves," said Sam. "If there are any birds going extinct and you need somebody to take care of them, he was the man. By species count, he was the world's largest dove breeder. He had more than eighty species. In fact, he overshot it a bit. It turns out a lot of these doves are fruit-eaters. It's one thing to put out eighty cages' worth of grain, but if you have to put out fruit, too, it becomes much more complicated. Pretty soon they're cooking in the house for the birds. I remember working with my mother, putting currants and rice together. We were always cooking for the birds. Most of it fell to my mother. My dad didn't actually cook. He was good at delegating. Finally she put her foot down, so they phased out of these fruit-eaters. My dad said, 'Give me endangered grain-eaters, nothing else.' "

*Canada geese*

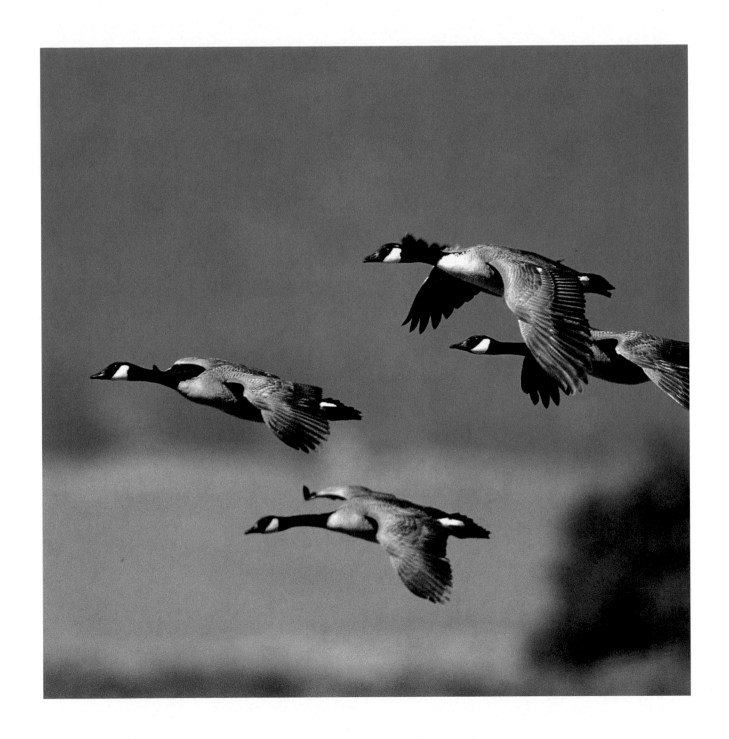

"August was very traditional," said his son-in-law, Richard Cuneo, now president of Sebastiani Vineyards. "*Italian* tradition. I think he had a box for girls and a box for boys. My wife was put in a box, and she didn't particularly care for the box. She didn't stay in it. August viewed things in a traditional way, which is, of course, a nice, comfortable way to see things. It makes it easier to find the answers."

Cuneo paused, recollected.

"I would say he was fairly autocratic. He had his own ideas, and he would be fairly definitive in his comments relative to these ideas. But it was different as it came to birds. I met my wife through the birds. I used to trade birds with August. I started going up there when I was about ten. He respected my bird judgment because I read more than he did. His interest was less academic. He was more a collector on a grand scale. He had caretakers, but he was very hands-on with his birds.

"He would respect bird people a lot more than wine peo ple or businesspeople. I worked for him for quite a few years before he died. He never, ever asked me my opinion as it related to wine. But he asked me a lot about birds. I'd give him suggestions, and lots of times he'd take the suggestion. We'd be walking through the aviaries, and he'd say, 'Do you think we ought to move these Nicobar pigeons over here where they get a little more sun?' And 'Maybe these Peruvian ground doves like it a little darker.' He would defer to people who he perceived knew more than he did. But he wouldn't do that in the wine business. I don't think he asked very many people their opinions on wine."

Cuneo laughed affectionately and nodded toward his wall. "His cabinet on birds was right here in this office."

In Sam Sebastiani's office, not long after my talk with Cuneo, I put this question to the winemaker. Where had his father's greater passion lain — had it been with his grapes or with his birds?

"I used to wonder about that," Sam answered. "About where the enthusiasm hit its highest. When he started getting into all these doves from around the world, he began making contacts with governments on islands. That took all his time. I used to criticize him, because he had two filing cabinets of four drawers each on his birds. I'd come in to try to talk wine, and he'd be on the phone about birds. I'd say, 'Why don't you have more *wine* stuff in your office?'"

Sam paused, gestured at a file cabinet in his crowded office.

"Well, here I am now, two filing drawers on birds." He laughed at himself, then returned to the subject of his father. "Where his heart really was, was with the birds."

It happens that my own father, the environmentalist David Brower, was born in 1912, the year before August Sebastiani. August grew up amid Sonoma's rows of vines; my father in the groves of academe, at the edge of the Berkeley campus. While August was trapping his birds in the North Bay, my father was netting butterflies in the East Bay hills. Both men drifted into conservation. As August built Sebastiani Vineyards into one of the biggest producers in California, my father, as first executive director of the Sierra Club, was reshaping that outfit into the nation's most powerful conservation organization. As August branched into bird rescue, becoming one of the world's biggest breeders of endangered doves, my father, too, went global, founding Friends of the Earth, which now has sister groups in sixty-five countries, then Earth Island Institute, along with an assortment of American outfits like the League of Conservation Voters and the Save San Francisco Bay Association.

One late-summer day, as I scouted the marsh, trying to

decide whether to accept the job as its chronicler, a flock of white pelicans set down at the northern end. The pelican is my father's favorite bird. These pelicans on Sam Sebastiani's marsh were huge. The American white pelican shares with the California condor the greatest wingspan in North American skies. On the marsh, one after another, the flock shook out and resettled their nine-and-a-half-foot spans.

It struck me, watching the birds, that my father, though he had never met August or Sam Sebastiani, had predicted both men.

At the dinner table in the mid-1950s, my father routinely used his wife and small children as his sounding boards. His habit then, as now, was to turn every conversation to conservation. To his way of thinking, all things — economy, morality, politics, discoveries in science, any current event — are tied up inextricably with the health and fate of the Earth. At the dinner table in those days, early in the Elvis period, he sometimes contemplated the future of the environmental movement, looking ahead to the next century and millennium, still more than forty years away. Ninety percent of the American landscape had been altered by man, he pointed out. Less than 10 percent remained wilderness. Just about all the wilderness that could be saved had already been saved. The big job for conservationists in the next millennium — indeed, throughout all the rest of human history — would be repair. Our task would be to go back over the 90 percent and undo the damage. If we could not learn to live less wastefully, making do with the resources of the 90 percent, then the resources "locked up" (as the exploiters liked to say) in the vestigial 10 percent of wilderness could not possibly save us.

The future of environmentalism lay in restoration.

Later, in the 1960s, as the environmental movement blossomed, my father's office was besieged by young volunteers seeking work. He was forced to acquaint them with a grim reality: There are very few jobs in environmentalism. All the jobs are out there in industry and the professions. Commerce is where the action is. If Earth is to be saved, commerce will have to be reformed, and this will happen only from the inside. Business-as-usual cannot be sustained on a finite planet. The environmental ethic has to be inculcated in all walks of life. If you are in law school, my father would suggest to young applicants, then become *green* lawyers. Do pro bono work for the environment. Let environmental principles guide your day-to-day lawyering, and if you find yourself on the staff of some polluter, then enlighten that corporation as best you can. If you are a teacher, let environmentalism inform your teaching. If you are an accountant, become a green accountant, to the extent that this is possible. If you are an *economist*, then God knows we need you, for not one of the preeminent practitioners of that bogus science, in all his specious calculations, has yet made any allowance for cost to the Earth.

*And if you are a winemaker*...I added, in my imagination, thirty years later, as the white flotilla of pelicans drifted eastward through Sam Sebastiani's cattails...*If you are a winemaker, restore thee a marsh.*

In Sam Sebastiani and his resurrected reeds, I had stumbled upon a man and a marsh for the future. Sam, like his father before him, was practicing the kind of private conservation and restoration on which the fate of the American earth will hang. This is how business-as-usual will have to be conducted for the remainder of our sojourn on the planet.

We need a new contract between man and nature. Not just a Magna Carta II, the document that my father, as he approaches ninety, is now fervently advocating, but something

*Overleaf: Tundra swans*

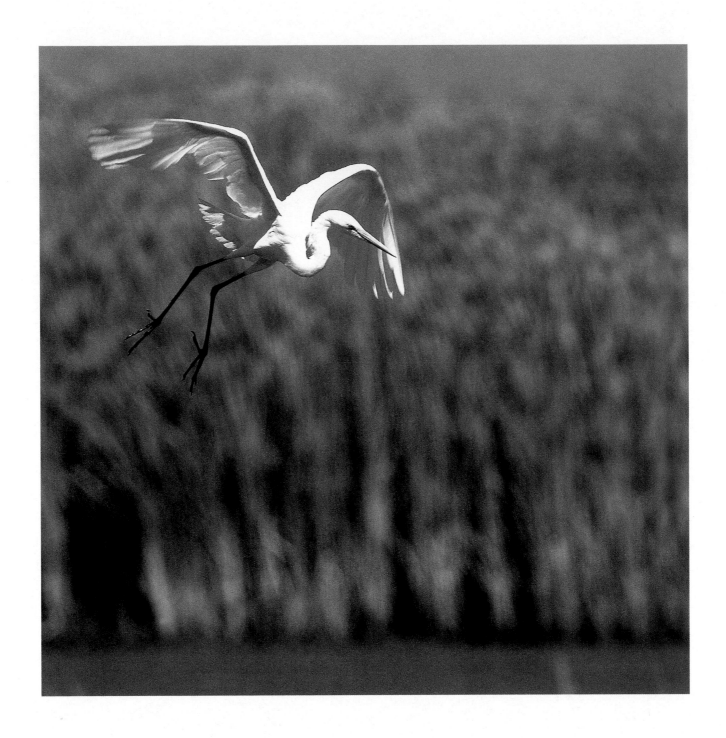

40

less grand. We need some sort of standard document for small landowners; a bit of boilerplate that millions of farmers, ranchers, and vintners will feel comfortable signing. The Sebastianis, it seemed to me, had provided a rough draft.

I worried a little that Viansa Wetlands was too small. Could these ninety acres of reeds sustain the huge burden of symbolism and hope that I wanted to heap on them? I was new to the marsh and I had yet to discover that a whole world is compressed in those ninety acres.

Then I remembered that Walden Pond covered just 61.5 acres. Sam Sebastiani's back 90, the seasonal pond of Viansa Wetlands, was half again as large as that.

"In imagination," Thoreau wrote in *Walden*, "I have bought all the farms in succession, for all were to be bought, and I knew their price. I walked over each farmer's premises, tasted his wild apples, discoursed on husbandry with him, took his farm at his price, at any price, mortgaging it to him in my mind; even put a higher price on it — took everything but a deed of it — took his word for his deed, for I dearly love to talk, cultivated it, and him too to some extent, I trust, and withdrew when I had enjoyed it long enough, leaving him to carry it on."

That's what I would do. Sam Sebastiani wasn't a farmer, he was a vintner, but the principle was the same. He was a busy man. He had a hundred employees at Viansa, a big payroll to meet, an overfull schedule, a cell phone that rang incessantly. I had yet to hold a conversation with him that went uninterrupted by some small crisis. He loved his marsh but seldom had a chance to wander it. I would enjoy his marsh for him.

"I have frequently seen a poet withdraw, having enjoyed the most valuable part of a farm," Thoreau wrote, "while the crusty farmer supposed that he had got a few wild apples only.

Why, the owner does not know it for many years when a poet has put his farm in rime, the most admirable kind of invisible fence, has fairly impounded it, milked it, skimmed it, and got all the cream, and left the farmer only the skimmed milk."

I am not a poet, I write prose, but the principle is the same. I could cream this marsh as effectively as any poet. I would take away the honking of geese, and their skeins on the horizon, and the rosy glow in their contour feathers as they beat low over the marsh at sunset. I would carry off the yip of coyotes after dark, and the hoot of owls, and all the plaintive nighttime queries of shorebirds, and the dark muttering of coots in the cattails, and then, the next morning, I would cart away the red-orange in the eyes of the killdeer, and that iridescent green in the heads of mallards, and the blue in the wings of blue-winged teal. I would take the plunge of terns, and the stoop of hawks, and the stealth of herons, and the silvery wakes spreading behind the muskrats.

To Sam Sebastiani I would leave the filling in of the muskrat tunnels on the levee. I would trust him to maintain the nesting boxes, and set out winter grain for the geese, and negotiate with the U.S. Army Corps of Engineers, the U.S. Fish and Wildlife Service, the California Department of Fish and Game, the California State Lands Commission, the Sonoma County Water Agency, the Sonoma County Reclamation District, the Marin-Sonoma County Mosquito Abatement District, and all the other agencies who wanted a piece of him. His share, in our division of labor, would be the tax on our land, and any legal fees we incurred, and the anxiety of ownership, and the cost of running the pumps.

A year in the marsh was good work, and I decided to accept it.

*Great egret landing*

41

WINTER

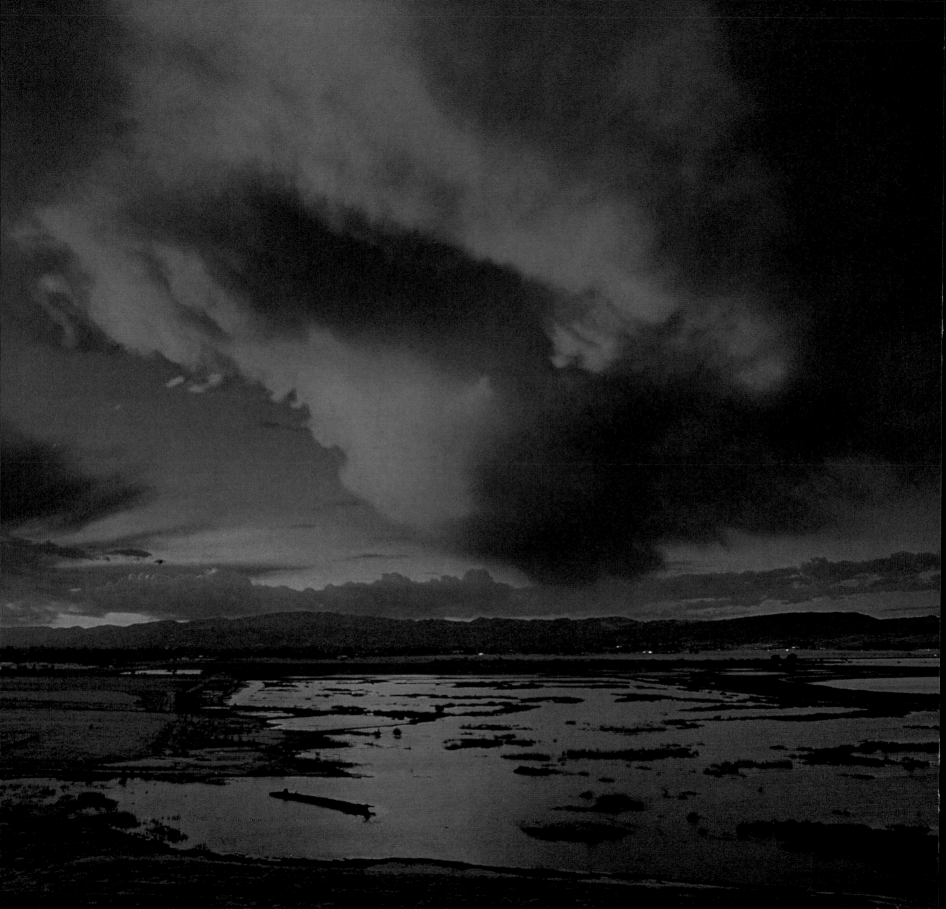

# Rain

The storms of El Niño winter followed one another in close succession, the heaviest rains in years. It was fine weather for ducks but dreary for humans, except in interludes when the sun broke through. In the intermissions, the air had a flawless, rain-washed clarity. You could see forever in the wine country, and the sun shone preternaturally bright. Scattered white clouds, remnants of the passing storm, cast traveling shadows on the Carneros hills, accenting their voluptuousness. The hills glowed unnaturally green. Down on the Sonoma floodplain, ephemeral lakes lay everywhere. The wet green fields were dotted with gulls. The marsh was brimful.

One sunny morning between storms, my twelve-year-old, David, led me down the Sonoma Creek levee, on the east side of the marsh, wearing gumboots borrowed from his uncle. The marsh was overflowing. The levee had been breached in four places by newborn creeks draining outward. The creeks had insufficient velocity to cut channels across the levee's crown, but each rivulet had succeeded in laying a swath through the levee grass. Descending the levee's outer bank, these adventitious streams ran in shallow steps over the grass. Under the cloudy current we could see the flattened blades bucking gently in the current.

At each creek, David stopped at midstream in his over-sized gumboots and danced. It was his Dance to the Marsh, or Dance to Winter, or Dance to Winter Rain, and it seemed to be a stationary version of "the Worm." I myself did not linger to dance. I kept up a steady pace. David, on finishing each cele-bration, was forced to hurry to catch up. He closed the distance between us incrementally by a kind of levee-surfing. Taking a running start, he would slide upright in the gumboots across the slick mud and grass of the levee. Gliding to a stop, he would sprint and slide again.

The sun shone with springtime radiance, but with a win-try absence of heat. It was the paradoxical sort of weather that makes all higher organisms glad to be alive. The cool brightness of the air feels wonderful on the cheeks. A joy of existence seems to enter there, through the skin of the face. It is some sort of catalysis, a kind of animal photosynthesis. Winter air and bright sunlight, acting on special receptors in the epidermis, manufacture joie de vivre.

In red-winged blackbirds, joy enters, too. They were singing all across the marsh. For blackbirds, perhaps, the joie de vivre is in the bright, cool éclat of the air lifting under their wings, or just in the sunlight and its promise of spring. From the dry cattails, the liquid *oh-ka-lee-onk* of blackbirds resounded. The red-winged blackbird is a reed-top singer, it declares to open skies, yet its song is cavernicolous, as if it were piping inside a deep stone well. The solitary males displayed their red epaulets. The gregarious females settled in drab flocks in the cattails, then rose up and settled farther on.

A red-tailed hawk watched the marsh from the topmost snag of a eucalyptus on the southeast levee. The hawk's tree stood in close rank with eight other eucalypts. They made a small, linear grove where the levee met Sam Sebastiani's hill, the last trees before the floodplain. From its perch on the snag, the hawk could survey the plain for voles, the hills for rabbits.

*Winter marsh*

Beneath the eucalyptus canopy, on a horizontal bough, was its big, unruly nest. The twigs and bark had been accreted over several nesting seasons by this red-tail and its mate, or by their predecessors. The red-tailed hawk is a species full of what ornithologists call site tenacity, or site fidelity, or philopatry. This bird and its mate had philopatriotically staked out the familiar tree. In mid-February, when the breeding season began, they intended to nest here again.

A turkey vulture soared above the floodplain, wings set in the strong dihedral V of its species. Now and then the V of vulture would tilt in the wind. A second, more distant vulture circled above the Carneros hills. This second vulture went into flex-glide. Arching its wings and flexing them at the wrist to bring them in closer, it dropped its wingtips, flattening the angle of the dihedral. The "fingers" of the primaries closed slightly and pointed more astern. The tail fan narrowed. The bird's aspect ratio decreased. It gained speed and lost altitude.

David continued his levee-surfing. His sliding across the levee mud was a kind of flex-glide, too, for he bent his knees and crouched to lower his center of gravity. I warned him several times that he was pushing the envelope, but he kept at it. He was now sliding amazing distances across the mud. Sometimes, at the start of the slide, he fought to maintain his balance, but he finished always with a grin and his arms spread in a wide dihedral V of victory.

A marsh hawk quartered low over the marsh, and here came that sharp dihedral again. The hawk's dihedral was unstable in the breeze, and it tilted more often than David's or the vulture's did.

Ornithologists have decreed that the marsh hawk, *Circus cyaneus*, should forevermore be called the northern harrier, but I grew up calling it marsh hawk. Marsh was what this bird was flying over. Marsh hawk it was still to me.

A black-shouldered kite perched on a coyote bush on the far side of Sonoma Creek levee. Its white head revolved, owl-like, to face us backward. It was briefly curious, watching us through the slim black mask of its eye markings. Then it completely lost interest.

The black-shouldered kite is expanding its breeding range, moving from California up into Oregon and down into the Southwest and the Gulf Coast. Its numbers, too, are increasing, but nowhere is the bird common, and I am always glad to see it. Dazzlingly white, except for its black shoulders and eyes, it makes an allegorical sort of raptor. It is given to sudden, luminous appearances. A specialist in mice, it hunts by hovering. Sometimes it happens that the hidden mouse is near a man. One morning, earlier this winter, that man had been me. Lacking vision sharp enough to detect the mouse, I had fallen under the delusion that the kite was interested in *me*. As the kite levitated overhead, backpaddling noiselessly on bright, white, falconlike wings, the sensation was unsettling. The allegorical bird, nimbused by the sun, hovered like a soul looking for a body to settle in. Finding my flesh already occupied — or watching, maybe, as the flesh of mouse disappeared down its hole — the bird had broken off and soared away.

Through my binoculars, now, I studied this perching kite.

*Elanus caeruleus*, the black-shouldered kite, does not have the look of an American bird. This one was perched in a coyote bush on a levee in Sonoma County, California, but it just did not have a New World aspect. In America we don't have white raptors. Our birds of prey are buff or dark. On the osprey there is a good deal of white, but the osprey is a global

*Red-winged blackbirds*

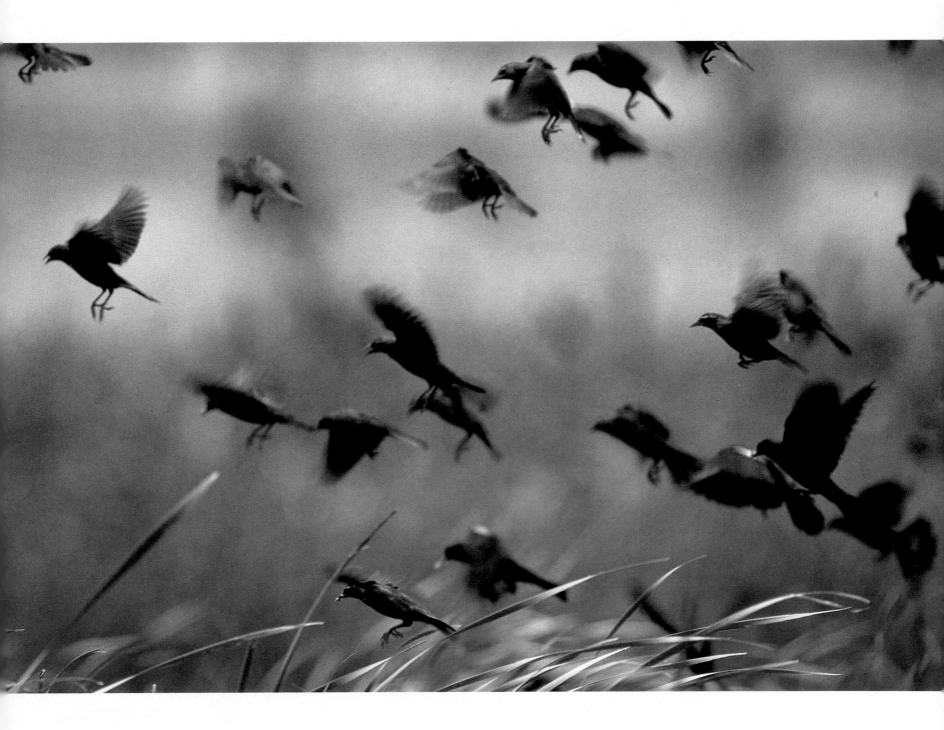

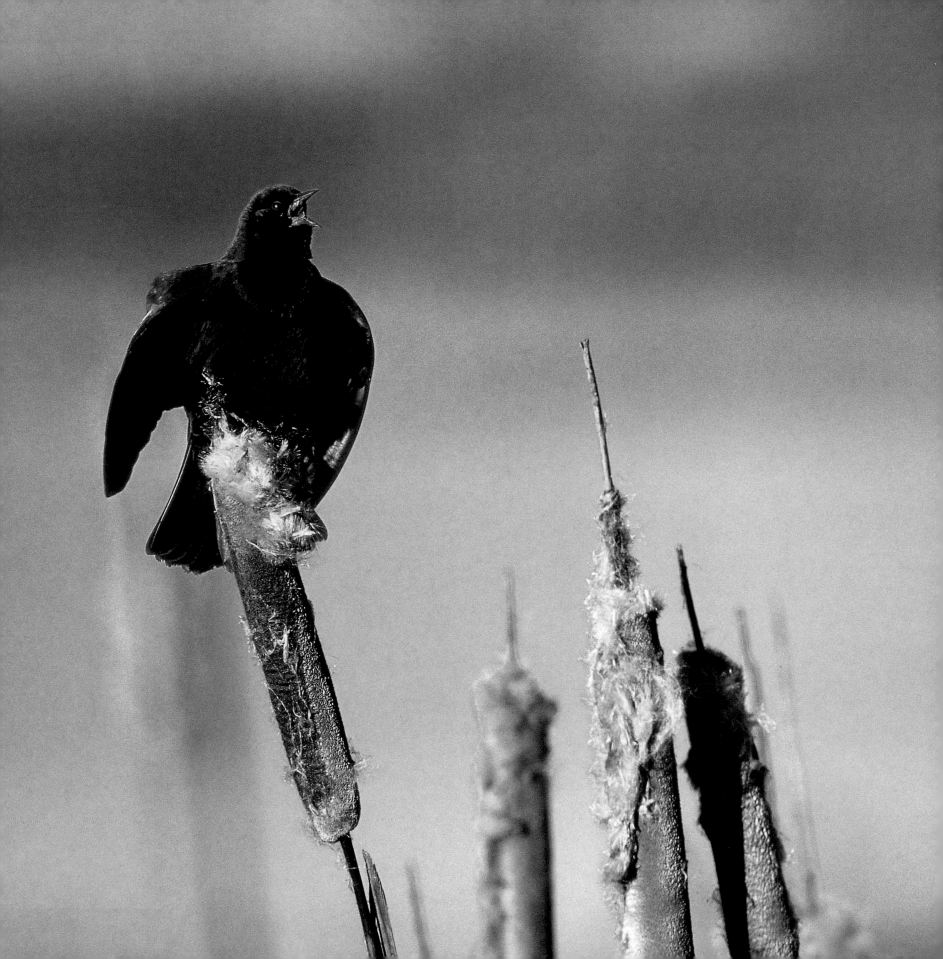

bird. Black on white are the colors of the Egyptian vulture, sometimes called "pharaoh's hen," a bird that ancient Egyptian sculptors liked to feature on their statues. Black on white are the colors of the Himalayan griffon, the booted eagle of Tibet, the white-breasted sea eagle of southeast Asia — all Old World birds. *Elanus caeruleus* belonged in that world, along with most of the planet's other kites. It looked like another raptor the Egyptians might have deified. On this bright, rain-washed day, the black-shouldered kite, perched on its bush, pale and falcon-like, its fierce red-orange eyes darkened as if by kohl, looked like a ceramic hawk from some pharaoh's tomb.

Another marsh hawk appeared, or perhaps the same hawk circling back again. The marsh hawk's genus name, *Circus*, derives from the Greek word for "circle" and describes the bird's circular search pattern. The hawk's dihedral tipped and tilted in the breeze. This was a female, like the first hawk. They probably were the same bird. The quartering of the marsh hawk — circuitous harrier — brought it over the Sonoma Creek levee.

The black-shouldered kite lifted off the coyote bush, showing the black carpel marks on its underwing, and it flew straight at the marsh hawk, forcing the larger bird to veer.

The kite's ferocity surprised me. It cannot have had a nest to defend, or a breeding territory, as this was the middle of winter. Flapping hard, the kite closed again on the marsh hawk, which again took evasive action. A marsh hawk is built much like a kite, and in proximity their resemblance was striking. (Both get their species names for the color of their backs, the hawk *cyaneus*, "dark blue," the kite *caeruleus*, "sky blue.") Both are birds of open country, grasslands, and marshes. Both are mousers. Maybe the kite recognized a competitor. To the kohl-dark eyes of the kite, perhaps, the hawk looked too

much like itself. The kite harried the northern harrier into the distance. Together the two birds disappeared in the direction of the Napa hills.

On reaching the otter run where my colleague, the photographer Michael Sewell, had set up his remote camera, I saw that the camera was gone. Sewell had removed it ahead of the rising water, apparently. At the same time Sewell had rescued, from either side of the otter run, the transmitter and receiver of the infrared beam that tripped the camera's shutter. My habit, on each visit to the marsh, was to read the receiver's red digital number, which counted how many times the beam had been broken. Then I would detour around, so as not to waste my partner's film in portraits of my boots. The beam, invisible to begin with, was just a ghost of invisibility now, yet habit is strong. The arresting hand of custom pressed hard against my chest, and I found it hard to step across the otter run. Some sort of residual beam, of a wavelength way out beyond the infrared, still shone, for me, across the otter path.

My son came levee-surfing up behind me. He slid through the missing beam as if it did not exist. He came to a stop, his arms spread in a victorious dihedral V. Then he took off again.

I wished he would pay a little more attention to the natural history. I hoped he was absorbing some of it subliminally. Like any twelve-year-old, he was caught up in his own physicality. Life outside could not compete with all the life within himself. The flight of birds pales in interest when you yourself can fly in gumboots along the top of a levee.

David paused to dance in the fourth creek draining the marsh. Beyond this creek, levee-surfing again, he hit an unusually fast stretch of mud. His gumboots flew out from under him,

*Red-winged blackbird displaying*

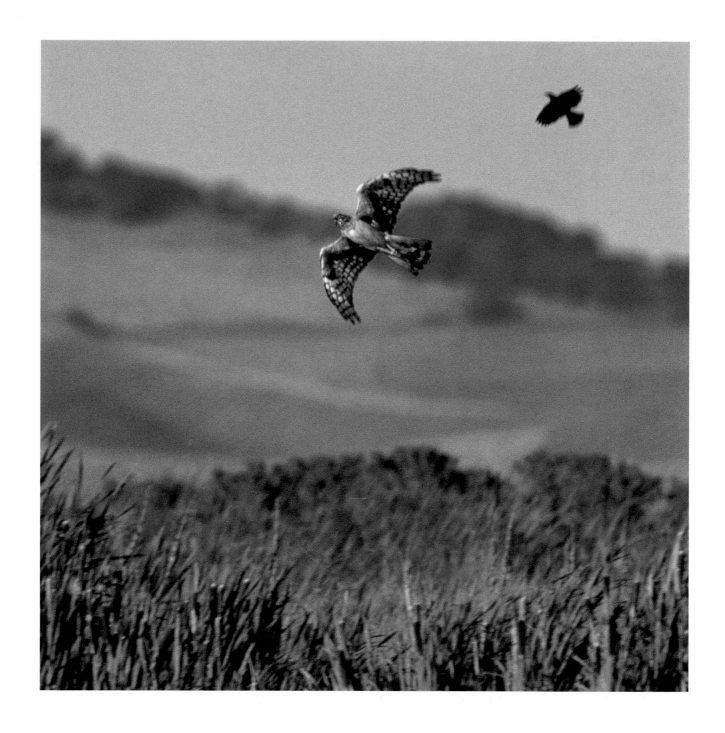

he upended and slithered two body lengths on his side. He rose slightly chastened and very muddy. He gave up levee-surfing, for the moment. He became somewhat more contemplative and began to show some interest in his surroundings.

At the widest part of the marsh, where the east levee made a dogleg and turned north, we found a new game trail blazed across the levee. The trail emerged from cattails at the corner of the marsh, made a faint impression across the crown of the levee, cut a deeper channel through a swale of dead summer vegetation beyond, and ended in a steep, muddy chute into the water of Sonoma Creek. In the mud of the chute, we found one clear track, a hind foot that had left a faint impression of the webbing between toes. "Otter," I told David. With a grass stem for pointer, I indicated the tracery of the web.

The trail was a new otter run. The muddy chute was an otter slide. David stood above the slide, admiring its slickness and steepness. This smooth, belly-carved groove in the cut-bank was the work of a real levee-surfer, a low-slung creature ideally built for sliding.

It was here, at the top of the slide, that the otters crossed from the freshwater ecosystem of the marsh to the brackish tidal system of Sonoma Creek. The boundary was marked by a narrow margin of pickleweed along the top edge of the bank. Pickleweed is a halophyte, a salt lover, and in California it is the indicator plant for salt marsh. On this side of the demarcation — west of the Pickleweed Line — the rise and fall of the water was seasonal, dependent on rain. On the other side, the rise and fall was diurnal, twice daily with the tides. On this side lay limnology, the standing water of pond. On that side lay intertidal ecology and the dendritic streamcourse of tidal flat. On this side grew cattails, arrowhead, marsh pennywort,

pondweed, water buttercup, spike rush. On that side grew cord-grass, lilaeopsis, common rush, California bulrush. On this side swam frogs and terrapins. On that side swam — I knew not what. Sonoma Creek lay just outside Sam Sebastiani's boundaries, and I had not looked into it. I could only guess what moved under its opaque waters: the occasional small sturgeon, leopard shark, and bat ray, probably.

The otter, for their part, did not recognize the boundary. They were at home in this universe and in the alternative universe on the other side.

In theoretical astrophysics, passageways between universes are called "worm holes." In physics they are still only theoretical. In Sam Sebastiani's marsh their reality is not in doubt, and otter use them all the time to slip from one realm to the other.

Scouting the edges of the run, we found fresh otter scat with fish scales and feathers in it. For otter, the marsh is smorgasbord. They eat a little bit of everything, and the color and shape of their scat varies accordingly. We looked around for rolling places, the circles of flattened tules laid down by playful otter, but found none. We looked for "sign heaps." River otter have a habit of twisting up tufts of grass to scent-mark with their anal glands, for in treeless landscapes like the Sonoma floodplain, they have no recourse but to manufacture their own signposts. The naturalist A. H. Luscomb, studying the ancestors of these very otter in the 1930s, mapped several sign heaps and rolling places visited religiously by nearly every otter passing along a certain slough of Suisun Bay for a fourteen-year period.

We found no heaps, but just off the otter run we did come across the ranchero of a field mouse, or vole. The vole's hole in the ground opened on a short run through thick dead grass. The run ended in a second hole, perfectly round, in the

*Red-winged blackbird harrying a northern harrier*

outer wall of a grass clump. This outer hole was screened, in its turn, by a kind of natural ramada, a latticework of dry, windfallen stalks of wild celery and thistle, very much like those brush arbors that Navajos build beside their hogans. From the plenitude of droppings under the arbor, it was apparent that the vole liked sitting out front. Sunning itself there, safely screened, it could watch the rise and fall of Sonoma Creek, and keep a nervous eye on harriers circling, and monitor otter flowing down the otter run.

It was just a perfect situation, for a vole. The vole's ranchero lay, it's true, very close to an otter run. Otter belong in the weasel family, the Mustelidae, great enemies of voles. But the troublesome weasels are at the smaller, slimmer end of the spectrum — least weasels, long-tailed weasels, and ermine — those snakelike, narrow-gauge hunters that can follow a rodent down its hole. A river otter is one of the girthier weasels. It can weigh thirty pounds. It is no specialist in field mice. If voles are capable of something like a smirk, then the whiskers of this one must have smirked occasionally, as the monstrous length and musky scent of otter passed just outside its door.

Reaching the western levee, we detoured into the narrow strip of no-man's-land that separates Sam Sebastiani's cattails from his last rows of grapevines, looking for the half shelters of jackrabbits. Not twenty paces into the scrub, we jumped a jackrabbit. It sprinted northward in a straight line, bounding high every six or seven strides, then veered sharply left into the bare winter vines, where we lost the great ears about four rows deep. We strolled to the vicinity of the rabbit's materialization. There we found the tussock of dead grass it had modified. The pressure of its body had sculpted the tussock into a kind of half wigwam, the stems molded into the shape of rabbit. From this little blind, the rabbit had watched us until we came too close.

This animal architecture — otter, vole, and rabbit — had a *Stuart Little* or *Wind in the Willows* feel that captured my son's imagination. His spill in levee-surfing had slowed him down sufficiently to give their handiwork his full attention.

Back on the levee again, we saw a meadowlark, the first one I had encountered in the marsh, and the only one I would ever see here. David asked me what that bird was. "Western meadowlark," I said, happy that he had asked. On reaching the car, we scraped off excess mud and climbed in. As we headed home, David watched the floodplain through the driver's-side window and he pointed out a forward-leaning egret there. His spill on the levee had been the best possible thing. For a couple of hours, at least, it had made a naturalist of him.

*Sunrise, winter marsh*

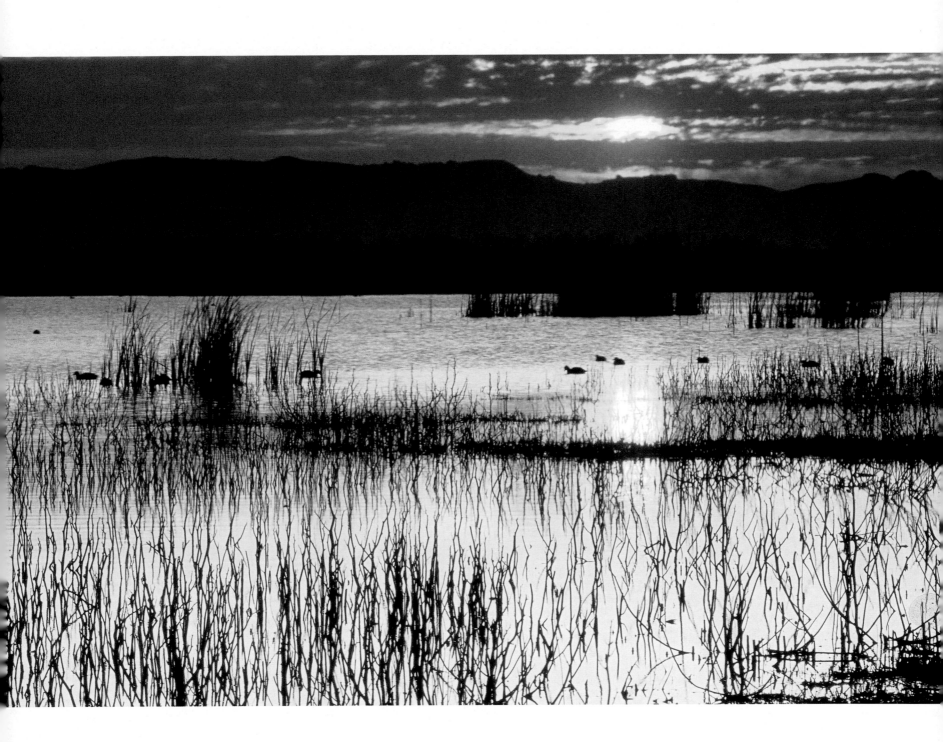

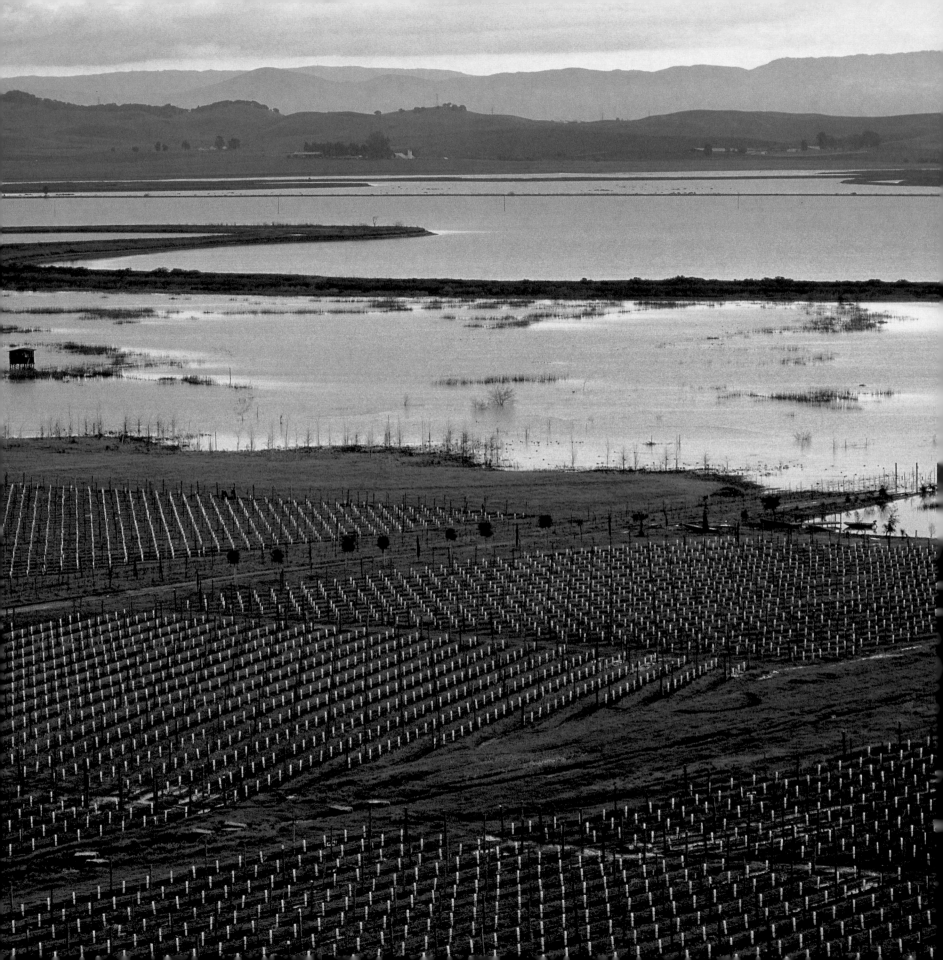

# El Niño

Another storm rolled in. The green light died on the Carneros hills. In heavy rain, the sculpture of the hills went two-dimensional as their rounded female forms darkened to gray, flat halftones. False April ended and January settled in again. The dirt road from Sam Sebastiani's hilltop down to the marsh became a torrent. The spadixes of the dead cattails — those velvety cigars atop the spikes — unraveled. Clumps and strips of the tight-packed seeds, brown outside and white within, hung off like wool. In the rain, each stand of cattails looked as muddy and disheveled as a flock of lost sheep.

In the vineyard bordering the western edge of the marsh, the grapevines hibernated, their buds arrested by the cold in the stage that phenologists call "enforced dormancy" or "rest." The buds had not been fooled by the warm intermissions in the procession of storms. If Sebastiani had transported cuttings from the vines to a greenhouse, they would have burst their buds in a few days, but the intervals between storms did not provide consecutive days of sufficient warmth, and the buds remained dormant.

There was a paradox in the winter chill. The cold, even as it enforced bud dormancy, was guaranteeing budbreak. Grapevines, like many perennials, require a period of low temperature if the dormancy of latent buds is eventually to be broken. The phenology, then, goes like this: first the cold, then budbreak in the vines, then barrel, bottle, wineglass, and finally a kind of budbreak on the tongue. What one tastes in the glass, for the most part, are the transmuted sugars of summer, but somewhere underneath lies the paradox of winter's chill. Under the bouquet, deep beneath the volatile surface of the wine, a truly discerning palate should be able to detect the cold nativity of budbreak: that paradox of winter chill that makes grapes, and wine, possible.

Out on the levee, the white tips of the willow catkins were emerging. It seemed a poor idea. The willows might have been smarter to wait a little, following the lead of the grapes.

The gray hills of Carneros receded in misty halftones. It was hard to believe that just hours ago, before this storm, those hills had been a brilliant green. It was difficult to reconstitute, in the mind's eye, the greenness of that green. Marsh and levee vegetation was all in Andrew Wyeth colors: muted grays, bleached golds, ochers, tans. These winter hues, by their very austerity, brought out the colors of the birds. The cinnamon teal, swimming amongst the dead cattails, went so incandescently cinnamon that they exceeded that color. They became cayenne-pepper teal, almost. Male purple finches, perching in gangs on the leafless branches of levee shrubs, fluffed big against the cold, their breasts a startling rosy red. Enlarged tenfold in my binoculars, the red of the breast feathers looked *sprayed* on. It was as if each bird had dipped headfirst into a mist of bright arterial blood. The finches were innocent seed eaters, yet they looked to have just hamstrung some victim and gobbled it alive.

Standing in bare vines on Sam Sebastiani's hilltop, one gray winter afternoon, I glassed a kestrel perched in a buckeye tree at midslope. The American kestrel, or sparrow hawk, is our smallest, commonest, most colorful falcon. It is a wonderfully variegated miniature that my big binoculars deminiaturized.

*Viansa vineyard and marsh in flood*

Against the wan hues of the winter marsh, this male kestrel lit up the binocular's optics: white cheeks, black Pancho Villa mustache marks, yellow eye ring and cere. Crown bicolored, a blue-gray tiara capped by rufous yarmulke of crown patch. *And that was just the head.* Below came rufous neck with oval dark patch, rufous breast grading into pale spotted belly, rufous back, blue-gray upper-wing coverts.

The Painter of kestrels, as a finishing touch, had used a brush tip to dot each blue-gray covert feather with a circle. Turning the brush sideways, He had barred each feather of the back.

I had seen kestrels before, naturally. My family had rehabilitated a kestrel once, a young bird we rescued in a sandstone canyon of the Southwest and nursed back to health at home. But that little falcon had been an immature female. This kestrel on the buckeye tree, an adult male, was something else again. If those colors came on an eagle-sized raptor, the kestrel would have been our national symbol.

A new succession of storms arrived. The rain fell with a tropical intensity, and in fact it was an intensity that El Niño had stolen from the tropics. It was rain that in any normal year would have fallen on the equator. This was the strongest El Niño since 1982–83, which was the strongest El Niño of the century.

The storms broke. The sun emerged. As the clouds scattered, they sent shadows fleeing over the green curves of the Carneros hills. The ephemeral lakes of the floodplain were now much larger and more numerous. If the hills were green as Ireland, and they were, then the plain had become a little Minnesota. Gulls driven inland by the weather stood in the fields. The floodplain had sprouted them everywhere,

whitecapped, like mushrooms after rain. Here and there among the gulls, taller and more angular, stood a snowy egret or great egret. In fields of unseasonal green, the birds were as white as the departing clouds, but their albedo was stronger. The whiteness of the gulls and egrets was more concentrated and luminous. The clouds were just vapor. The birds had the breath of life in them.

The sunlight seemed a special dispensation, miraculous, after all the rain. Walking the levee in sunshine, I felt like an escapee.

The young immortals of various civilizations — the future Mikado of Japan, the high priest of the Zapotecs, the Inca of the Incas — were locked away indoors by their retainers, on the theory that the light of that other deity, the sun, should not shine on the divine person. Occasionally one of these prisoners must have slipped out of the palace, and that was exactly how I felt, striding Sam Sebastiani's levee between storms.

Atop the old tracks of my son's levee surfing, not yet washed out, were imprinted new tracks of coyote, raccoon, Canada goose, and heron. I missed my son's companionship. Each time I saw the slathery spoor of his gumboots, I smiled a paternal smile. Yet there is something to be said, too, for solitude in the marsh. An adolescent levee surfer sends up startled mallards and pintails in greater numbers than a quiet walker does. I missed my son, but it was not bad to be alone. The sun shone with a springtime radiance, but with a wintry absence of scent. The marsh smelled faintly of wet earth and the new grass that ran in a narrow green lane down the center of the levee.

Occasionally, with a wind shift, I smelled the strong salt scent of the sea.

Sonoma Creek is a tidal stream that drains, on ebb, into

*Male kestrel on buckeye tree*

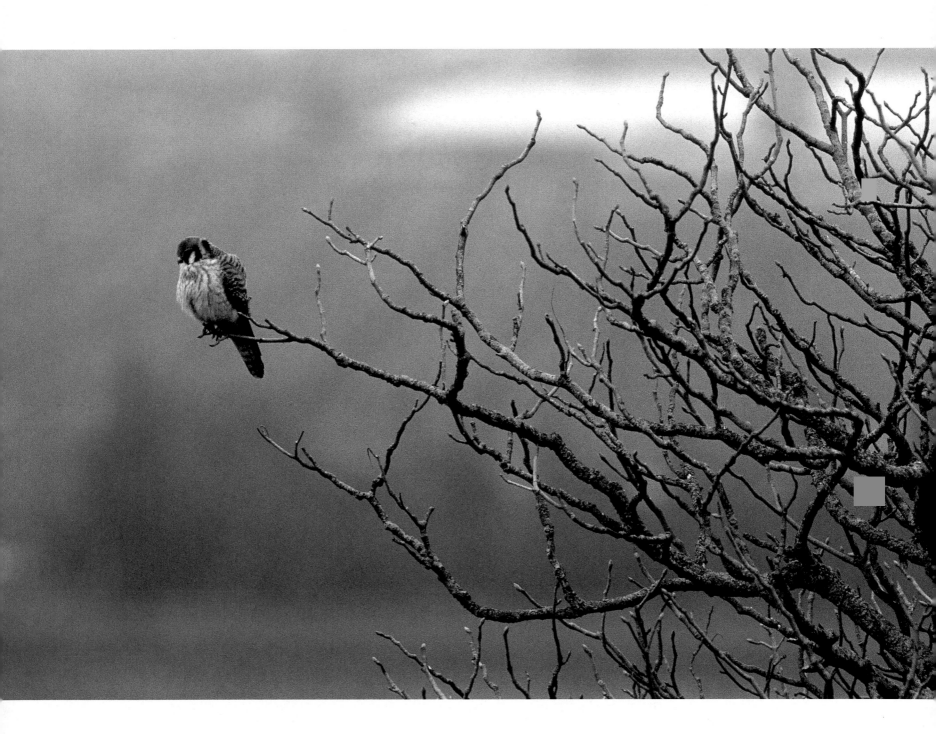

San Pablo Bay. At flood the flow reverses, and San Pablo Bay, along with the greater estuary of San Francisco Bay, and then the Pacific and the world ocean, all drain into Sonoma Creek. Like any tidal creek, Sonoma had two watersheds: the hills to the east, and the mountainous swells of the North Pacific to the west.

Out there, at the big, salty end of Sonoma Creek, where its waters widen into the ocean chop beyond the Golden Gate, fishermen were catching tuna, barracuda, and other subtropical fish that had followed warm El Niño waters north. A mako shark showed up in Monterey Bay. A marlin was caught by a surprised angler off the coast of Washington State. Populations of local fish were crashing. The altered wind patterns of El Niño reduced the upwelling along the continental shelf and killed productivity. Without the upwelling of cold, deep water, nutrients simply sank. They were no longer being returned to the surface zone of sunlight where the tiny plants of the ocean, the phytoplankton, could make use of them. As the phytoplankton thinned, so did the zooplankton that fed on them, then the sardines, herring, and other fishes that feed on zooplankton, and then sea lions and harbor seals that feed on the fishes. Eight thousand sea-lion pups were counted dead on the beaches of San Miguel Island. Two-thirds of the fur seal pups died at the Adams Cove rookery on San Miguel. Brown pelican reproduction fell off in Baja California. Salmon shifted to colder waters farther north. In the deserts of the Southwest, rodents were surviving the mild, wet winter in such numbers that

health authorities began preparing for a spring outbreak of hantavirus. Up on the Mendenhall Glacier of Alaska, the dawn chorus of varied thrushes began at 6:30 in the morning of February 27, the earliest date ever recorded. Down in Chile's Atacama Desert, the driest landscape on earth, El Niño rains watered a once-in-a-lifetime flowering, and just south of the Atacama, in the Chilean coastal desert town of Arica, thousands of hungry and confused pelicans invaded the streets, stalling traffic. El Niño, even as it warmed temperate seas, chilled the poles. In Antarctica, the birth rate declined among Weddell seals. In the Arctic, polar bears chose not to hibernate, so severe was the cold. As water temperature and sea level rose in the eastern Pacific, they dropped in the western Pacific. Dengue spread in the islands on that side. Exposed corals bleached. There were giant forest fires in Indonesia, floods in China, famine in the highlands of New Guinea. The supertyphoon Paka struck Guam with 236-mile-per-hour winds, the highest ever recorded.

In Sonoma County, California, another storm rolled into Sam Sebastiani's marsh. The first moist gust, full of the smell of rain, started wavelets marching across the surface of the marsh. A few advance drops pocked the wavelets, then the downpour flattened them out. In a white mist of rebounding droplets, the cattails went nebulous gray. The Carneros hills disappeared in the slanting curtain of rain. The rain fell hard for days.

*Cattail spadix dispersing its seed*

*Overleaf: Cattails in fog*

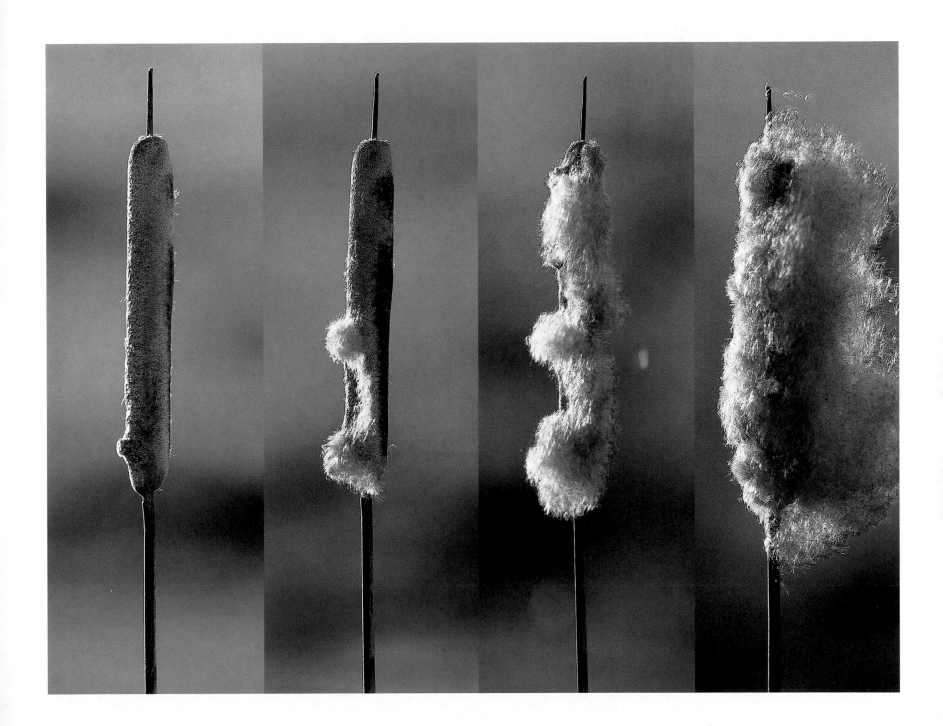

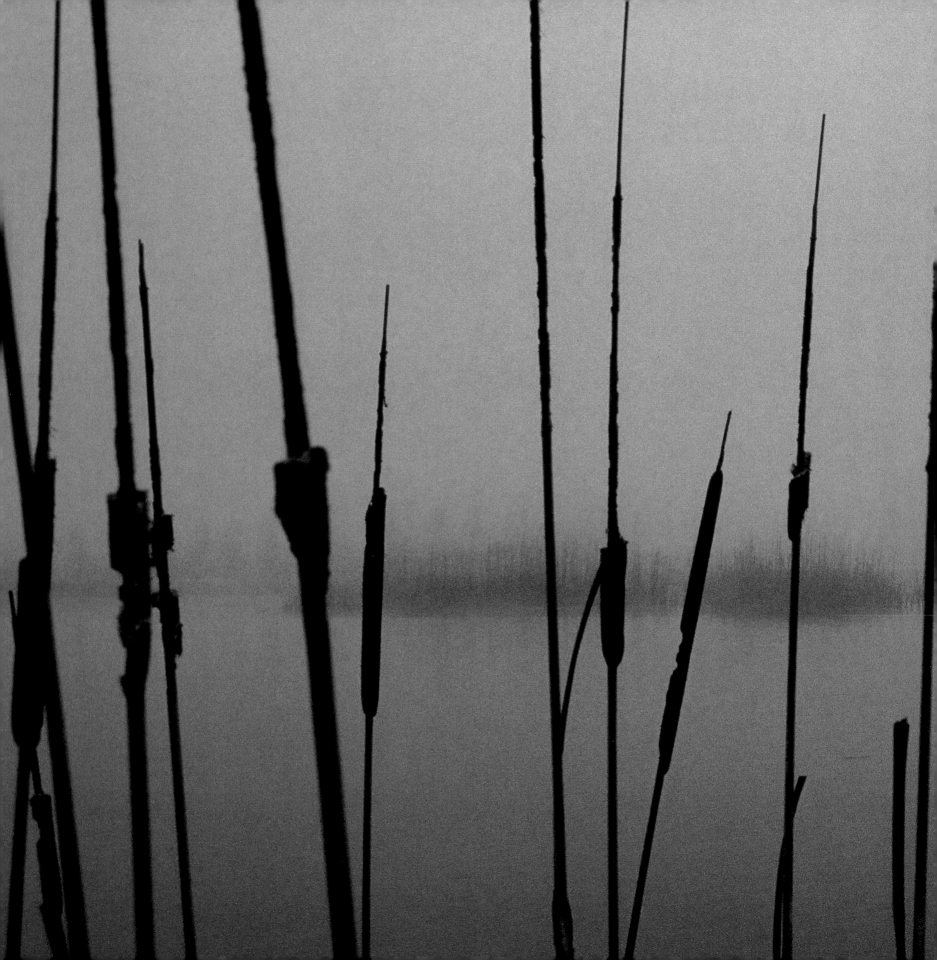

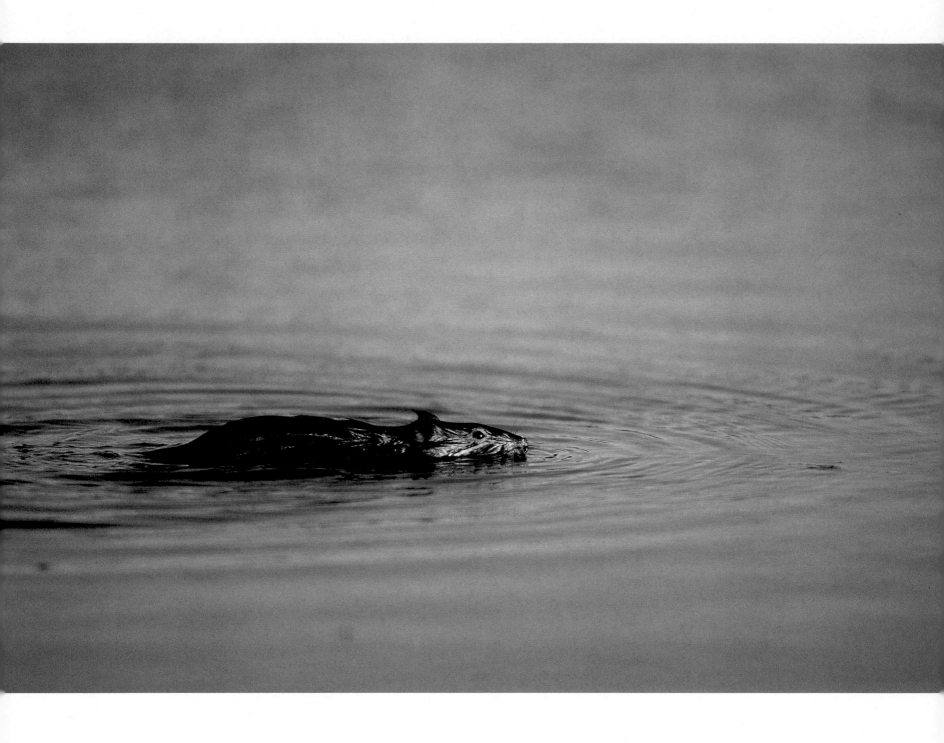

# Muskrats

Somewhere on the Sonoma floodplain, a levee failed under unrelenting rain, inundating the northern end of the marsh. The north levee went waist-deep under water. To walk the marsh perimeter, I had to pull on chest-waders. Nothing showed of the submerged levee but the line of poles marking its route. I followed the poles closely. The levee crown was only ten feet wide, sloping off sharply into deep water on either side. One false step, and I would overtop my waders. Westward, the last rows of Sam Sebastiani's vines were flooded, and northward, the Cline Cellars land — the Plain of Cline, I had come to call it in my notes — was submerged as well. Viansa Wetlands had swollen into a brown inland sea.

The bulky legs of the waders resisted the water. Underused muscles at the top of my thighs grew pleasantly sore from dragging my feet forward against the resistant weight of the marsh. Every fifteen or twenty paces, one foot or the other would suddenly plunge, breaking through the ceiling of a muskrat tunnel. Bending the opposite knee, I would grunt, yank free the sunken foot, and stride on.

This accidental discovery, with the probes of my feet, that muskrat tunnels riddled the levee, came as a great surprise. I seldom saw muskrats — one or two daily, at most. Muskrats were either much more numerous in Sam Sebastiani's marsh than I had imagined, or much more industrious.

The muskrat, *Ondatra zibethicus*, is a giant, rat-sized vole modified for aquatic life. Like fur seal or beaver, it has dense, water-repellent underfur for warmth and above that, long, glossy guard hairs for streamlining through the water. Its feet are partially webbed, its tail laterally compressed for use as an oar in swimming. It feeds on water plants, cattails especially, and occasionally, for dessert, it downs a freshwater clam or a crayfish.

Through binoculars I had watched muskrats harvest cattail shoots, swimming from stand to stand with the growing sheaf of rushes held crosswise in the mouth. The green "whiskers" of harvested cattails had made a wide wake behind. I had followed muskrat runs — narrow avenues of flattened cattails — across the levee banks. I had stumbled across the big cattail balls of muskrat nests. Pushing through the reeds in chest-waders, I had come upon openings cleared by muskrats within nearly every stand of cattails. Inside these muskrat clearings floated the rafts of felled cattails that muskrats use as observation posts, dinner tables, and latrines. I would run a finger across the striations cut by muskrat teeth in half-eaten cattail shoots. Sometimes, in investigative mode, I would sniff the little piles of turds that the muskrats leave on the floating stalks, piled neat as cannonballs on a courthouse lawn. The muskrat gets its name from scent glands near the anus, which deposit their musk along with the feces, but I seldom detected any muskiness, just a good, clean smell, as if the muskrat digestion system had distilled out some fresh *essence du cattail*.

I had developed, in other words, some intimacy with muskrats, yet never had I sensed the *muskrattiness* of the animal so joltingly as on this winter day, plunging again and again into the pitfalls and booby traps of their tunnels in the levee.

The muskrat is not native to California. Its center of evolution seems to have been the prairie pothole region of the

*Muskrat at dusk*

Northern Plains, where glaciers scooped out marsh basins everywhere. Introduced to the San Joaquin Delta, the muskrat has prospered, undermining riverbanks and levees everywhere, adapting so completely to the tules that they are now bearers of tularemia. Sam Sebastiani, in making this wetlands, had been thinking of a refuge for waterfowl, but many other creatures had come unsummoned to his reeds. Muskrats had crashed his party and now his levees were infiltrated, too.

It was not my duty to maintain Viansa's levees. At first I was able enjoy the Russian roulette of the levee walk. Ten steps, or fifteen, then, whoa! a lurch downward through roof of muskrat tunnel. It was an interesting sensation: wading the expanded brown sea of the wetlands while mapping muskrat dens with my feet. Then, finally, as I pulled my foot free of yet another tunnel, my legs fatigued. I grew tired of muskrats. Sam Sebastiani had succeeded a little too well in restoring life to his marsh.

*Cinnamon teal females*

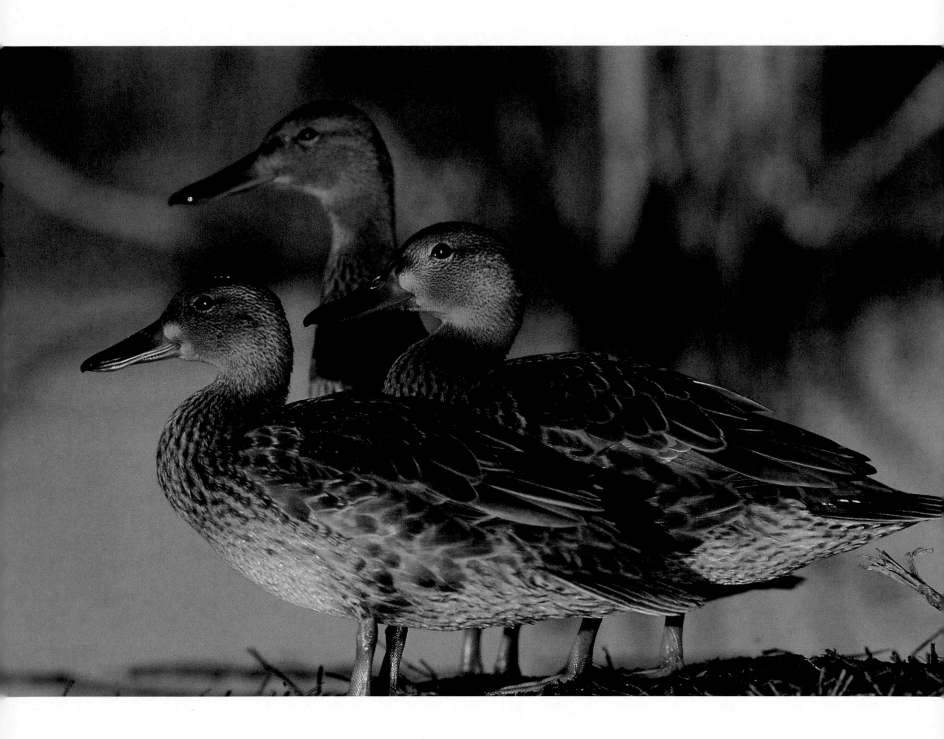

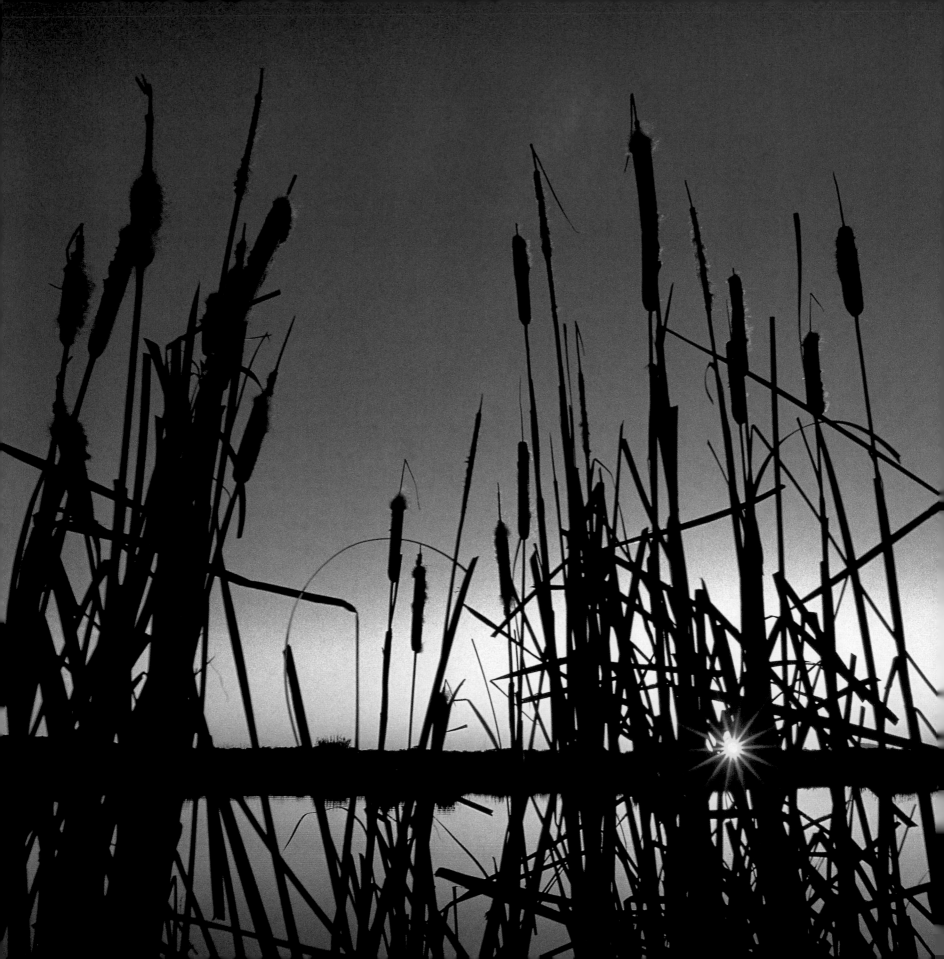

## Uta-Napishtim's Ark

Muskrats rear their young in nest balls of shredded vegetation, which they lodge securely in cattails above water level. I knew of one such muskrat lodge in the cattails of the northwest corner of Viansa Wetlands, and one winter day, with the marsh in flood, I searched for the spot. The nest ball had disappeared completely under the high water. Not a trace of it remained. The nest had been hidden deep in the cattails, shaded by the thick green plantation of culms rising tall overhead. Now only a handful of dead and broken stalks remained, barely clearing the surface. The spadixes of summer, those perfectly cylindrical, velvety brown cigars of tight-packed female flowers, were all now wind-stripped, spalling off their last spirals and tufts of seed.

Directly above the spot where the lodge had been, its owner, or some other muskrat, had felled a half-dozen cattail culms to make an observation raft. The muskrat had lunched here above the submerged roof of the lodge. It had made the best of things with a picnic, like those floodplain humans awaiting rescue atop their shingles.

The culms floated side by side, buoyant enough to support the muskrat while it ate and rested and observed the marsh. Muskrats make these raftlike bivouacs throughout the year, and in nearly every stand of cattails, in any season, you can find several of them. At one end of this raft lay nibbled fragments of new cattail shoots. At the far end of the raft, five feet away from the leftover shoots, lay a pile of muskrat droppings.

Along the muskrat's line of sight from its raft, I looked out across the brown lake that had once been marsh. I found it difficult to recollect the summer topography here. Where had the little continents and archipelagos of cattails stood? Where had they been accented by the taller, darker green copses of bulrushes? Where were the bays and coves and channels that insinuated the reeds? I could not quite remember. A seasonal marsh is forever obliterating vestiges of its former shape and earlier seasons. Is there any other landscape that so regularly and completely transforms itself? The Alps in a heavy winter, perhaps? An atoll after typhoon?

Our myth of the Deluge has its origins in flooded reeds like these.

The first marsh dwellers in history were the Sumerians, who established their great civilization in southern Iraq sometime before 3000 B.C. Marsh imagery dominates Sumerian legend. We know so, because the Sumerians invented writing and left more than 200,000 cuneiform tablets to tell us what they thought. Doubtless there were earlier marsh peoples, but they left no record of their tenure. Sumerians were the first marsh dwellers in history because they *invented* history, as an inevitable consequence of their cuneiform. It was from the Sumerians that the Hebrews borrowed their story of the Deluge. The Hebrews, a desert tribe, must have figured that the Sumerians, a seasonally flooded people, should know from high water, and the Old Testament's Hebrew authors, in writing up the Flood, had the good sense to hew closely to the original report. Noah is named Uta-Napishtim in the Sumerian version. The god whose voice warns Uta-Napishtim is not the stern

*Early-morning cattails*
*Overleaf: Mated pair of mallards*

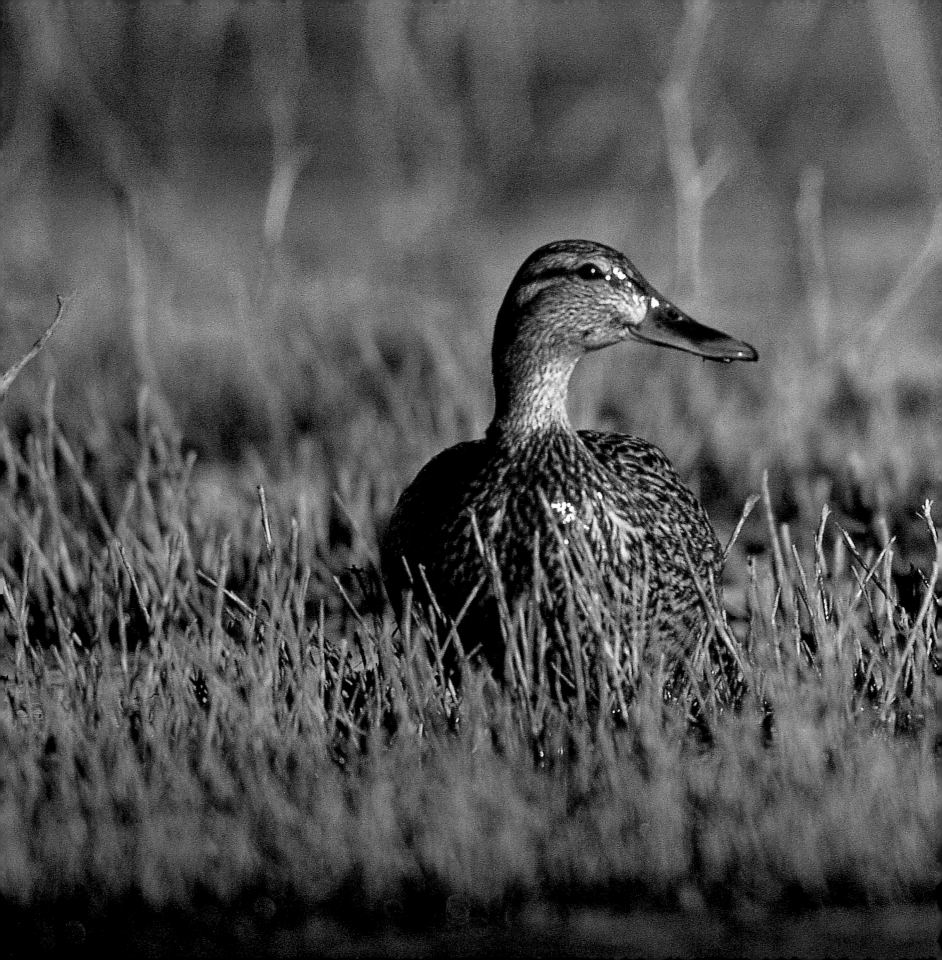

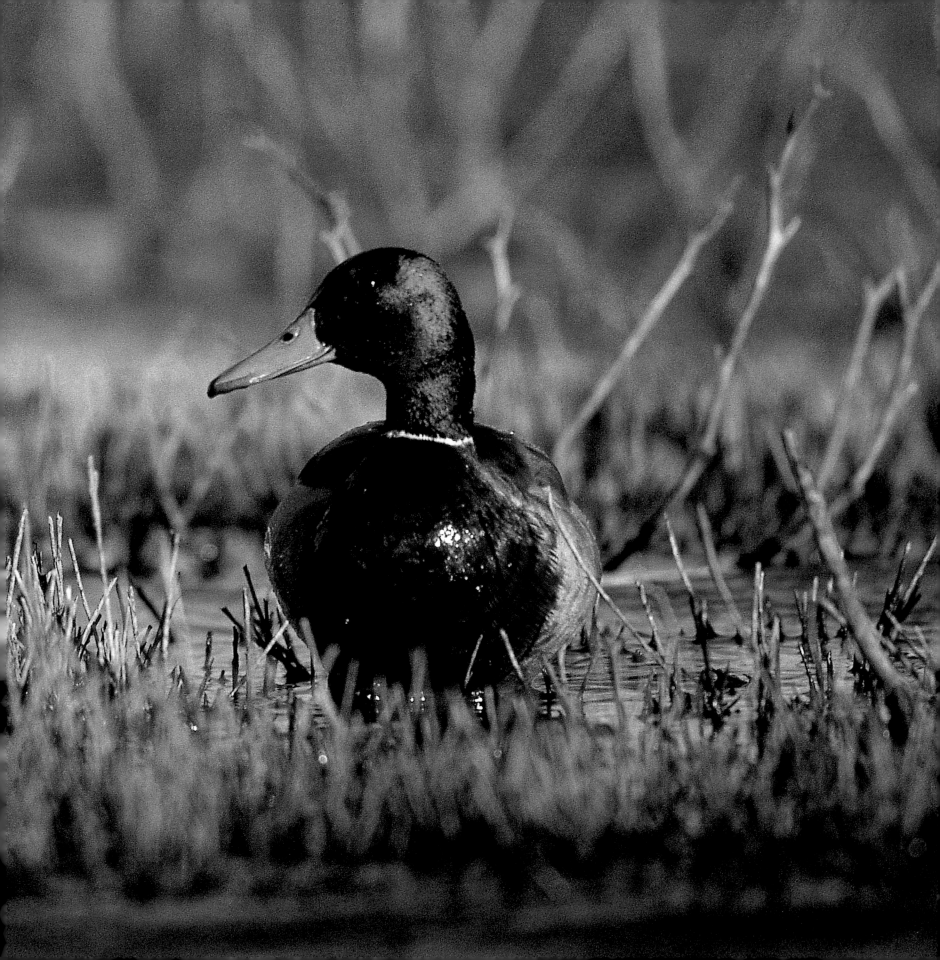

Jehovah, but the friendly god Enki. Enki does not suggest gopher wood for the ark, but a more convenient material.

"Reed house, reed house," Enki whispers, outside Uta-Napishtim's wall. "Tear down your house and build a boat."

In the Sumerian version, the reed ark comes to rest finally on Mount Nisir, not Mount Ararat. Uta-Napishtim releases a dove, just as Noah does. Uta-Napishtim's dove finds no land and returns to the boat. He then releases a swallow, with no better luck. He releases a raven, which never returns.

Until my year in the marsh, I had never heard of Uta-Napishtim. That was one of the pleasures of this assignment: it had opened up marsh literature to me, leading first into the reeds, then into the library. Today, standing amidst these American cattails, dead and brown, with the dry rattle of the winter wind in them, I ruminated on the reeds of Iraq. I considered the parables that have come down to us in cuneiform, then in the Semitic and Aramaic alphabets.

The word "cuneiform" derives from the Latin *cuneus*, or "wedge," an allusion to the shape of the Sumerian stylus and to the mark it left on the clay. The inspiration for the shape, scholars speculate, is the arrowhead. From my vantage in the marsh, this seemed unlikely. The point of the wedge was drawn out much too long to represent an arrowhead. The cunei of cuneiform looks more like a stylized reed. It reminded me more than a little of that Uto-Aztecan glyph depicting *tullin*, or tule. Whole paragraphs of cuneiform are almost marshy in their spikiness.

Writing began in Sumerian marshes. It would not be so surprising if its strokes derived their shape from Sumerian reeds.

Uta-Napishtim, lifting one of the doves he had rescued from extinction, released it to scout for dry land. In the Hebrew retelling, Noah did the same. And in the promised land of California, several millennia later — it occured to me now — August Sebastiani had followed suit. Rescuing doves from extinction and then releasing them to restored habitats was what August Sebastiani loved best.

August Sebastiani had a good deal of Noah in him, it seemed to me. Both were Mediterranean men. Both were patriarchs of large, dynastic families. "And Noah began to be an husbandman, and he planted a vineyard," says the Bible. August planted a vineyard, too. With Noah, the vineyard followed the animal-rescue work, whereas with August it went the other way around, but both knew doves and both knew grapes. If August was Noah, then his son Sam — cleaner of the cages of the rescued ducks, and later cook for the rare doves — would be Shem.

"Pretty soon I'm thinking, 'Jesus Christ, I gotta come home every day at three just to cook for the birds!'" Sam once told me.

Shem must often have made the same complaint.

All this was idle reverie, of course. The mind does tend to wander when feet are in the reeds. Comparing the Sebastianis with the first generations of Adam was a stretch. It glossed over big differences. Noah lived 950 years for example, whereas August only made 66. And as for Uta-Napishtim, all he shared with the Sebastianis — so far as the cuneiform tells us — was a certain fondness for fowl and a certain way with reeds. The reverie was idle, yet it allowed me to see this marsh in a new light. Sam Sebastiani's ninety acres of cattails and bulrushes, if harvested and bundled and joined together in a hull, would have made a sizable watercraft. I recognized his little refuge for what it was: an ungathered ark of reeds.

*Turtle sunning on a muskrat raft*

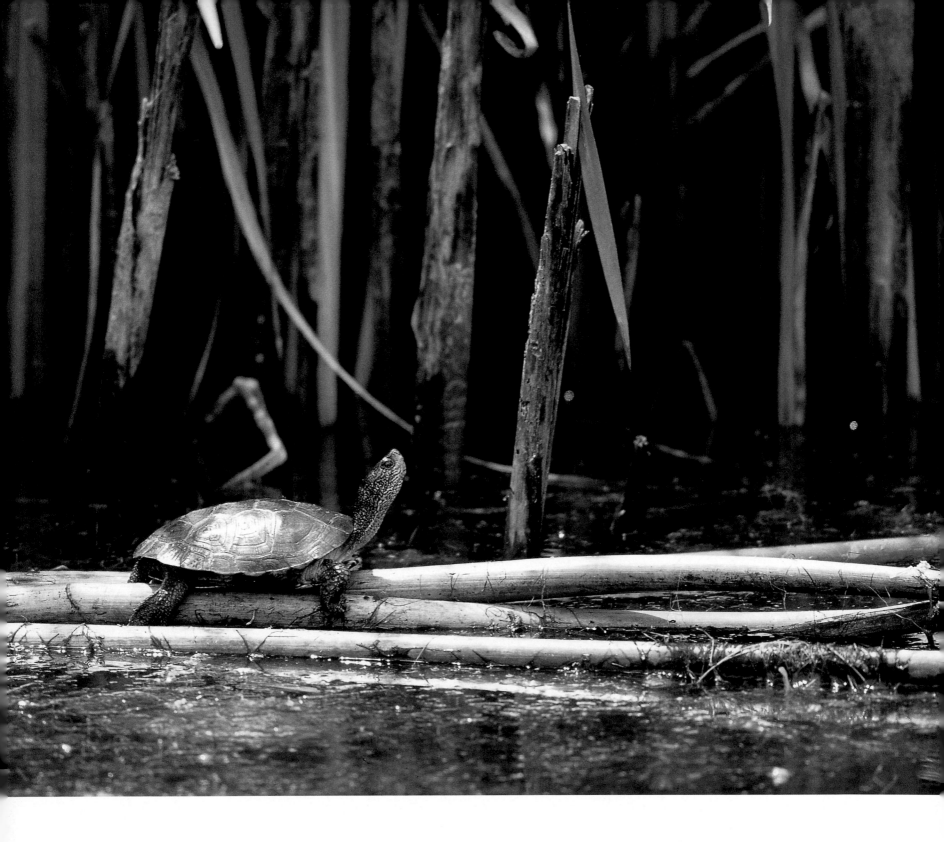

71

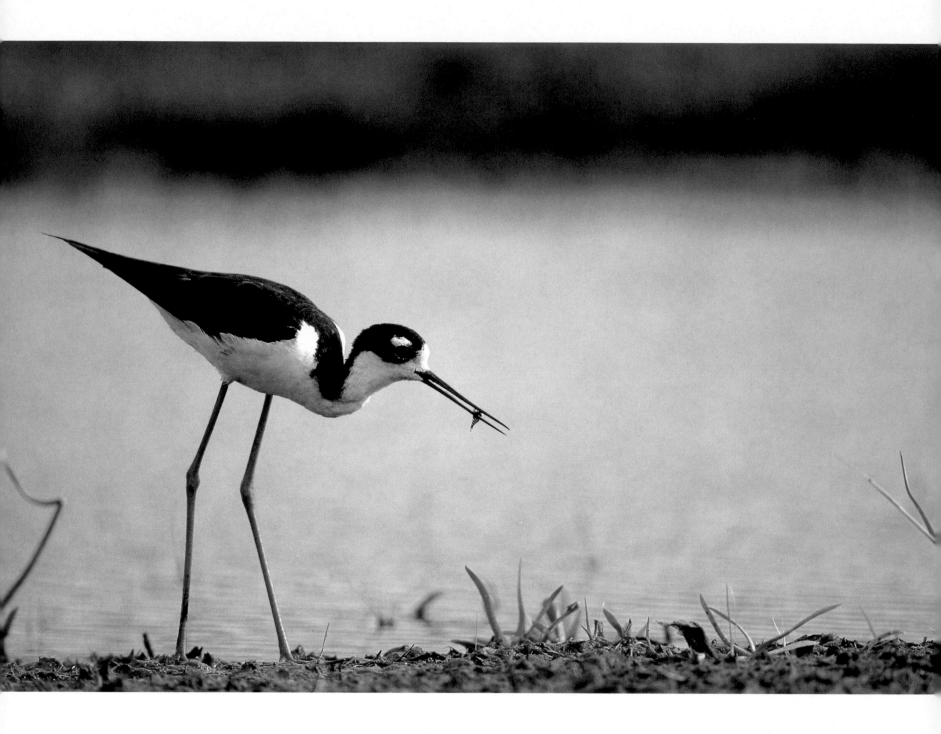

# Eclipse

There are two casts of characters in Sam Sebastiani's marsh. The first, a small local repertory group, lives here year-round, or nearly so. Coots, common moorhens, pied-billed grebes, ruddy ducks, gadwalls, cinnamon teal, avocets, black-necked stilts, and killdeer all court, nest, and rear their families in the tules. Swallows and barn owls occupy nest boxes the winemaker has built around the marsh margins. On the hillside beyond the eucalyptus of the hawk nest, in our year in the marsh, coyotes had dug their den, and at dusk Michael Sewell and I sometimes heard their yipping as they set out on the hunt. Michael's remote camera on the levee recorded the return of the coyotes, and it documented the rounds of rest of the night shift: otter stepping through the beam to trigger flash portraits of themselves; possums, racoons, herons, bitterns, a family of skunks, a badger, Sam Sebastiani's dog, the boots of the occasional human trespasser.

The second cast of characters, much larger, is composed of itinerant players: white pelicans, osprey, harriers, kites, falcons, arctic ducks, and great legions of shorebirds — the sandpipers, willets, curlews, godwits, yellowlegs, phalaropes, dowitchers, and snipe that march quick-time and spindly-legged along the marsh margins on their way to someplace else. There is always some new face in the marsh.

For migrant birds, winter is the season here. Peak use by waterfowl comes in late January and in February, after New Year's rains fill the marsh. Of the 35,000 canvasbacks that winter annually on San Francisco Bay, about 10 percent spend time in Viansa Wetlands. More than fifty species of waterbirds have been counted in the marsh. Wood ducks pass through, and redheads, and ring-necked ducks. In 1995, a flock of brant wintered here, which came as a surprise. The brant, a small, arctic, eelgrass-eating goose, generally winters along the coast. No eelgrass grows in the freshwater of Sam Sebastiani's marsh, so something else about the place lured the brant inland, causing them to make an exception to their rule. On a single, record-breaking winter day, 10,000 waterfowl were counted on the marsh's ninety acres.

Walking the levee in the wake of the last big El Niño storm, I brought out my notebook now and again to record what I saw. There were coots, as always in the foreground. There were cinnamon teal, pied-billed grebes, cormorants, golden eyes, mallards, canvasbacks. At my approach, all the waterbirds moved away into farther cattails. A few ducks, especially the mallards, took to the air. The sky over the Sonoma floodplain was alive in its complex winter traffic pattern: waterfowl at various heights, traveling in various directions. A wedge of geese here, a line of ducks there, a threesome yonder, a near pair of pintails lifting out of Sebastiani's cattails to join the holding pattern above.

A few buffleheads drifted on the deep water along the north levee. The bufflehead is one of the smallest of ducks, yet its presence in the marsh is never a secret, for it is a high-contrast bird. The white sides and head patch of the males, and the white cheek spot of the females, announce the species at great distances. These buffleheads were bound for breeding grounds in the fiords of southeast Alaska, or the Yukon Valley,

*Black-necked stilt*

or Great Slave Lake. Now and then a bufflehead would execute its exuberant surface dive, jumping entirely clear of the water to smash back through the surface again.

In the inundated field to the north — the old Haddon Salt Ranch, now Cline Cellars land — Canada geese stood in small, scattered groups. I counted fourteen birds. The farthest geese were so distant on the floodplain I could not be certain of their identity. The closest turned their black necks to follow my progress along the elevation of the north levee.

Turning down the western shore of the marsh, I saw another group of geese foraging along the path. This gaggle failed to move off as I advanced. In profile, no waterbird is nobler than the Canada goose, but seen end-on they are awfully beamy. *Oil tankers*, I thought. This group boldly held their ground, like those sentinel geese of the Romans. It was not until I closed to thirty yards away that I understood the nature of their courage. They were decoys. Michael Sewell had set them here to bring geese into his camera blind.

Sewell's decoys were plastic and utilitarian. Up close they were not very convincing, and I was surprised that they had fooled me. Sam Sebastiani, I remembered, had inherited wooden decoys, antique and valuable, from his father. In the difficult early days of Viansa Winery, Sam had been forced to sell the decoys, along with his prize mules and other possessions, in order to make ends meet.

A small flotilla of ruddy ducks moved away from me. The males among them were in gray winter plumage. They were low-contrast birds, at the opposite end of the spectrum from those high-contrast buffleheads earlier. The bright blue bill of the breeding season had faded to a dull blue-gray. The very ruddiness of the ruddy ducks had vanished. The males

were hard to distinguish from the females. Most North American male ducks go into "eclipse" at the end of the summer, molting their bright breeding plumage and spending a few months in cryptic eclipse plumage. Some species, like the ruddy duck, remain in eclipse until the next breeding season. They lose their flight feathers along with their color, and until the next molt are unable to fly. Drab, feminized, flightless, they retreat into the depths of the marsh and hide.

It had become my habit to see Sam Sebastiani in his marsh, and I saw his history reflected now in these ruddy ducks, paddling off into the reeds.

On being fired as head of Sebastiani Winery, Sam had lost his decoys. He had lost his mules. He had lost the big home where he and Vicki, in their days of presiding over the Sebastiani enterprises, had entertained extravagantly. In their exile, Sam and Vicki had moved to a prefabricated house trucked in three sections to a cow pasture and stapled together there. Vicki, embarrassed by her new circumstances, had gone into hibernation as a hostess. Sam was now sleeping with the cows, as his grandfather Samuele had done before him in Tuscany. Sam had gone into eclipse plumage as surely as any of these ducks.

In the other sort of eclipse, the astronomical kind, we know the sun or moon will emerge again. We might feel a certain atavistic malaise, but we know this shadow will pass. In the eclipse of his fortunes, Sam Sebastiani had no such certainty. For all he knew, this penumbra might last forever. Peering down at the dull blue-gray of his winter bill, the ruddy duck in eclipse must doubt sometimes that it will glow bright blue again. He has no guarantee that this winter of his discontent will ever turn to spring.

*Male ruddy ducks in spring*

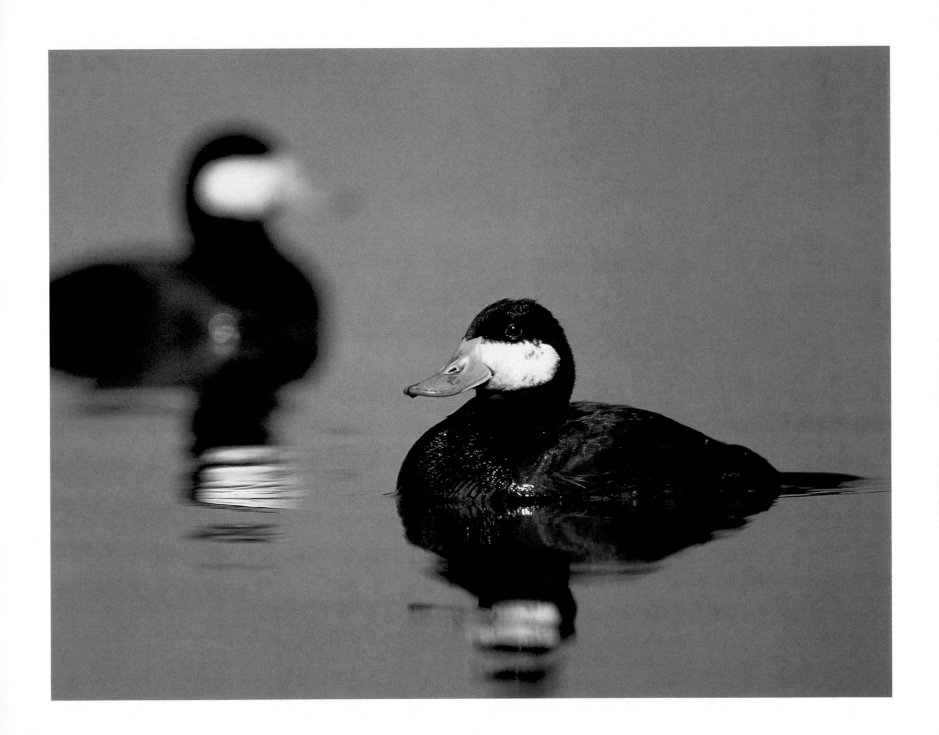

SPRING

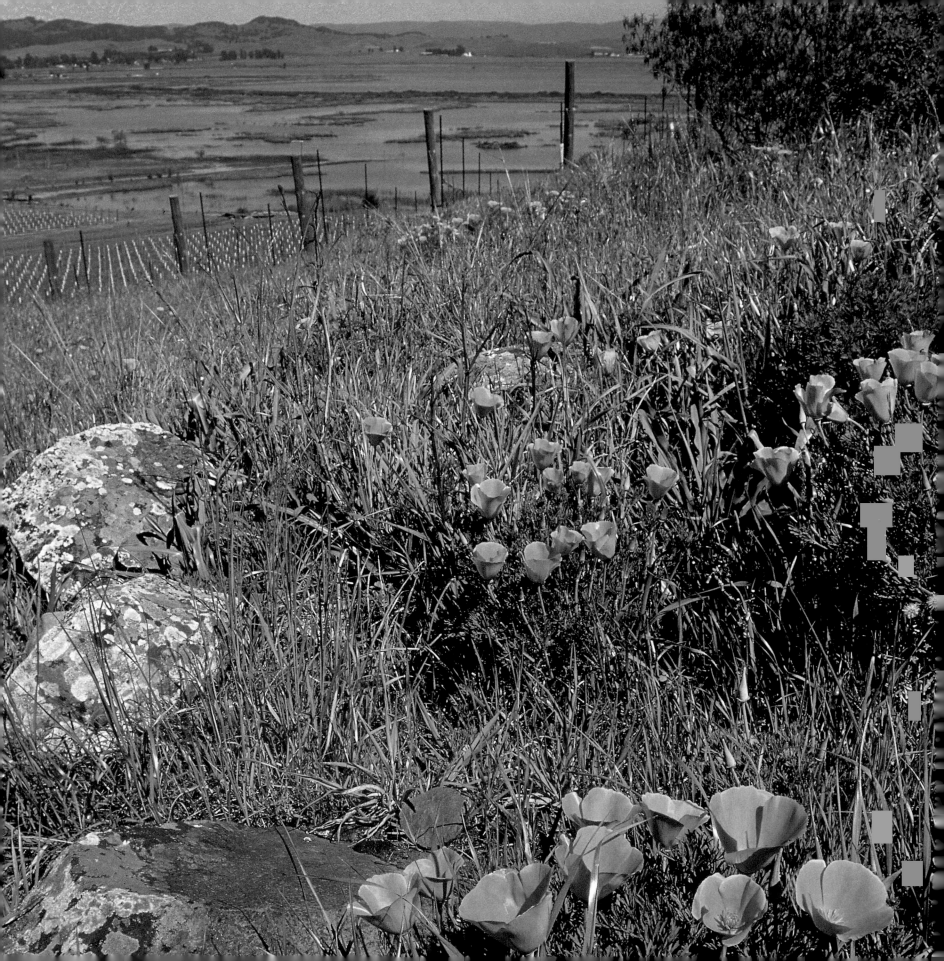

## Equinox

Here and there in the marsh, wherever there was open water, male ruddy ducks sailed like little gunboats, nodding violently. The display of the ruddy duck is a savage involuntary tic, a sort of avian Tourette's syndrome. The drake looks radically downward on himself in a succession of jerks, as if to admire, cross-eyed, the new blue of his own bill.

It was March 19, two days before the vernal equinox. I had come to the marsh for a final look at winter in the reeds. Two days hence, the sun would cross the celestial equator in its shift to the south. Spring would officially begin. It had been three weeks since my last visit, and I was surprised by how far winter's flood had fallen. The marsh looked five feet shallower. The north levee was terra firma again. Inundated three weeks ago, it was now high and dry. The crown of the Sonoma Creek levee was green, with wild radish already in flower. The marsh was full of northbound ducks. The sky was full of swallows. The sun might still be on its winter path, officially, but down on Earth, in the wine country of California, spring was under way.

The ruddy drakes patrolled the marsh, nodding furiously. The shadow of winter eclipse had passed from their plumage. The spring sun was full upon them. They were *ruddy* ducks again: rufous bodies, bright white cheek patches, sky-blue bills. The ruddy is a small duck, but blocky in build, and the male in springtime carries himself like a little Chesty Nimitz, breast puffed out, tail cocked up vertically. The triangular flag of the tail — white with black trim — flies from his poop deck like the fleet colors. He looks ready to fire off salvos in any direction.

Duck courtship displays are complex. In the marshes where waterfowl gather to breed, various species must display in close proximity to one another, and distinctive displays save cross-species embarrassment. The Tourette's syndrome of the ruddy may have begun in self-admiration, but that was only the foundation. Long ago some narcissistic ruddy, nodding sharply to admire his blue bill and display it, struck his chest and produced a sound he liked. Now all ruddy males do this, nodding downward until the bill strikes the chest at waterline, producing a bubbly splash ahead of him and a spongy, muted, percussive sound. No mallard hen could ever mistake this soggy drumming for the whistling of the mallard drake. No female blue-winged teal could confuse it for the pumping motion and out-of-rhythm *took!* calls of the male of her species.

This display of the ruddy duck is called "bubbling" by ornithologists. The constant effervescence ahead of him waterlogs the drake's breast. The dark, wet feathers make a kind of plimsoll line, sharply demarcated along the prow of the bird. Where most waterfowl spend hours preening and oiling their feathers to waterproof them, the ruddy duck seems to deliberately compromise his insulation — and right on his cutwater, where the bird meets the pond. How do ruddies avoid hypothermia? An extra layer of fat, maybe? Some sort of under-plumage? Someone should look into it.

Now and again, in an odd, hallucinatory display, a ruddy would take off to skim low and furious over the water, neck outstretched, wingtips strafing the surface in a line of splashes to either side, ferociously attacking nothing at all. No other bird

*Poppies above vineyard and marsh*

was anywhere near. After chasing off his phantom enemy, the ruddy would land with a splash and commence his Tourette's tic-ing and bubbling in a triumphant and self-satisfied way.

I set off down the shoreline of the marsh. A morning fog capped the Carneros hills, like a last try at winter, but it quickly burned off. A killdeer ran down the shore ahead of me, warning of my arrival. Killdeer are the town criers of the marsh. *Kill-deeah! Kill-deaah! Kill-deeah!* this killdeer shrilled. The scientific name of the killdeer, *Charadrius vociferus*, suits it as well as the common one. Every fifteen yards or so, the killdeer stopped to look back at me. I admired the blocky yet streamlined sculpture of the bird. The killdeer looks like the work of some Quebecois carver, a confidence decoy chiseled from wood. I admired the red ring around its eye, and the sharp cry of murder that alerted the marsh to me.

Sam Sebastiani's hill had begun to bloom with the wild-flowers he had sown there, and with wind-sown volunteers as well. Climbing halfway up, I checked on a den in the bole of a big, semi-recumbent buckeye tree on the slope. I had first detected the den by its musky smell as I surveyed the marsh from the hilltop. Coon? Badger? I could not tell. Whatever was digging the den had excavated more dirt since I last visited. It had dragged a plastic bag in there. A pack rat, maybe.

I returned to the marsh shore. On the open water, I saw cormorants, buffleheads, pintails, greater scaups, canvasbacks, gadwalls. Hanging about the cattails were coots, cinnamon teal, blue herons, great egrets, red-winged blackbirds. In the widest part of the marsh, where a long channel through the cattails came ashore to become the otter run across the levee, I spotted a swimming muskrat. The muskrat parted the water with its whiskers and left a long, silvery wake behind.

"It is at this moment of each year that I wish I were a muskrat, eye-deep in the marsh," Aldo Leopold wrote in the March chapter of *A Sand County Almanac*. I knew just how he felt.

A golden eagle stooped on the field to the north of the marsh, a tiny spot in the sky that quickly grew large. Scattered groups of Canada geese were grazing on the field, and a goose must have been the target. As the eagle stayed on the ground, I deduced that he had killed his goose.

On the western shore, a red-tailed hawk perched on a fence post. At my approach, it took wing with such obvious reluctance that I walked over for a look. At the base of the post was the jackrabbit the hawk had just begun to eat. It was a big rabbit. The meat at the shoulder was fresh and red. I tested a hind leg and it was very springy — the muscle still full of jump, no rigor mortis as yet.

Spring is about renewal, but death figures, too.

A short distance from the rabbit, I waded into the shal-lows to retrieve a male bufflehead afloat there. Sam Sebastiani had asked that I remove dead ducks from the water, and here it was easy to oblige. I admired the great white eye patch that covered most of the bird's squarish head. From a distance, a buf-flehead looks black and white, but up close, with bufflehead in hand, you can see a greenish-purple, iridescent sheen in the dark feathers. In game fish — marlin, tuna, dorado, trout — the iridescence begins fading as the fish dies. In game birds it lives on for a while. On the white breast of the bufflehead was one small spot of blood. No. 4 shot, I estimated.

The sky over marsh and levee would fill suddenly with cliff swallows, and would just as suddenly empty. The appear-ances of the swallows seemed to coincide with intermittent swarms of mayflies, at first, but then the correlation faltered. I

*Great egret*

80

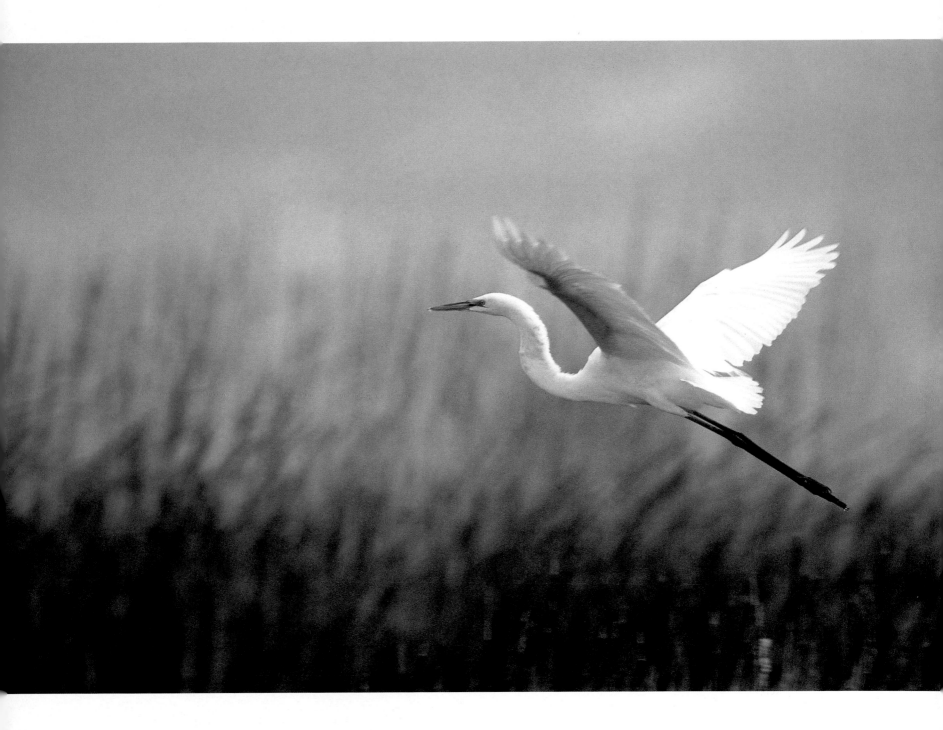

began to think these brief blizzards of swallows were just a pulse in the migration of the birds.

Today, March 19, is the date the swallows are supposed to return to Capistrano. Swallows are harbingers of spring, all right, but they do not keep to such strict schedules. For the return to Capistrano — and to Viansa Wetlands, for that matter — any time around the vernal equinox will do.

At Viansa, indeed, "return" is not quite the word, for some swallows have never left. A few tree swallows and violet-green swallows overwinter here, as the warmish marsh water moderates the cold season and makes it bearable. In late February, transient tree swallows and violet-greens arrive, flying over their overwintering cousins, on their way north. In the first week of March, barn swallows begin appearing. By mid-March, cliff swallows are showing up. By the end of March, large flocks of cliff swallows — the commonest species here — are hunting evening insects over the Viansa reeds. The first wave of cliff swallows passes on northward. In early April, a second wave, composed of those cliff swallows and barn swallows who will breed here, arrives.

The sky thronged again with cliff swallows. Ruddy ducks displayed blue bills on the water. Frogs piped from the reeds. Spring had arrived in Sam Sebastiani's marsh.

*Black-necked stilt chick*

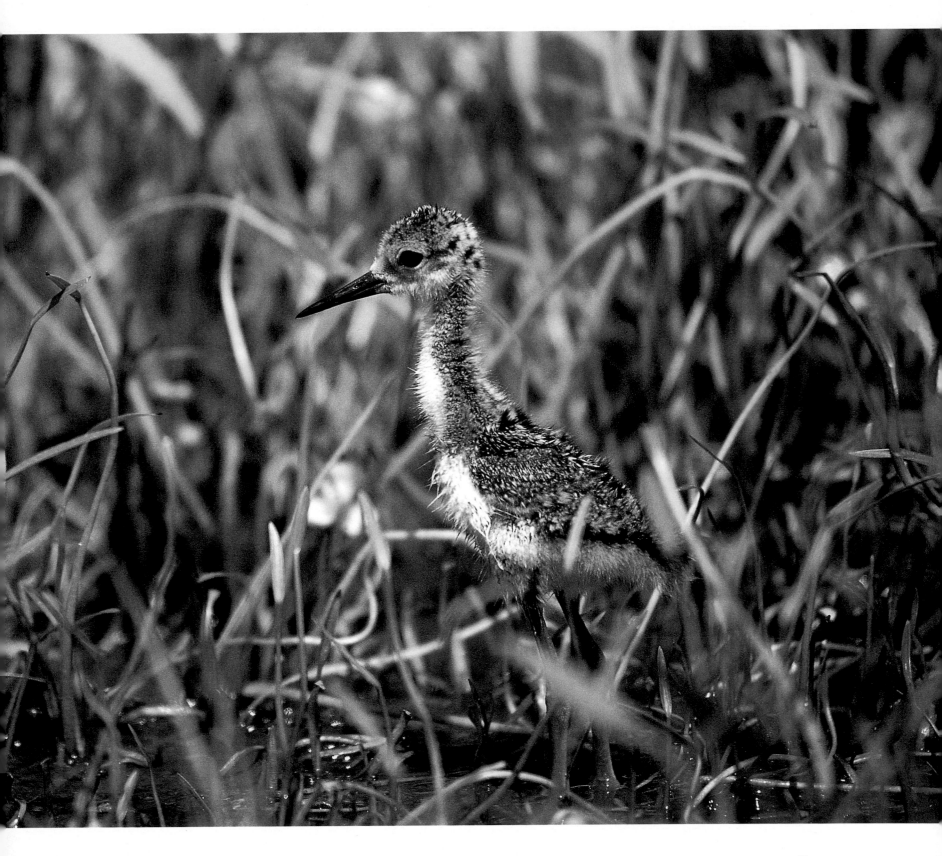

## Tragedy of the Carp

It is startling how fast spring progresses in a marsh. Cattails and bulrushes grow skyward faster than any plants save giant kelp, and even as the reeds are rising, the high water of winter rains is falling. A marsh in winter flood has little topographical relief, but in springtime, as the cattails wax and the water wanes, topography comes rapidly upon it. The relief sharpens daily, and soon the channels and embayments make deep, reed-walled canyons in the marsh.

In Sam Sebastiani's wetlands, in the spring of El Niño, nothing testified to the speed at which winter's flood subsided like the tragedy of the carp.

High water and failing levees had liberated the carp to swim wherever they pleased on the Sonoma floodplain. The deluge had opened up a paradise of good forage for them. For a week or two, the floodplain was all theirs: the world according to carp. They fed along the tops of levees, and at the sides of submerged vineyard roads, and in the stubble of hayfields. Their barbels probed the mud of gopher holes and the silt of flooded vegetable gardens. They sampled the muck under the vines of Vernaccia, Teroldego, and Primitovo — those neglected Italian varieties that Sebastiani had resurrected along with his marsh — and they barbeled the good red soil beneath some of the finest California varietals. But the paradise of the carp proved brief and illusory. The flood subsided, trapping the fish here and there in the backwaters of the floodplain. Eden had cast them out. At Viansa Wetlands, a large number were isolated in a ditch of stagnant water between the marsh levee and the levee of Sonoma Creek.

What first caught my eye was splashing and a silvery gleam in the brown water of the ditch. The carp had gathered in a solid silver raft at the mouth of the marsh outlet. A turbulent freshet a week ago, the outlet had shrunk to a narrow rivulet flowing down from the reeds. Carp are not a schooling fish, normally, but the confines of the ditch had made a school of them. They slowly finned just beneath the surface, a bright, living delta of backs. Here and there a frantic fish, gathering courage, would surge over the backs of the others, fighting to replace the leaders of a desperate, wriggling migration up the trickle from the marsh.

I had never seen anything like this, and my eye took a moment to make sense of it. From a distance, I did not recognize the phenomenon as fish. The heavy bodies, a silvery olive-green, two or three feet long, armored in the oversized, cycloid scales of carp, jammed the serpentine course of the rivulet. They looked like some sort of huge reptile: a giant anaconda thrashing its way uprivulet, maybe, or the tail of a silver-scaled dragon slipping down. This descending dragon, if that's what it was — this Nessie of Sam Sebastiani's marsh — had just escaped from the reeds. The last twelve feet of her was sliding snakelike into the muddy water of the ditch. On moving closer, I realized the dragon was carp.

For a moment I was stunned and baffled. How had this small ditch spawned so many huge fish? It seemed preternatural, like a biblical omen. A plague of carp. Then I remembered how fast the water had subsided here. The carp had not *originated* in this ditch; they were simply ending here.

*Trapped carp*

85

The carp struggled upstream like spawning salmon. At the mouth of the rivulet, I straddled the thick, silvery, olive-green dragon's tail of the school, my legs widespread, my boots on either bank. I bestrode the carp like a colossus, my shadow falling across their backs, but the fish ignored me. The pink-rimmed mouths gaped roundly. Carp have low oxygen requirements, but they do need a little of that gas. These fish were so crazy for the oxygenated water flowing down from the marsh that a big predator like me mattered not at all to them.

Salmon and shad are anadromous, swimming up from the sea to spawn. Eels are catadromous, swimming down. These carp were neither. They were *paludromous*, to invent a term. They were swimming marshward to survive. This very exigency — the drying up of pools and puddles — was what drove the evolution of the lungfish and walking fish and mudskippers. But great expanses of geological time were required for that. The carp had only days. Their desperation to reach the marsh suggested that time was running out for them. Carpe diem indeed.

Either bank of the rivulet had been scooped out and undermined by the urgent wriggling of terete bodies. Fish erosion! It was a form of attrition new to me. The headwall of the narrowing, carp-carved arroyo was in the shape of the head of carp. There was room only for a single fish there, at the apex of the carp pyramid. This lead fish was always a large one. It finned in the undiluted flow of the rivulet, luxuriating in the oxygenated water passing over its gills until, losing its frenzy for breath, it was displaced by a more frenzied fish from behind. Now and again the lead fish, with a powerful staccato flutter of its tail, tried to climb up the "falls" of the rivulet, only to slide back.

There was no escape for these carp. The rivulet was too narrow. It dead-ended in a shallow pool fed by a slender, two-foot-tall waterfall from the pipe draining the marsh. No fish — not the most athletic of salmon, much less these portly carp — could have climbed that downspout into the pipe. The carp would never make it to the marsh.

On the bottom of the shallow pool, under the plash of the pipe, sat a crayfish. It was waiting, perhaps. As mortality rose among the trapped carp, the scavenging figured to be excellent here. In the distance, atop the Sonoma Creek levee and on the short-grass plain to the north, a dozen egrets and great blue herons stood — a scattered gathering — and these opportunists were waiting for sure.

I decided to spear a carp and see what it had been eating. The stomachs of fish are full of surprises. Carp have the barbeled, bottom-feeding look of fish who dine on unexpected things. Underneath my curiosity, no doubt, was a measure of bloodlust. A dash of murderousness is instinctive, I think, in most predatory creatures, hungry or not, when game offers itself up in this plentiful, serendipitous way. Any heron or grizzly bear or Miwok Indian would have known the feeling — or so I like to think.

I had no qualms about killing carp. They were not some threatened species. This disaster for the carp was hardly an ecological disaster. It was ecological justice, if anything.

The common carp, *Cyprinus carpio,* is an introduced species that has proliferated in lakes and streams all over the New World, becoming a serious pest. These particular carp were descended from fish brought in by Julius Poppe, a Prussian cigar-maker who came to San Francisco in 1850. Buying 700 acres out of the Petaluma Grant from General Vallejo and Chief Pul Pula of the local Miwoks, he started a dairy ranch in a valley under Wildcat Mountain. Commuting to San Francisco

*Struggling carp*

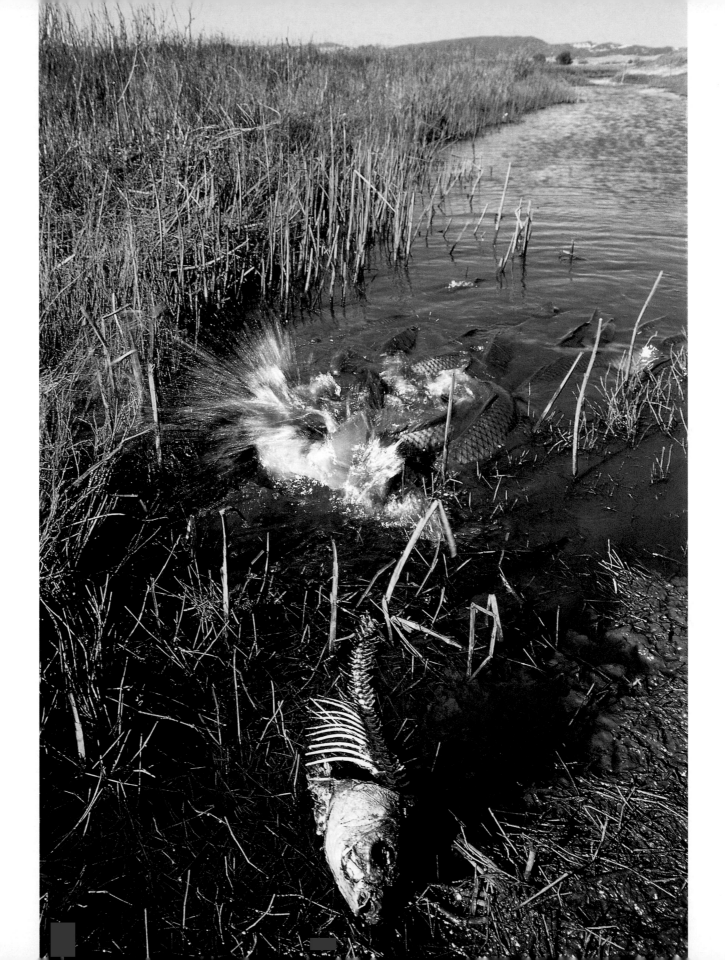

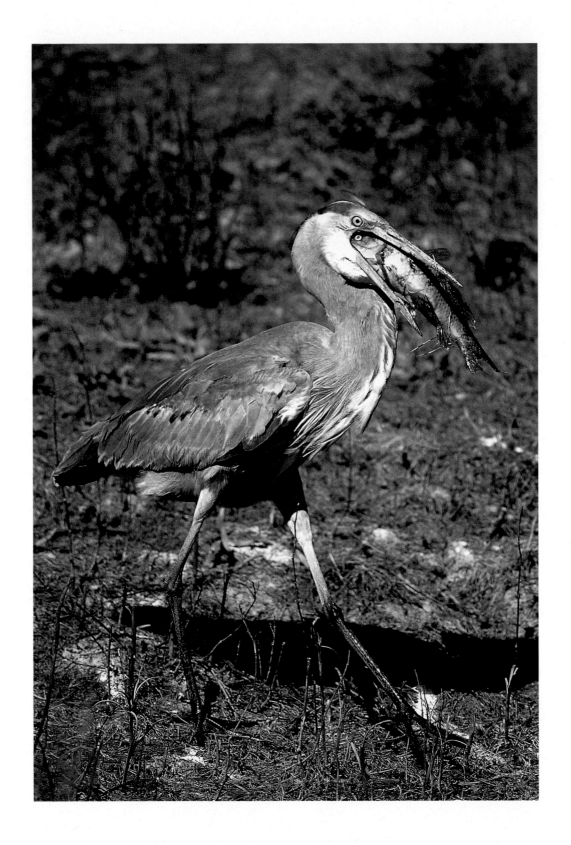

by boat to run his cigar business, Poppe left it to his wife and mother-in-law to tend the cows. In 1871, returning from a trip to Germany, he brought five lean and sickly carp home to Sonoma. Poppe had set out with 83 fish, but the long trip from Europe to New York, and then around the Horn to California without ice or refrigeration, had killed most of them. The survivors were both male and female, as chance would have it, and soon Poppe had six large breeding ponds and was selling fish all over California. The carp were intentionally released to stock streams and they escaped in floods. Soon the fish were everywhere.

It is *good* to kill Julius Poppe's carp. Not only are carp ecologically incorrect, they are also — to my eye, at least — unlovely. There is something creepy and embryonic about the short, fleshy barbels under the chin. The toothless, protrusible mouth seems somehow degenerate. (Carp are in the family of the minnows: gigantic versions of those little fish, and they have minnowy mouthparts.) Carp have no adipose fin, which leaves the lower back unattractively blank. The big scales look primitive, like the sort of ichthyic armor that should have been phased out eons ago.

Searching the levee for some sort of lance, I finally found a stick, deeply bowed but sharp. I set about trying to spear a carp. My point kept glancing off the streamlined bodies. The struck fish, when they noticed my spear at all, would violently tail-slap away. After I had assaulted three or four, my bad intentions were communicated to the entire school, and they retreated downstream. Anoxic conditions in the ditch immediately faced them about and sent them up the rivulet again. They flowed again under the colossus of me, and my shadow again darkened the silver of their backs.

Aiming for the gills of the biggest carp, I felt the point go in this time. The carp flipped powerfully away, knocking me off balance. I was shocked by the strength of the fish. I felt sudden new admiration for carp. It was good that this big carp had shaken the spear. Had I set the point solidly, he might have carried me down like Ahab into the depths of the ditch. The struck fish disappeared into the silvery throng, where I could not distinguish him in order to finish him off. I was uncertain I had wounded him at all until I saw that the stream below was running red with blood. I tried to trace the red to its source, but in the wriggling mass of carp this was impossible.

I lost all enthusiasm. With the apparition of blood, the tragedy of the carp became Greek to me. Sophocles appeared at my shoulder — or Aristophanes, I guess it was, as the egrets and herons, waiting hunched and watchful on the floodplain, were straight out of the chorus of *The Birds*. These carp were in extremis. They were marshaling their last resources against a sudden fall from grace. Attacking them now seemed wrong. My spearing was not science, just boyish cruelty. That these fish were doomed anyway seemed not to matter. I tossed away my spear.

This is one of the ways I differ from a grizzly. A fishing bear does not flash on Sophocles or Aristophanes. He is immune to pathos. He does not cry, "Out, cursed spot!" the moment he gets a little red in tooth and claw.

Two days later, the carp were still thronging at the mouth of the rivulet, but their numbers had fallen. I brought my son to see the fish. Five great blue herons and several egrets flapped away from the ditch as we approached. The carp were somewhat shier now, after the predation of herons. They were still attempting their hopeless mass migration up the rivulet. From the field beyond the northern levee, the herons and egrets

*Great blue heron with carp*

watched us resentfully. A turkey vulture there ignored us, head down as it tore at the remains of a carp.

A week afterward, when I next visited the marsh, the tragedy of the carp had played itself out. The muddy water of the ditch had dropped nearly a foot, exposing a wide rim of muddy terrace. The rivulet from the marsh, in flowing over the terrace, had added one meander and about nine feet of length. On the terrace mud, where the vultures and herons had dropped them, were the skeletons of three carp, and a scattering of their big cycloid scales, and one whole catfish. The belly of the catfish extruded a pink rosette of intestine. Some half-hearted heron had opened the fish but had been too full of carp to finish the job.

There was no trace of living carp. In their place were rafts of some tiny water insect, dancing in multitudes. They seemed to be a breeding aggregation, animated by the infusion of fresh water from the marsh. Scooping up a whole flotilla, I focused on one bug. Under my magnifier, I could just make out microscopic legs. Individually the water mites appeared coal black, but collectively they took on a bluish sheen. The blue-black rafts were thickest on either bank of the rivulet. Now and again, like shore ice, a raft of the insects would break loose and go rotating out across the surface of the ditch. The clumps marked the vortices of gentle current like some hydrological experiment with blue-black dye. Looking into the sun, I saw scintillations everywhere — out on open water and around the spike rushes that bordered shore — the sun reflecting from millions of tiny backs.

Spring in the marsh is a succession of little seasons as each plant and animal comes into its own. The season of the carp was over. The season of the water mites had begun. Two days ago, this muddy water had been dimpled everywhere by the round, gasping, pink-rimmed mouths of carp. Now it dervished with rafts of insects. Forty-eight hours ago, this ditch had been a slow waltz to death; now it jitterbugged with life.

I picked up one of the big cycloid scales of carp. Cycloid scales are thin and unenameled and they show concentric growth rings. The rear edges are not serrate, as in the other sort of scale, the ctenoid kind. Where ctenoid fish feel rough when you rub them the wrong way, cycloid fish feel smooth. It had been a smooth and seamless armor of overlapping cycloid scales that had deflected my spear.

I rubbed the smoothness of the scale between thumb and forefinger. I needed a *memento mori* of the carp, and this would do. A medieval scholar would have preferred the skull of carp, no doubt, but I was put off by the stink, and the scale fit much more easily in my pocket. Allowing my thumb to trace circles atop the concentric circles of the growth rings, I wondered. Why had the tragedy of the carp impressed me so? It had been the unexpectedness, first off. It had been the plenitude. It had been the inescapable fate of the fish.

The multitudes and the high drama of nature — the caribou in migration, the huge breeding aggregations of sea snakes, the living rivers of anchovies, the great flocks of water-fowl — are wonders of the wilderness, we tend to think. But the truth is that nature is microcosmic and close at hand. Creation can fold all its amplitude into a man-made landscape, and that landscape need not be remote or large. A patch of restored reeds will do. This spring, Creation had fit multitudes and high tragedy into the ninety acres of Sam Sebastiani's marsh.

*Great blue heron*

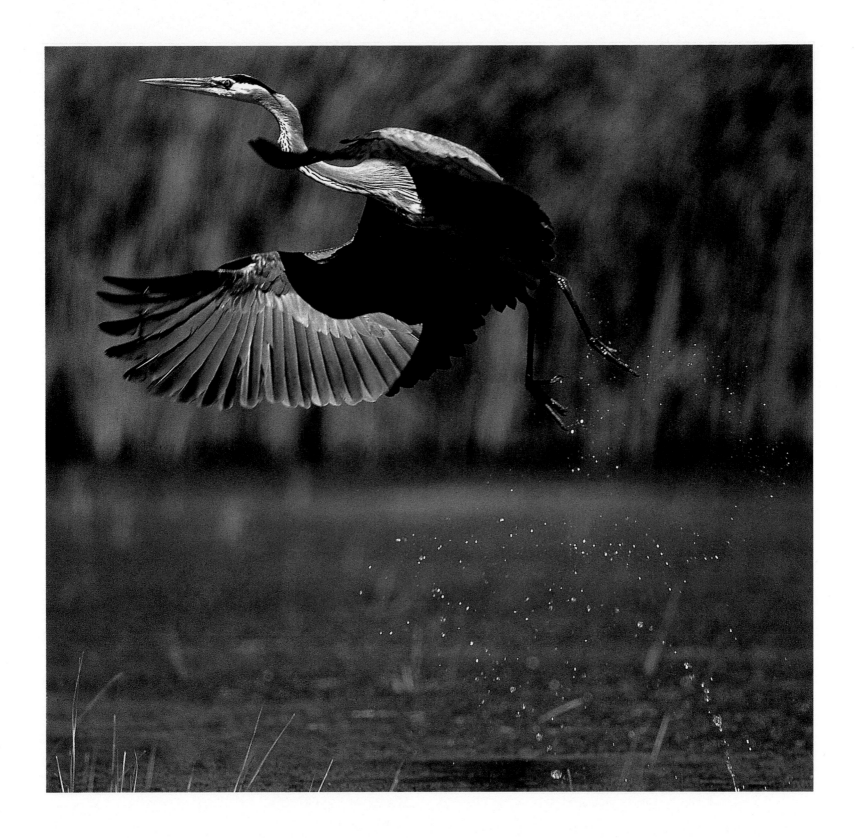

## Wild Radish

Spring was sequential on the levee. It sprouted first in wild radish along the crown, then moved on down the levee's inner bank as the falling water made way for it. As the waterline retreated, there was a day or two of shoreline mud, then a new sward of wild radish sprang up. The radish quickly came into flower along the crown — varicolored blossoms of pink, blue, white — then the flowering, too, moved downbank. You see the same sort of graduated springtime in the mountains, where alpine plants germinate as the snow melts upslope. Here the germination proceeded in the opposite direction. Walk five feet down the levee bank, and your feet were in another season, a somewhat earlier spring.

By mid-April along the crown, the pointy seedpods of wild radish had begun to fatten among the varicolored flowers. The levee bank now displayed, in profile, the entire springtime of wild radish — all the stages in the youth of the plant: At waterline, a green lawn of new radish cotyledons pushed out of the mud. At midslope, a plantation of broad, pinnate, mustard-like leaves was bushing up. On the upper slope grew radish in flower, and on the crown, radish gone to seed.

The pods began to go bumpy, forming constrictions between the swellings of the seeds. The pods already tasted sharply of radish. "The radish," wrote Dioscorides, "breeds winds and heats, is welcome to the mouth but not good for the stomach." Ignoring Dioscorides, I harvested the pods, pulling off double handfuls and bringing them home as garnish for fiery salads.

On the north levee — the last of Viansa Wetlands to emerge from the flood — spring was delayed. Finally a line of spring-green cattails arose there, along the bank of the levee. It quickly became a wall.

Spring was slow to arrive in the vineyard. The vines remained "in wood" while the cattails shot skyward. Bare, dormant trellises ran down to the fast-rising, spring-green shore of reeds. It began to seem that budbreak would never occur in the vines. In the wake of El Niño, the winemakers of Sonoma and Napa counties were predicting a bad crop. They were appearing regularly on the television news, grim-faced, gesturing stoically at the saturated vineyard soil. Then, finally, consecutive days of warmth quickened the vines. First budswell, then budbreak, then the first green shoots, then tiny leaf clusters, then prebloom. Common vetch, the bean planted between rows of vines to fix nitrogen, set its extravagant white flowers and then was disked under, along with the other nitrogen-fixers — Austrian peas and bell beans, along with barley and oats. It was sad to see the exuberance of the white flowers turned under, but the vetch had done its job, from the vintner's point of view. In some imperceptible way, Sam Sebastiani's wine would amount to beans and would taste of them.

Along shore, at the base of the cattails, the opaque and muddy water of winter clarified. The sediment load was settling out with the passage of time and the purifying influence of cattails and bulrushes. The marsh was distilling itself.

The muskrats were living large. They had switched completely from the Irish famine of muskrat winter — a dogged subsistence on the starch of tubers — to the delicacy of cattail shoots, in which nutrients are concentrated for the fast growth

*Wild radish in bloom with winery beyond*

of spring. On their rafts of felled cattails, there were no tubers among their leftovers, just pale strips of shoots, the ends serrate with the marks of their teeth.

The Russian olives planted at wide intervals along the levee were all in their frosty-green, willowlike foliage. Downwind of each small tree was a plume of powerful fragrance, a peculiar, cloying sweetness, a *fermented* smell, somehow.

Joe Sebastiani hitched up his mower and drove his tractor down the crown of the levee. The next day a big gopher snake, fat with spring voles, sunned itself on the mown grass.

In the vineyard the vines bloomed. The trellises greened up. Early in the season, growth is almost exponential in grapevines. Along the trellises, the big, palmately lobed leaves of the grapes matured and darkened below the wire, and above the wire, bursts of new spring-green leaves grew exponentially upward. The old leaves were dark green; the new leaves, and the new tendrils searching skyward, were of a greenness almost yellow. It made for a cheering optical effect, even on gray, overcast days. It was as if each vine were rising from shadow into sunshine.

Down in the marsh, the same yellow-green of fast growth showed in the rising walls of cattails. The cattail green was particularly beautiful when the sun was low, at dawn and sunset. Here and there atop the culms, the reddening sun reflected, redoubled, from the red epaulets of red-winged blackbirds. Studying the hot red embers of epaulets atop the spring green, it struck me that Sam Sebastiani's resurrection of this wetlands was not a one-time event. As long as the levee held, impounding its water here, the magical reappearance of the reeds would be cyclical and endless. There was perpetuity in the bargain. The marsh was to be reborn, and reborn, and reborn all over again.

*Black-necked stilt*

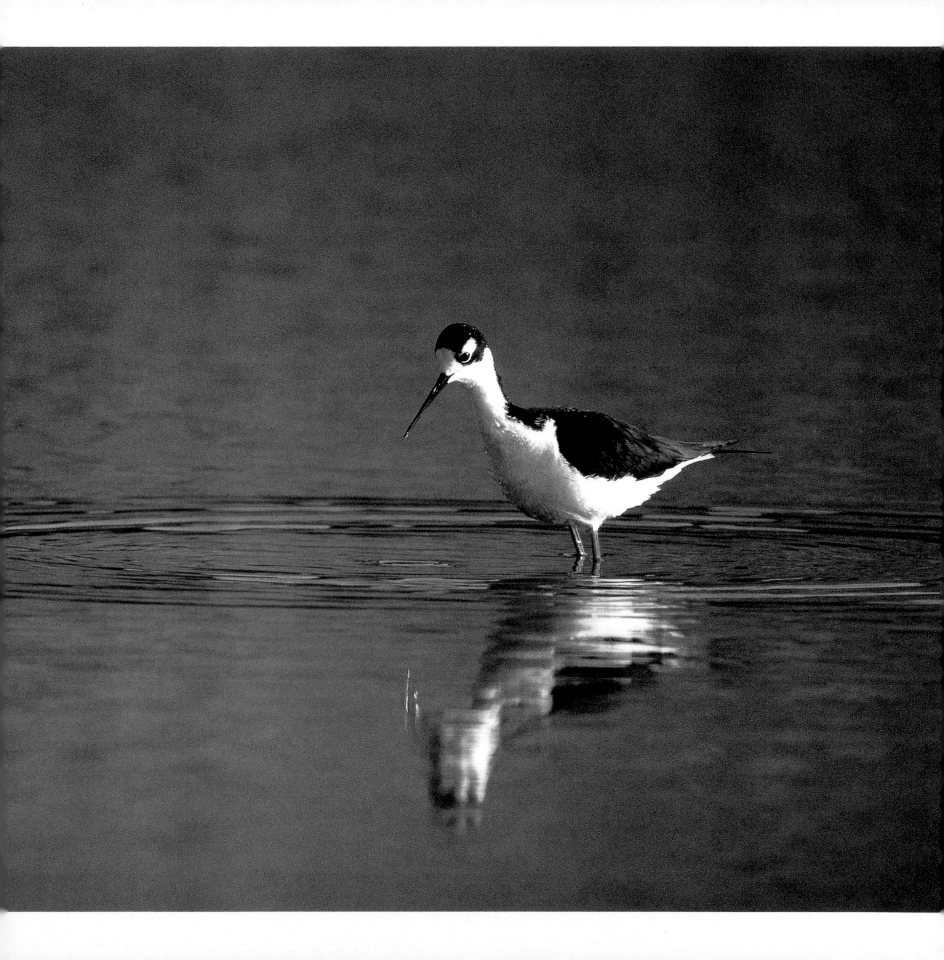

## Reedsong

Red-winged blackbirds swayed and sang atop the cattails and displayed their red epaulets. If any bird is emblematic of North American wetlands, it is this one. Flocks of redwing males are among the first arrivals in breeding marshes all across the continent. The bird's scientific name, *Agelaius* ("belonging to a flock") *phoeniceus* ("deep red"), catches the essence of the species and describes nicely these noisy returning clouds of spring.

For the red-winged blackbirds of California, spring begins in February. In Sam Sebastiani's marsh, the blackbirds had started staking out their territories back then, but now their territorial ambitions grew, and their posturing intensified. Each male spread his tail, drooped his wings, fluffed himself up big, elevated his red epaulets. Bobbing head downward—his motion exaggerated by the flex of the cattail—he sang. His liquid *o-ka-lee-onk* was answered from the next stand of cattails. Sometimes the full *o-ka-lee-onk* echoed; other times a curt *konk-la-ree*. By early April, the marsh was all balkanized into red-wing territories. At the center of each little republic perched its president, displaying the musical flag of himself.

Beneath the blackbirds, in the dense middle storey of the cattails, long-billed marsh wrens flitted and filtered throughout the marsh, singing their brave territorial songs. A wren declaration from one stand of cattails, *Cut-cut-turrrrrr-ur*, was always answered from the next.

The song repertoires of the wrens were rich. Eastern populations of marsh wrens sing from 30 to 70 songs each, a number impressive enough; but Western populations sing from 110 to 210, and the song-control region of the Western wren brain is more than a third larger. Thoreau heard fine wren music at Walden, no doubt, but we heard better in Sam Sebastiani's cattails. Displaying, the marsh wrens cocked their tails upward so radically that sometimes they almost met the backs of their heads. Performing this wren salute, they sang.

It was dumfounding, the amount of energy the marsh birds put into springtime declaration. In April the wrens and other birds of the marsh would rather declare than eat.

One day, pausing near the pier to listen, I heard the marsh music reflected from behind me. I turned. A mockingbird, perched in one of the young palms that lined the refuge road, was running through a medley of tunes stolen from all across the kingdom of birds. It did its impression of tree frog, briefly, then returned to birdsong. Mockingbirds scoff at the idea of copyright. What mockingbirds mock, more than the individual songs of other species, is the whole notion of intellectual property. They are irritating in their glibness, and I almost allowed myself to grow indignant; then it struck me that mockingbird piracy was no different from my own. In my notebook I had been laboriously rendering the *konk-la-ree* of blackbird and *cow-queer-coo* of quail. The mockingbird did the same, only naturally and effortlessly and with much higher fidelity. I imagined now that I heard editorial comment in the mockingbird's song. I heard wise-ass observation on the life of the marsh. *And the mockingbird was right*. His parodies were on the mark. I took his point: Sam Sebastiani's marsh in springtime goes completely crazy with song.

*Red-winged blackbird in cattails*

The music was martial music, full of territorial imperative. The birds were not just sounding off; they backed up what they said, and the sky over the marsh swirled with dogfights. Air superiority belonged to the red-winged blackbirds. They scrambled to challenge everything that flew over, except the biplanes from Schellville Airfield and the U-2s of the highest hawks and vultures. Once I was able to swing my binoculars along with a blackbird as it strafed a red-tailed hawk that had strayed too low over the marsh. Magnified, the attack was dramatic. As the blackbird closed on the hawk, its red epaulets flashed like wing guns on a Spitfire. It was illuminating, seeing the two reds in close proximity. They were the same color in name only. They occupied different regions of the spectrum: the scarlet-winged blackbird and the rust-winged hawk.

My binoculars paced another blackbird as it closed on a black-crowned night heron. Unshakable, implacable, painted red and black — the colors of Apache warpaint — it overtook the much larger bird. As it struck, it flared its epaulets, lighting up like a marlin hitting the lure. It nailed the heron

in the preen gland or thereabouts and held on. For two or three seconds it flew along attached.

Above the Sonoma floodplain, two golden eagles gripped talons and tumbled a moment, then broke apart — a dogfight of another sort; the fierce, unsentimental courtship of raptors. Above the Viansa reeds, a male marsh hawk flew repeatedly at a female, who made small corrections and veered away. As the male closed with the female, he gave the two birds relative scale. It was startling how much larger the female is in this species. The male was an immature, in a young male's spring plumage — a creamy rufous underside — yet he harried the female as if he were grown.

The dogfights sometimes came to earth. One egret would land in the shallows too close to another, at which the first bird would raise crest, lower chin, and chase the second along the shore. The dogfights came down to water. Coots chased other waterfowl across the surface, and sometimes below. Ruddy ducks engaged their enemies, phantom and real.

Springtime in the marsh is the season of love and music and war.

*Brewer's blackbirds*

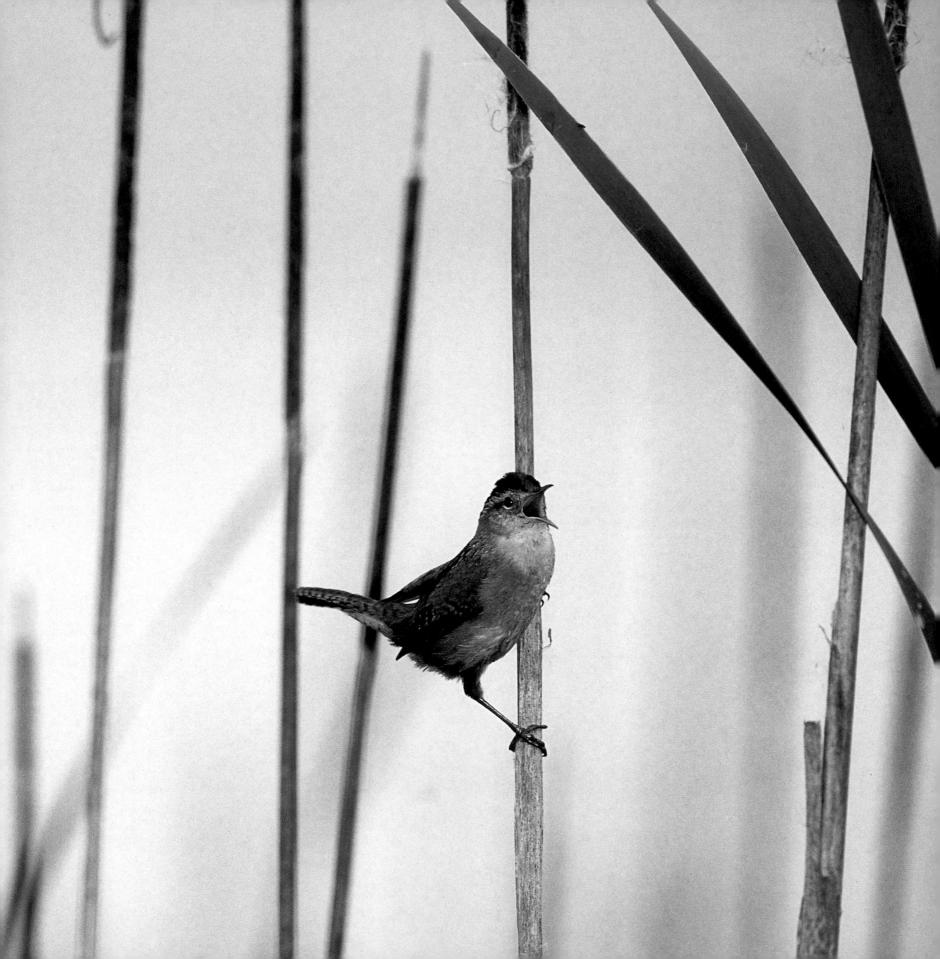

# Wrenovation

The territorial songs of the birds, without any rephrasing, became work songs as nest construction began all over the marsh.

A ruby-crowned kinglet perched on an old, dry cattail and worried the brown cigar of the spadix, stabbing at it viciously until her beak was crammed with cattail cotton, a wad twice the size of her head. She shook her head sharply from side to side, which sent clouds of excess cotton and seeds wafting off on the breeze. Was she winnowing her harvest? Or was this head-shaking just the exuberance of spring? She flew off with her load in the direction of Sonoma Creek.

Barn swallows and cliff swallows milled and fluttered above a small mud bar a short distance off the marsh's little dock. Lining the bar, six or eight in a row, they pecked up beakfuls of mud. The mud of the bar seemed to be special in some way. The swallows flocked to it like pilgrims to Lourdes.

One afternoon, in dense cattails, standing waist-deep in my waders, I spent an hour behind binoculars watching a marsh wren build his nest. Male and female marsh wrens are marked the same — brown, with a white stripe through the eye — but the male is easy to identify. He is the one who does the building. The female, accompanied by the male, inspects the finished exterior, and if all is satisfactory she lines the inside with feathers and the finest plant fibers.

Marsh wrens are fearless. They have that small-bird sangfroid, a confidence that comes from being below target size for human beings. This wren, ignoring me as I watched from fifteen feet away, continued about his business. His every move was adapted to life in the reeds. The short wings were made for quick stops, starts, and tight turns in the tules. He was adept at the maneuver that rock climbers call "chimneying," ascent between two opposing surfaces by application of pressure against either one. In the marsh the technique would be "bulrushing," I suppose. Here the opposing surfaces are not rock walls but the stalks of adjacent tules. My wren bulrushed swiftly upward with a foot grasping either stalk. He did the splits between stalks without discomfort; could go well past the splits with no apparent pain.

It was illuminating, following the magnified little wren about. I saw details in the marsh I had completely missed before. The tules, prior to the wren, had seemed the purest of monocultures — or duocultures, rather: a sea of cattails mixed with islands of bulrushes. The world of the wren was a pure thicket of vertical culms, yet everything the bird collected was an exception to that rule. A marsh wren has no use for the big, stiff, pith-filled Greek columns of tule culms, except as pillars to support his nest. What this wren brought in, and wove around those pillars, was everything else: rootlets, leaf fragments, the dried and pithless sheaths of long-dead cattails, cattail kapok plucked from spadixes, and wet and scalloped pieces of some plant I could not identify. The marsh wren has an eye for all the aberrant textures in the marsh. After following him on his rounds, I had an eye for those textures, too.

After a male marsh wren has built two or three nests, and his females have lined the interiors of those, he goes on to build between six and two dozen dummy nests, facsimiles that go unlined. It is a puzzle that he should go on such a one-bird

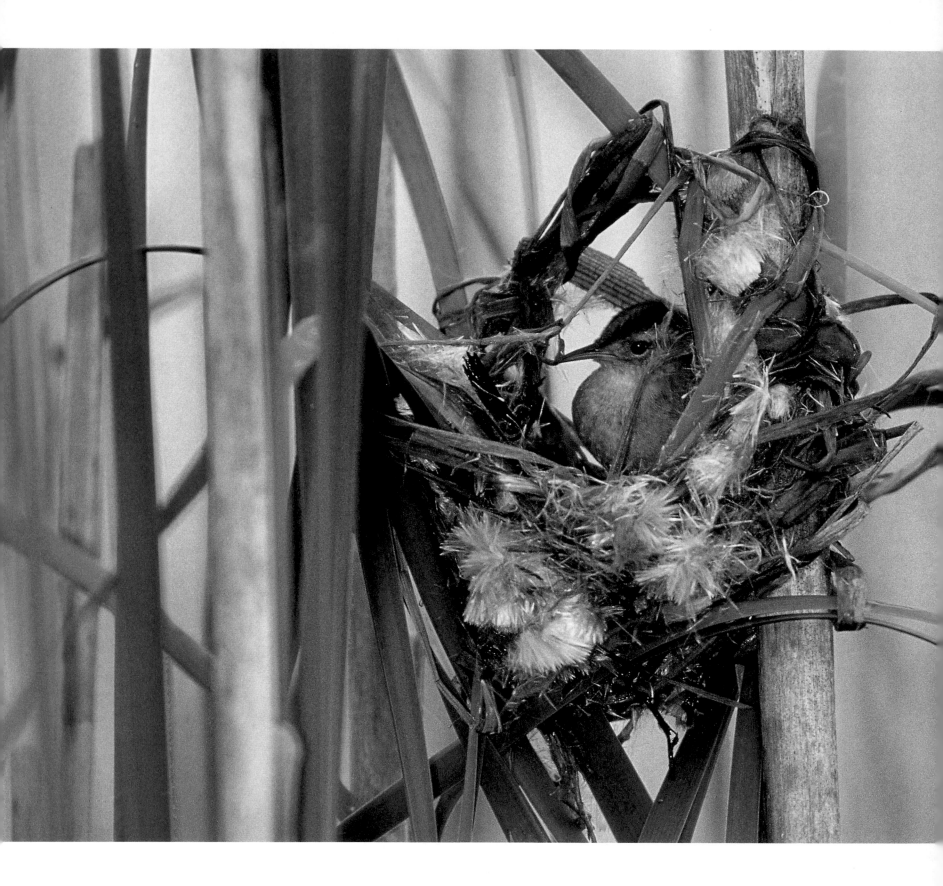

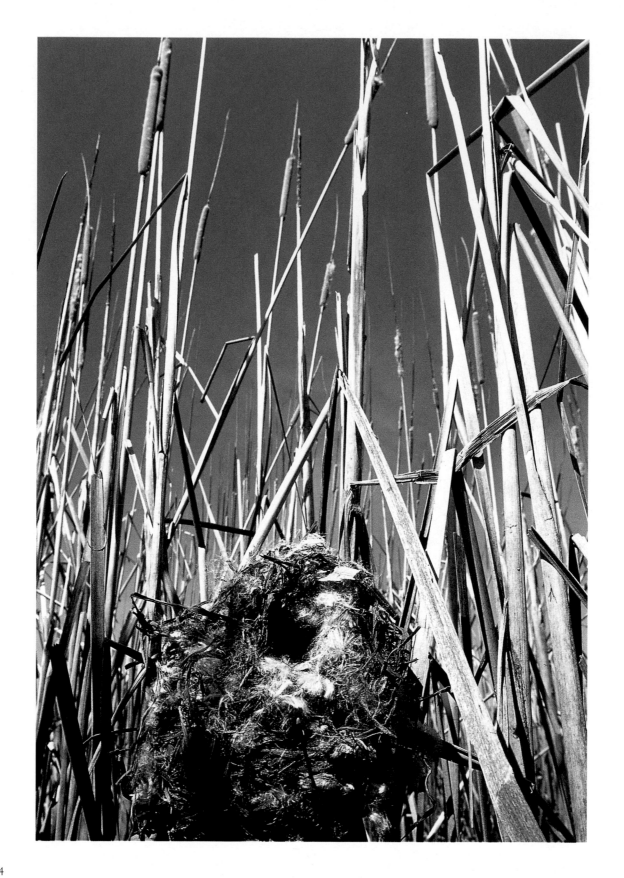

building boom. After the breeding season, he and his mates will occasionally use a dummy nest for roosting, but why so many extras? My own guess is that this little village of dummy nests has to do with the wren's million-year war with red-winged blackbirds. Wrens often destroy the eggs and young of the blackbirds, and the redwings, recognizing the smaller birds as enemies, reciprocate, destroying the eggs and young of wrens. Maybe the wrens build dummy nests for the same reason that generals build dummy gun emplacements.

My wren flew in dangling a long strip of reed sheath, three times as long as himself. He tossed it down atop the half-finished nest with asperity, or perhaps just impatience. He flew underneath, where he perched to study the strip from the vantage of his basement. He pulled the strip through the woof of the nest, then cocked his head to study his beakwork. He did not like the look of it. He pulled out that stitch and tugged the strip through the warp of the nest this time. It was still not right. Finally, after much fussy readjustment of the strip, he was satisfied and flew off for the next item. And so it went with every odd scrap of the marsh he brought in.

The rounded oblong of a marsh-wren nest, like any art, is the product of thousands of small decisions. The first draft is very rough and subject to endless editing. A blueprint for the nest exists in the instincts of the marsh wren, obviously. The design must all be there — the rounded oblong shape, the circular entry hole up toward the top, the thickened entrance sill projecting inward to form an igloo-style entry tube, then the retort-shaped chamber below. But the blueprint seems to be fragmented. I don't believe the wren is able to unfold his plans, spread them out on the table, and refresh himself as to the finished shape — not as a human contractor might do. The wren

finds his way through the project by a series of trials and errors, reworking each leaf fragment and filament of reed until that component somehow strikes him as right.

Each wren reinvents the marsh-wren nest every time he builds. He starts from scratch, yet somehow the nest comes out looking like all his dummy nests, and like the nests of all his wren neighbors in this marsh, and in the next marsh, and in farther marshes and ponds all across North America, and like every other rounded oblong dwelling in the countless ruined reedtop cities of thousands of generations of wrens before him.

The wren nemesis, the red-winged blackbird, working by a similar trial and error, reinvented its nest in the reeds. With blackbirds, the blueprint calls for a deep, cup-shaped nest, and in this species the female is the builder. In Sam Sebastiani's marsh, the female wove long leaves and stems around adjacent tules, framed in the cups, insulated them with roots, mud, fibers, and decaying leaves, and lined them with dry grasses from the levee and spike rushes from the marsh. Inside, beginning in late March, they laid four smooth, glossy eggs of the palest blue, scrawled in black. The eggs of the redwing, like those of the other blackbirds and the orioles, are dribbled and spattered in a drip-painting style that anticipated, by several million years, the work of Jackson Pollock.

Cliff swallows built their gourd-shaped nests wherever they could find a vertical wall and an overhang. They mixed up a special swallow adobe, fortifying the mud with plant fibers and fragments. Each beakload showed in the finished nest, its surface a rough cobbling of mud pellets.

Barn swallows built the shallow, open cups of their nests with their own brand of adobe. Here, too, each beakload showed in the cobbled finish. The barn swallows colonized the

*Wren nest*

dark, weathered wood of abandoned barns out on the Sonoma floodplain. They settled in the nest boxes that Sam Sebastiani had built for them around the margins of his marsh.

In the bulrushes of his western shore, Sam had built a duck-watching shack. The shack was made in the marsh-wren style — atop tall stilts — but its posts were of wood, not of tule. Cliff swallows appropriated the shack's outer walls and built their little Anasazi villages under the eaves. In the nests they laid from three to six creamy-white, speckled eggs imperceptibly tinted pink. The eggs were long and subelliptical. Fast-flying, streamlined birds like swifts, swallows, and hummingbirds tend to have eggs in this long, streamlined shape. These aerial sprinters and barnstormers hint, even before hatching, at the sort of creatures they will become.

Barn swallows, flying in through the camouflage-netted windows of the shack, colonized the interior, nesting along a slight ledge where the walls met the slant of the roof. In their comings and goings, they drip-painted the floor with guano. It was Jackson Pollock again. The floor painting of the swallows, like the floor painting of Pollock, was all about process, full of information about the speed and appetite of the artists. The shack interior took on that alkaline, phosphate-mine ambience of any rookery. The room was no longer a pleasant place for human beings. It was fine for perching, but it did not invite sitting down. The swallows lined their nests sparsely with feathers. On top they laid from four to eight glossy white eggs lightly spotted with lilac. The eggs were long and subelliptical, full of the promise of speed already, though for now they lay perfectly still.

Ruddy ducks built raftlike nests anchored to the base of cattails. At waterline the ruddies wove a floating foundation of reeds and weeds, then built upward. They crowned the nest finally by pulling surrounding reeds in over the top to make a canopy. They laid some of their dull-white eggs in this shadowy nest. Other eggs they reserved for the nests of other waterfowl.

The female ruddy duck is a brood parasite. She lays her eggs in the nests of redheads, canvasbacks, grebes, rails, and particularly in the nests of other ruddies, tricking the parasitized mothers into perpetuating her genes. Brood parasitism makes good evolutionary sense, but another odd ruddy custom, the "dump nest," is harder to figure. In a dump nest, several females deposit a great clutch of as many as sixty eggs and never return.

The ruddy is a small duck. The female weighs only a pound, yet lays an egg the size of a turkey's. The egg is rough and granular, and she sometimes lays as many as twenty. Perhaps this huge, rough, plentiful egg explains it all — both the dump nest and brood parasitism, too. The female ruddy must feel an overwhelming desire to get her eggs behind her.

Black-necked stilts built the shallow hollows of their nests on a long bar off the western shore of the marsh. In this El Niño year, much of the bar was underwater, showing as a line of low islands, and some of the nests were awash; but black-necked stilts like it this way. *Himantopus mexicanus,* the black-necked stilt, nests in loose colonies along the shallow edges of brackish lagoons, alkaline lakes, mangrove swamps, flooded fields, and wet savannas. If the water rises, the stilts build their nests higher with the addition of plant material. In dry conditions, the nest is a spartan cradle of a few scraps of plants; in wet, it becomes a higher assemblage of the same materials. In this variable nest, the female lays from three to five smooth, slightly glossy, speckled, pale-buff eggs.

In mid-May, Michael Sewell and I waded out one morning to the bar of the stilts. The photographer paused by one of

*Swallows collecting mud*
*Overleaf: Sam's shack at dawn*

106

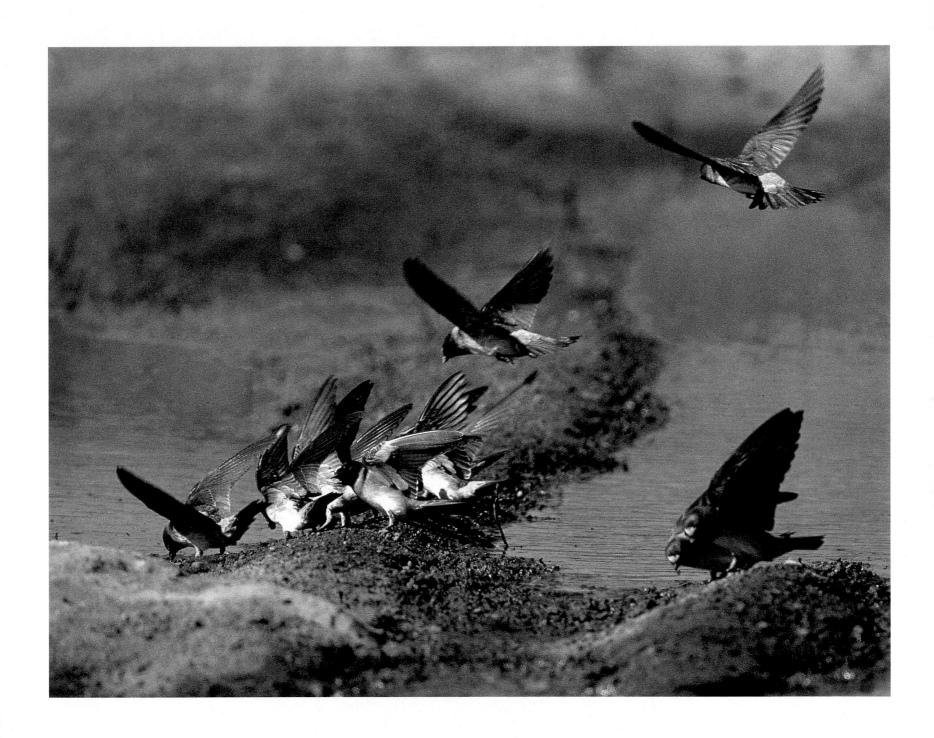

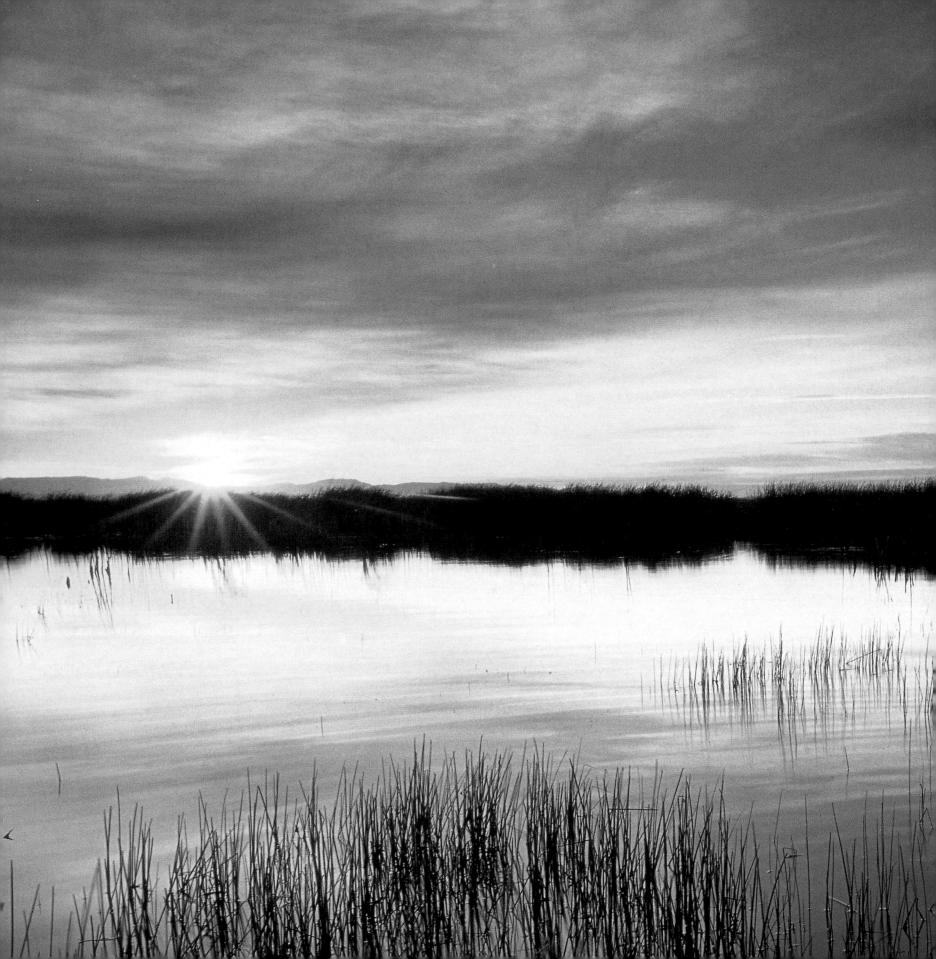

the nests, his favorite. The nest had become an island, completely surrounded by the moat of the marsh, and this insularity made it a dramatic subject for the camera. Today Sewell worried that the nest was a little too inundated. Wading to the nearest stand of tules, he gripped a handful of dead brown culms near the base, broke them off with a single twist, then folded the stalks back on themselves, making a sort of double panpipe of tubes. We lifted the nest, and he shored it up underneath with the panpipe. He covered his tule foundation with mud, which he patted down to compact. When he had finished camouflaging his handiwork, he gave me a sidelong glance. Wildlife photographers are uneasy about their little adjustments to nature, especially when there are witnesses. "I'm doing it for the stilts," he said, "and I'm doing it for me."

We stopped at six stilt nests, each of which held four teardrop-shaped eggs. Shorebirds and cliff dwellers tend to lay "pyriform" eggs like these, pointy at the narrow end. Pointy eggs can roll only in tight circles, a great advantage for species that nest on bare ground or narrow ledges. Pale-buff when laid, the stilt eggs were now nest-stained an olive drab. The arrangement of the eggs was always the same. The small ends met at the middle of each nest, with the large ends outward. Arranged like this, with the apexes inward like slices of pie, a clutch of pyriform eggs is easy for the incubating parent to cover.

I fell in love with stilt eggs. It had something to do with their warmth, so brave and hopeful in the cool shallows beyond the scanty ramparts of the nest. It had to do with their pyriform shape, such an elegant solution to the problem of the narrow ledge and open ground. It had to do with the uniform geometry of their arrangement, the small ends always inward.

The stilts felt as I did. They, too, were enamored of their eggs. Whenever anyone approached the nesting bar, the birds resorted to a variety of distraction displays. The first, in which the stilt simply stood and beat half-open wings, seemed intended to alert other stilts as much as to fool the enemy. As you came nearer, the stilts would take wing and flap your way obliquely, screaming *kyeep-kyeep-kyeep,* graceful in flight, their long red legs held out straight behind them. Alighting in the shallows, the stilts would begin a mock-incubation display. Beating half-open wings, each bird would fluff out its white breast feathers and tentatively dip several times as if to sit in the brooding position. You were asked to believe that the stilt was incubating in that spot, and eggs were available there. If you continued toward the bar and their nests, the stilts grew more anxious and went into broken-wing acts. In the moment of landing, the bird seemed to hit some sort of invisible wind shear just above the tips of the spike rushes, suffering a sudden inexplicable break of its wing.

Calamities mounted. If the broken-wing act failed, the bird often fell victim to a grand-mal seizure, pitching forward drunkenly, splashing its breast in shallow water or smacking its chin there. *"Neuro-toxin!"* the idea seemed to be. *"I've ingested lethal amounts of DDT!"* In another, rarer display, the bird would hover, yipping loudly, its long red legs dangling almost straight down, then making slight, awkward pedaling motions in the air. *"Bicycle!"* the bird seemed to mime. You were asked to believe that the stilt's bicycle had been stolen right out from under it.

Black-necked stilts are "precocial," ornithological jargon for what the rest of us would call "precocious." Young stilts hatch covered with down, eyes wide open. They are able to move around on their own soon afterward, with an uncanny ability to dematerialize in the thinnest stubble of grass. In pre-

*Black-necked stilt on nest*

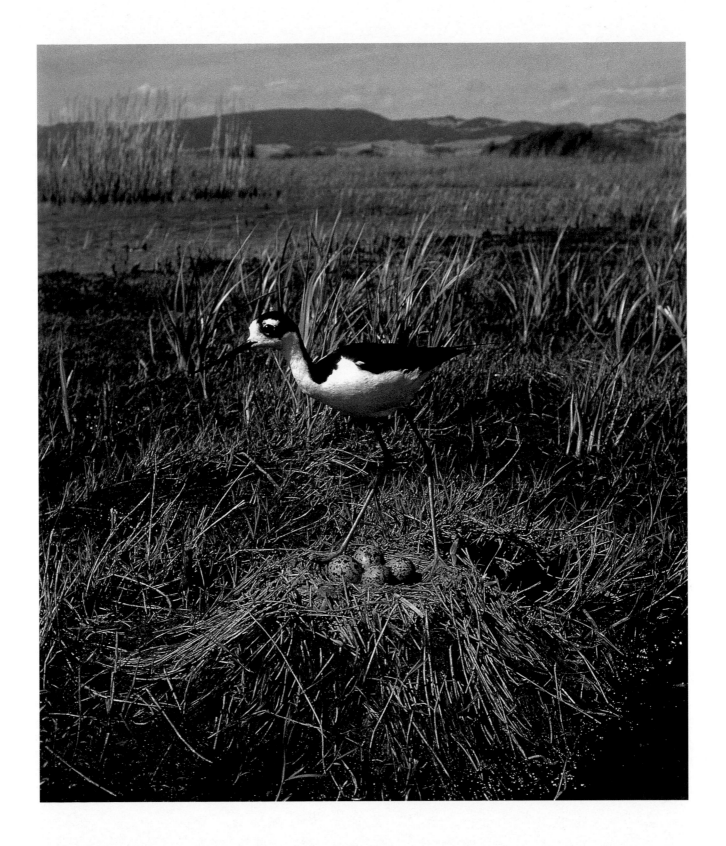

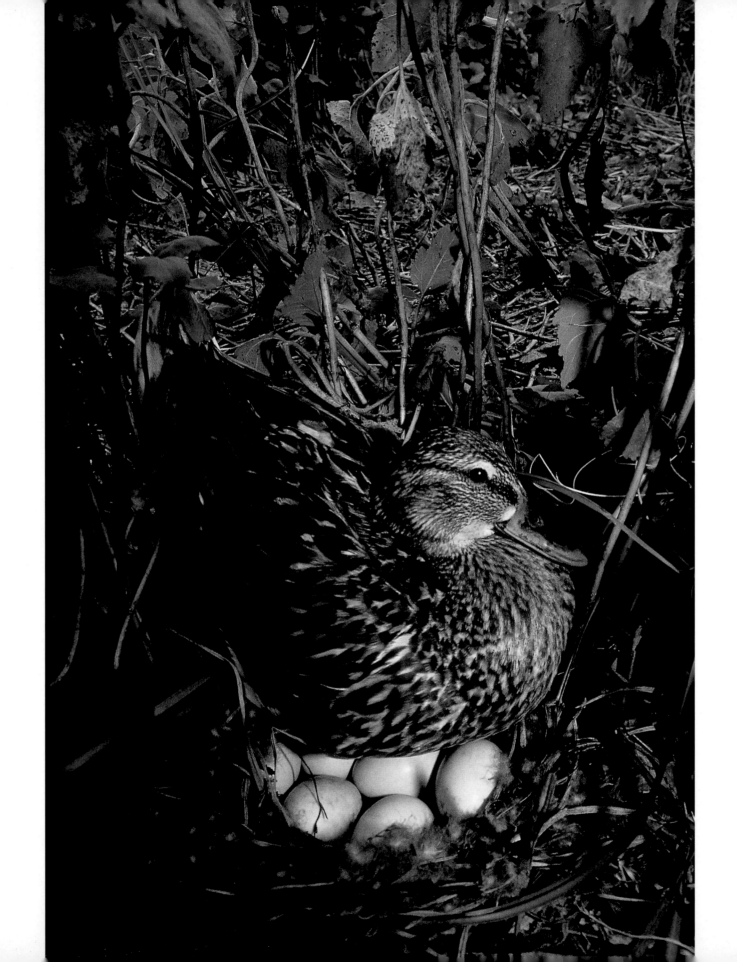

cocial species, distraction displays are strongest at the time of hatching, when the parents have the most invested in their eggs. Immediately afterward, the performances fade, for the nestlings are quickly able to fend for themselves.

Common moorhens — the single pair residing in the marsh — built the bulky platform of their nest in the cattails, and in it laid seven smooth, glossy, pale-buff, blotchy eggs.

Pied-billed grebes built floating nests of rotting vegetation in the cattails, and in the shallow, wet basin atop the platform they laid from four to seven elliptical white eggs faintly tinted blue.

Gadwalls hid the feather-lined hollows of their nests in thick shoreline vegetation and laid from seven to sixteen oval, cream-colored eggs.

Cinnamon teal built the carefully concealed, grass-lined hollows of their nests in dense vegetation at the water's edge, or they erected more bulky structures out in the tules. In either, they laid from five to fourteen elliptical, white, semi-glossy eggs.

Killdeer excavated their "nests" — minimal scrapes on bare ground — in dry marsh bottom at the southern end of the Viansa Wetlands. In these scrapes they laid four smooth, pale-buff, pyriform eggs. The eggs were pyriform so as not to roll away over the bare ground. The tight circles inherent in their geometry tended to arrange all four eggs with points inward. The eggs were blotched dark, in patterns that had a marbly swirl to them, like storms on Jupiter. The biggest blotches occurred at the egg's big end. The weather was better at the pointy end, where the big storms broke up into a mackerel sky of speckles. The blotches and speckles camouflaged the eggs against the bare ground.

On the observer, the effect of the marsh eggs was cumulative. Each new shape and pattern reflected on the one before. Its difference accented, in retrospect, the distinction of all the eggs seen previously.

The hard-shelled egg is a reptile invention, but it has been left to the birds to realize all the possibilities: long elliptical, elliptical, spherical; short subelliptical, subelliptical, long subelliptical; long oval, oval, short oval; short pyriform, pyriform, long pyriform. Pointillist, abstract expressionist, minimalist. Pale blue, bluer, bluest, turquoise, green, cream, pink, rose, rust. Lunar, martian, jovian. Rough, smooth, glossy, semi-glossy, dull. Slightly greasy and water-repellent in ducks, kinetic in swifts and swallows, yolky in precocial birds, less yolky in altricial species. The egg is a nearly perfect life-support system. Oxygen diffuses inward through pores in the shell; carbon dioxide and water diffuse outward. A little parental warmth and occasional turning is all that's required.

In late April, at the south end of the marsh, I flushed my first baby killdeer of the season. It already had its infant's version of the black killdeer collar. In killdeer chicks, the collar is a single band; on growing up, every killdeer rises to the rank of corporal, adding a second stripe. The chick had a slender black headband, and a black streak through the eye. Hatchling killdeer can run as soon as their down is dry, and this one scuttled quick-time down the shoreline ahead of me. One of its parents ran up in consternation. It suffered a broken wing on the way. Trailing its wingtip tragically, the adult bird tried to lead me up toward Sam Sebastiani's hill. Of the two birds, the chick seemed the calmer. It took to the water — the first swim of its life, no doubt — and paddled in a circle back behind me to come out on shore again.

Female gadwalls led flotillas of gadwallets through the archipelagos of cattails. Ruddy ducks led files of unruddy, gray-

*Mallard hen settling on eggs*

and-white ducklings. Moorhens guided their moorchicks out of the tules. The single pair of moorhens in the marsh were now a family of five. The three chicks — small black feather balls with red bills — were still learning to manage their gigantic feet.

Pied-billed grebes introduced their amazing offspring to the pools and channels within the cattails.

The grebes first carried their grebelets around on their backs, then shed their young and rode loose herd on them. In the baby pied-billed grebe, the bill is not yet pied, but everything else is. The body zebra-striped, the face filigreed in striking black-and-white patterns like those on the face of a Maori warrior.

The weave of a marsh wren's nest, drying quickly, looks old and weathered within a day or two of construction. I never learned to tell this year's nest from last year's, or dummy nest from real. Throughout the spring, the rounded oblongs of the nests diverted me. They were everywhere in the tules. I often detoured to poke my finger gently into the entry hole to see if the nest was occupied. None ever were. All the nests I fingered were wet and dank inside. The dummy nests were designed, perhaps, to fool red-winged blackbirds, but they worked just as well against me.

On the sixth of June, my fingertip detected warmth toward the bottom of a wren nest. Feeling around, I encountered two small, warm lumps. I gently worked a finger under one and maneuvered it delicately up and out of the nest. The wren chick was naked except for whitish downy feathers on its head and back. It was all beak at this stage. It had a huge trapezoidal gape. The gape flanges were an arresting yellow. It did not much resemble its parent. The disproportionate beak looked nothing like the surgical instrument of the adult wren.

Marsh wrens grow into their beaks, just as humans grow into their craniums.

In the very next nest, I detected warmth again and this time felt eggs at the bottom. My thrill in finding them was out of all proportion to the size of my discovery. Grinning foolishly, I maneuvered one tiny, dark brown egg out through the entry hole, admired it briefly, then carefully worked it back down to the bottom.

When I returned to the marsh a week later, many of the wren nests I fingered were warm. I brought up one more hatchling — this one newer than the first, its body entirely pink and naked, its only feathers a white, Einstein-like frazzle atop its head. Then I decided my investigations should end. This could become an addiction. The decent thing was to leave these nests unmolested. From a nest in a stand of bulrushes, I brought up one last egg. It lay in the middle of my palm: exquisite, dark brown, short-subelliptical. It was astonishing, the warmth the miniature thing emanated. It felt nuclear-powered — and a form of nuclear power it was. The thrill in holding wren eggs did not seem to fade. It had something to do with the coolness of the spring morning and the heat of the egg. It had to do with all those dank and empty dummy nests I had probed earlier. The eggs were a vote of confidence. Next year was not to be a silent spring, after all. It had to do with brevity of contemplation. These were not Fabergé eggs I could handle at leisure; they had to go almost immediately back in the nest.

It was hard to imagine a lovelier receptacle for the future of your species, or a receptacle better-engineered. The egg is an avian triumph coequal with the feather and flight. The egg, in all its forms and colors, is the most important product of Sam Sebastiani's marsh.

*Coot chick pipping out*
*Overleaf: Mallard hen and ducklings*

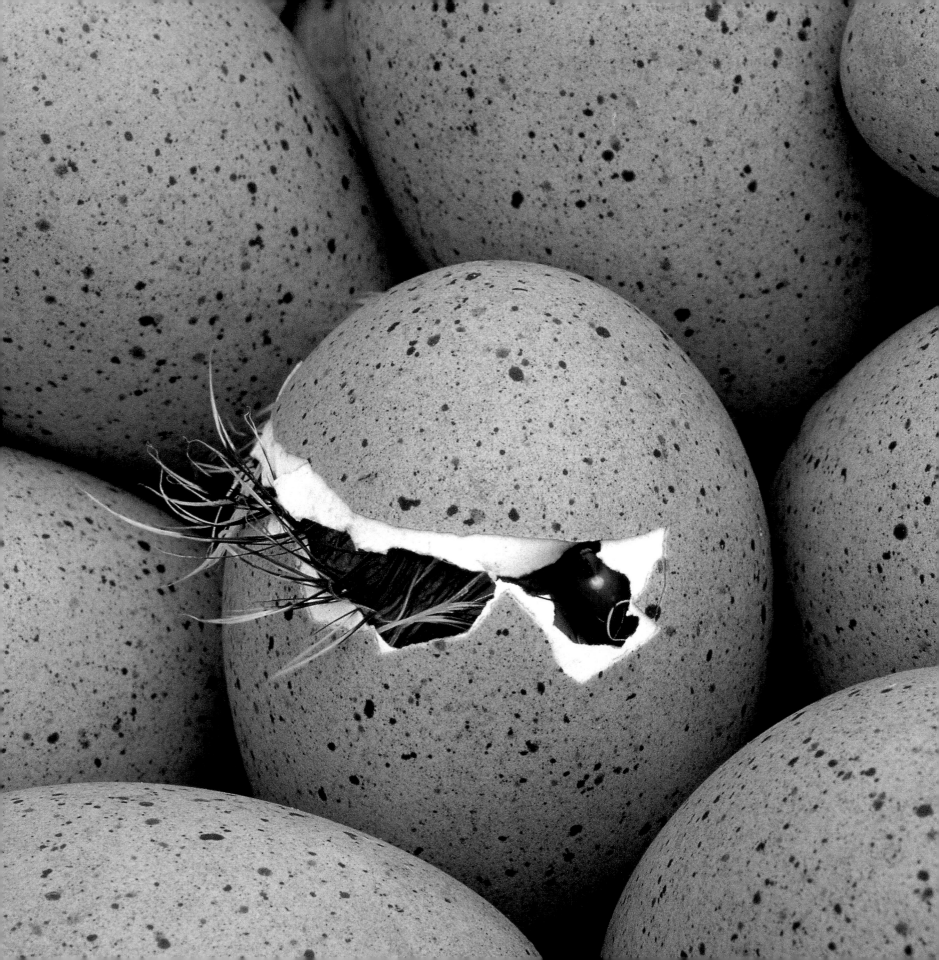

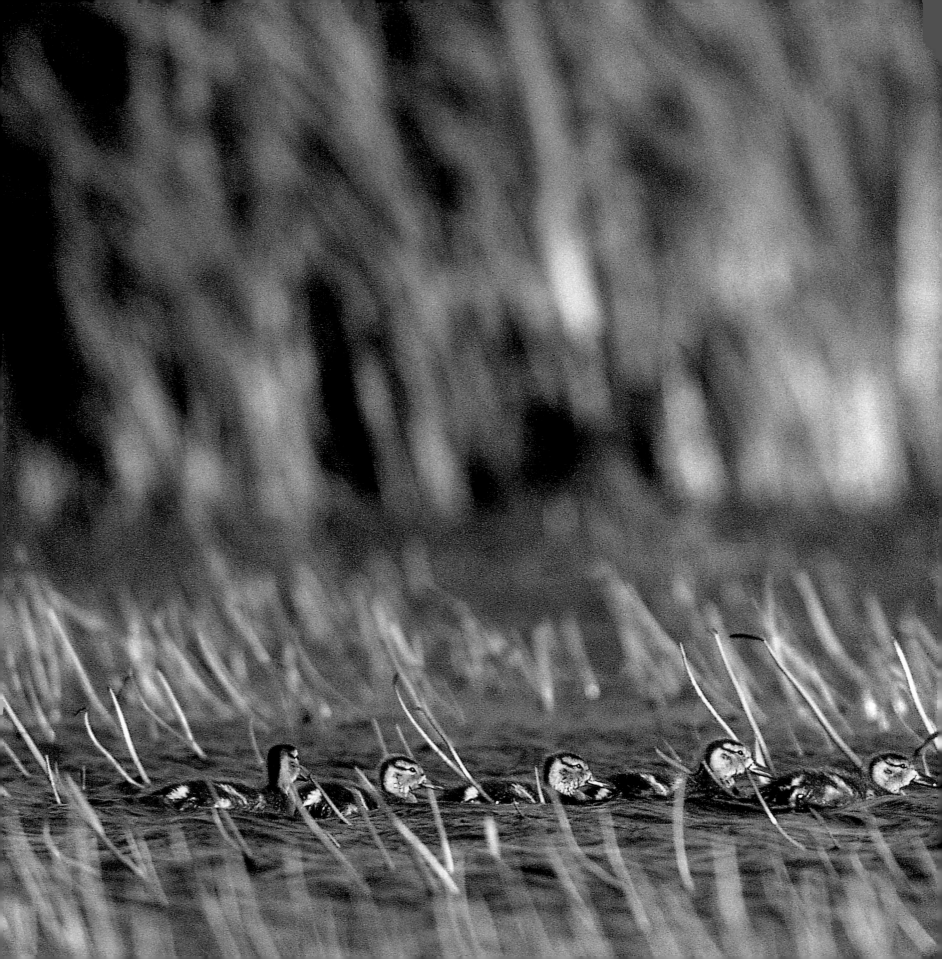

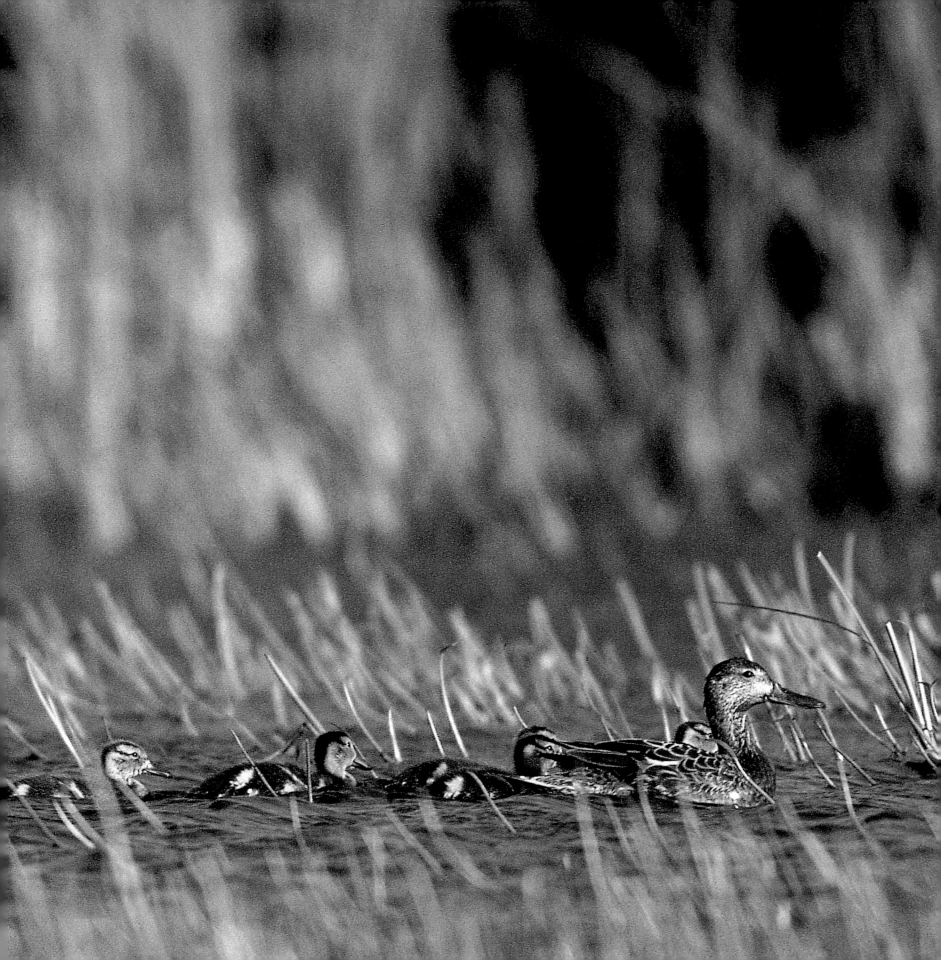

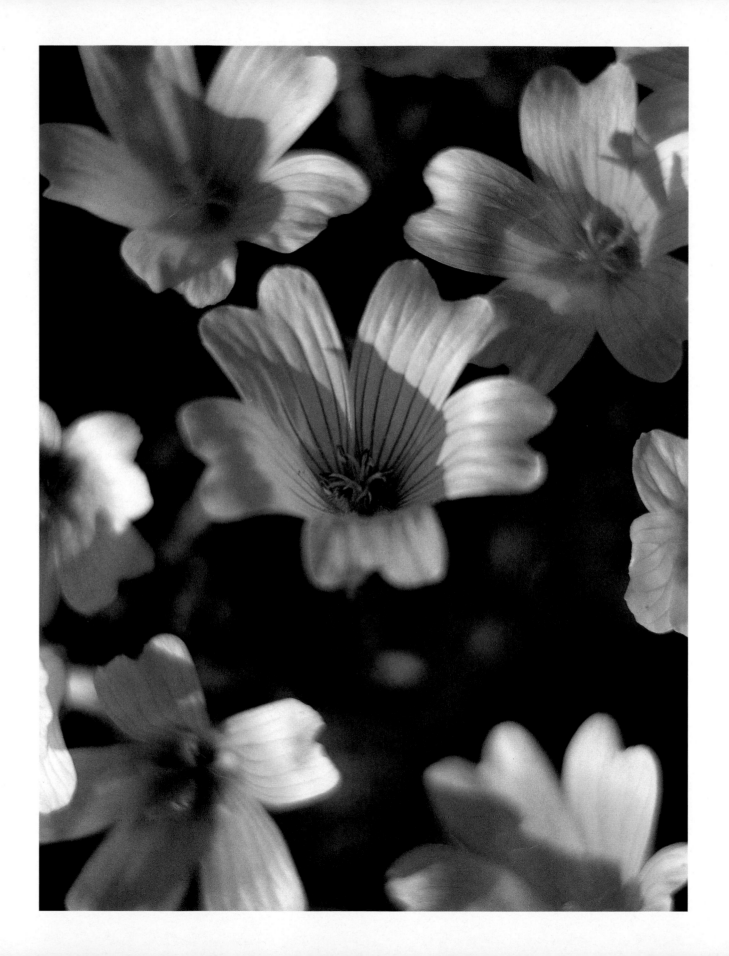

## Perizoon and Aufwuchs

The lancelike leaves of curly dock, *Rumex crispus,* grew up amidst the wild radish of the levee. The dock sent up tall stalks, which sprouted dense clusters of green buds. The shores of the ditch of the massacred carp germinated some sort of chardlike plant. On the muddy terrace where the herons and vultures had scattered the skeletons and scales of carp, the last traces of that massacre disappeared in a monoculture of broad leaves.

Toward the end of May, hot-air balloons blossomed in bright primary colors in the sky over the Sonoma floodplain and the Napa hills beyond. The ballooning season had begun in the wine country. Chamomile appeared along the levee crown. The buds of the chamomile were spherical, like the balloons, but they hugged the ground and came in just one color, a yellowish green. The chamomile lent the faint, slightly unpleasant odor — esters of angelic acid — to the ever more complicated scent of the marsh.

The little grove of cottonwoods that Sam Sebastiani had planted at the southwest corner of the marsh filled that end of the marsh with the clean, tonic, sinus-clearing fragrance of riparian trees. There is something about the chemistry of trees growing along streamcourses and ponds — willows, alder, cottonwoods — that generates this special smell. Sniffing all the parts of one test cottonwood in Sebastiani's grove — bark, stems, leaves — I established, to my own satisfaction, that the smell emanates from the leaves.

The new leaves of willow and other streamside trees are extraordinarily rich in ascorbic acid. Perhaps the good smell of the cottonwood grove was simply that — the ascorbic sharpness

of vitamin C. Willow, too, was the original source of acetylsalicylic acid: aspirin. Perhaps the fragrance was an acetylsalicylic fragrance. In either case, it was a good, salubrious smell.

The green seed clusters of curly dock began to redden.

Aufwuchs and perizoon bloomed in the marsh waters. Aufwuchs are algae, fungi, and detritus on freshwater substrates. Perizoon are small animals that live and feed on the aufwuchs. In the little ocean of the marsh, these were the phytoplankton and zooplankton, and they respond as plankton does to lengthening days of sunlight. The clearings made by muskrats in the reeds began to fill with duckweed and small, green-brown clumps of algae and the tiny, bright green leaves of floating wort. Populations of small, innocuous shoreflies boomed. Populations of minnows exploded, dimpling the surface of the marsh and the ephemeral pools ouside.

On the first of June, I jumped a fat vole in the levee grass. The vole was nearly as wide as long, having fed a little too well upon the bounty of spring. He looked like one of those big male voles that barn owls are known to select. Glancing at the nest box where the marsh's barn owls were now dozing, I muttered a warning to the vole. Come nightfall, he'd best squeeze his fat behind down some hole.

The marsh steadily grew shallower. Small, watery prairies of rushes and spikerushes appeared between the stands of cattails and bulrushes. Red-winged and tricolored blackbirds were drawn to these newborn prairies. They settled in flocks, explored the spikerushes, then rose in flocks again.

The last of the previous year's cattails — the tips of the

*Meadow foam*

old culms blackened as if burned — had all but disappeared in the green surge of this year's cattails. At the beginning of spring, it had been the reverse: a lawn of green cattail shoots sprouting at the base of a dry plantation of dead culms.

The otter run, at the beginning of spring, had crossed a triangular patch of shortgrass prairie between the marsh and the Sonoma Creek slough. That prairie was now a little jungle. Assorted weeds had sprung up, and grasses, and fennel. Poison hemlock had grown nine feet tall and was flowering white at the tops. The passage of otters kept the run unobstructed close to the ground, but a human attempting to follow the otter trail had to bushwhack. On the bank of the slough, a new ground-cover — yellow-flowering, with a leaf like strawberry — grew right down to the intertidal boundary of pickleweed and tules. The otters liked the feel of this groundcover under their backs and they flattened it in several rolling circles at the edge of the run.

On the western shore of the marsh, a disorderly garden of volunteer plants reached its fingers up into the vineyard: long, westward-trending strips of wilderness between rows of grapes. Then one day a fieldworker with a gas-powered weed-eater worked his way down the rows, leveling the curly dock and other weeds that had sprung up, taming each wild strip.

*Sagittaria latifolia,* duck potato, made its appearance. It had been trying to appear for some time, but waterfowl are so fond of duck potato, and they graze it so heavily, that nothing showed above water but the pale, shorn stems. It was not until the third week of June that the first leaf was allowed to grow out to its arrow shape. Then, with lengthening days of sun-light and shallowing of marsh, photosynthesis ran wild, and

the *Sagittaria* overwhelmed the fowl, growing faster than they could crop it. It formed meadows here and there in the shal-lows, and it flourished on wet bottom from which the marsh had just retreated.

In deeper water, the soup of water plants continued to thicken. Exploring the marsh in waders, you quickly gathered great, heavy "boots" of duckweed. Every twenty paces or so, you had to stop to unburden your feet, or the mounting weight and drag of duckweed would soon slow you to a halt.

The wild radish on the Sonoma Creek levee was all in seedpods now. Having flowered through much of winter and all of spring, the radish was finally losing its color. Star thistle forced its way up through the fading radish. Almost overnight, either edge of the levee crown became a briar patch of thistle thorns, then bloomed with yellow thistle flowers.

The Russian olives lost their fermented fragrance, but the alders and cottonwoods continued to broadcast their good, riparian, ascorbic, acetylsalicylic smell. The broken-wing acts and fake incubation displays faded among the black-necked stilts, but among the ruddy ducks courtship and territorial skir-mishing continued hot and heavy.

One day three female ruddies, following a male through the field of my binoculars, startled me by breaking out into a display of male head-nodding. It was the violent tic of the ruddy drake, but not quite so emphatic. The Tourette's syn-drome of the males seemed to be catching. I consulted my field guide. Female ruddies have a stripe through the whiteness of the eye patch. These three ducks had none. They were not females at all, but immature males. The newest generation of ruddy ducks was already coming of age.

*Pondweed*

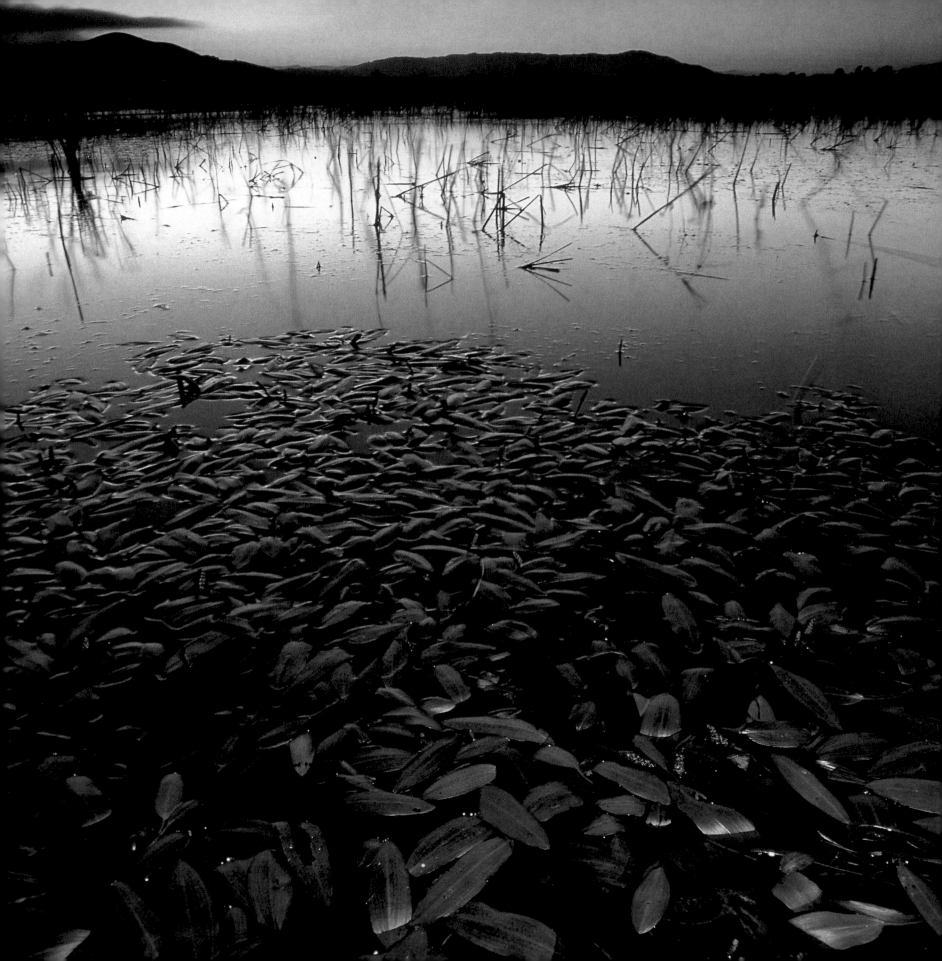

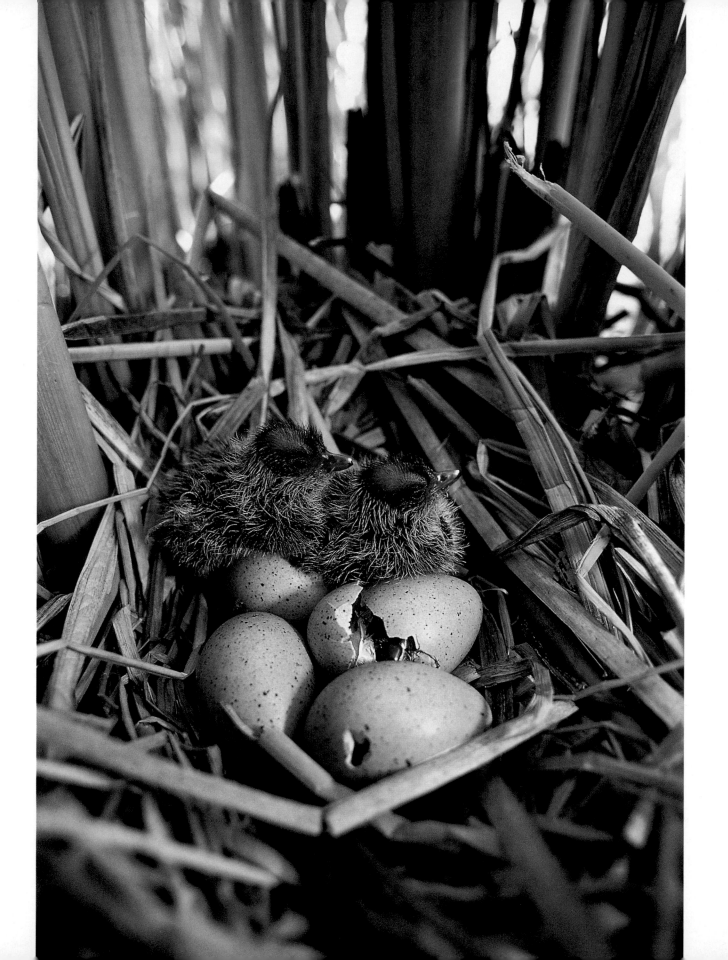

## Call of the Coot

Early in my year in the marsh, when the drab colors, low armor-plated brow, and idiotic bobbing motion appeared in my binoculars, I had the nearly universal reaction: *Just a coot.* I swung the binoculars onward in search of something worthwhile.

The disrepute of the coot is entrenched in our language. "They are stupid and fly slowly, and can hardly be classified as game birds," according to Webster. In its first sense, "coot" refers narrowly to genus *Fulica,* the coot proper. In its second sense, it refers to surf ducks or scoters, in its third to murres, and in its fourth to "a stupid fellow; gull; simpleton; as a silly *coot.*"

The American coot is also known as mudhen, mud coot, mud duck, baldface, blue peter, crow-bill, crow-duck, pond crow, sea crow, flusterer, shuffler, and pull-doo, among others. None of these aliases can be said to radiate nobility. None is a graceful, shining name like "swan," or a clean, trim term like "tern."

In my own disregard for the coot, I reached adulthood believing it was some kind of duck. The coot in fact is a rail. It has the big, lobed feet, short wings, and reluctance to fly that characterize all the family Rallidae. But where other rails are shy, mysterious birds of the reeds, the coot goes about life openly. The old rail specialty, that impossible elongation of self to squeeze wraithlike, a feathered Houdini, in perfect silence, between contiguous reed stems, is a talent lost to the coot. The coot is not thin as a rail. Its chunky build and the white frontal shield on its forehead make it the ironclad of the family, a *Monitor* or *Merrimac* of the Rallidae.

If, above waterline, the coot is the most ducklike rail in shape, below water it retains those unwebbed rail feet. Where ducks glide smoothly across the surface, like targets in an arcade, the coot labors along with head pumping foolishly. It is the effort required in swimming weblessly, no doubt, that sets the head to nodding, as in a man trying to walk on his knees.

Where the startled mallard, from a dead standstill on the water, springs vertically and athletically skyward, crying sharply and causing a sharp emotion in the breast of the viewer, the startled coot, for its part, patters desperately away over the surface in a Keystone Kops chase that seldom gets airborne and has earned the bird the nickname "splatterer." The launch of a mallard, or pintail, or shoveler — that vertical liftoff on a bright explosion of droplets — can blur the viewer's vision with sudden, inexplicable tears. The interminable comic takeoff of a coot wins at most a crooked smile.

The iridescent green in the mallard's head, the blue in the wings of a blue-winged teal, are magical, shifting, "structural" colors, produced not by pigments but by reflective barbules on the feathers, which allow the hue to change continually with the angle of reflection. The industrial slate-gray of the coot is unvarying. It stays the same dull color at any angle or time of day. Coot-gray, or a shade very close, is what the Navy paints its battleships. A bunch of coots riding at anchor has all the poetry and romance of a mothballed fleet of minesweepers.

The autumn cry of the loon says *Far North.* (And in summer, on the breeding grounds, the loon's lunatic laughter hints at the vast solitudes that drove it crazy.) The honking of

*Hatchling coots*

geese has the sweep of Arctic tundra in it, and the cycle of seasons, and the miracle of migration, and some ineffable sad-yet-joyous poignancy at the very heart of life. The call of the coot in cattails, muttering and chortling to itself like a drunk on the corner, sings only of marsh muck and the black, slimy, decayed stems of rushes that the bird brings up to eat.

Where other rails are seldom seen, the coot is seen too much. The curse of the coot is its commonness.

One day in the marsh, with the spring sun behind me and a coot ahead, I caught the bird in profile in my big ten-power fieldglasses. For the first time I realized the brilliance of the blood-red eye. Coot plumage may be drab, but the bird's eye holds a warlike luminosity that no color plate will ever capture.

I began to rethink coots. I was forced to reconsider, first, this matter of the commonness of coot. To complain that the coot is everywhere is to admit that it is extraordinarily successful, which is to concede that, in a Darwinian sense, it must be remarkably good.

In what ways good? Wherein the success of the coot? The bird's adaptations to wetland life are not immediately obvious. They are not characteristics that jump out at you, like the webbed feet, catapultic takeoff, and fast flight of the duck.

At first I thought the coot's success might be in its big vocabulary, its powers of communication. Peterson's *A Field Guide to Western Birds* transcribes coot talk as "*kuk kuk kuk kuk kuk; kakakakakakakaka,* etc." The key word is "etc.," and Peterson could safely have added several more of those. The coot is endlessly voluble. Unlike its upstairs neighbor, the marsh wren, which says the same sort of thing, beautifully, over and over again, the coot is full of cackles, croaks, natterings, long interior monologues, and little polyglot exclamations of surprise, contentment, and alarm. It is the mockingbird of the marsh. If the red-winged blackbird is the voice of the marsh canopy — flexing with its perch on the tip of a cattail, flashing its red epaulettes, and singing its liquid *o-ka-lee-onk* — then the marsh wren is voice of the mid-storey, and the coot the throaty and guttural voice of the roots.

When the spoken word is not enough, the coot makes semaphores of various parts of itself, employing a repertoire of at least fourteen displays. My favorite is the maneuver that might be called "Mooning the Enemy." After a furious, red-eyed, water-walking chase after a rival, its frontal shield swelling in anger, a coot will reverse the last of its momentum in a quick U-turn. Dropping its chin to the water and raising tail, it will ruffle itself out as big as possible and victoriously flash the white V on its backside at the opposition.

Coots are belligerent, territorial, quick-tempered birds. Most coot warfare is internecine, for nothing irritates a coot like another coot; yet the bird will attack nearly anything that strays into range. On the marsh I watched coots chase off cinnamon teal, cormorants, pied-billed grebes, and gadwalls. The coot is dominant over its cousin the common moorhen. Chasing ruddy ducks across the surface, a coot will continue the pursuit underwater, diving down through the surface ring that the escaping ruddy has made. Coots have no use for muskrats. When those giant water voles submerge to escape, the birds will pursue on the surface, roiling the water with their feet — the mudhen depth charge. Flocks of coots will resort to the same wild splashing to confuse eagles pursuing them. Once I saw a big Caspian tern plunge in near cattails, then emerge with a silvery fish in its beak and an instantaneous and implacable coot on its tail.

*Juvenile coots*
*Overleaf: Coot fight*

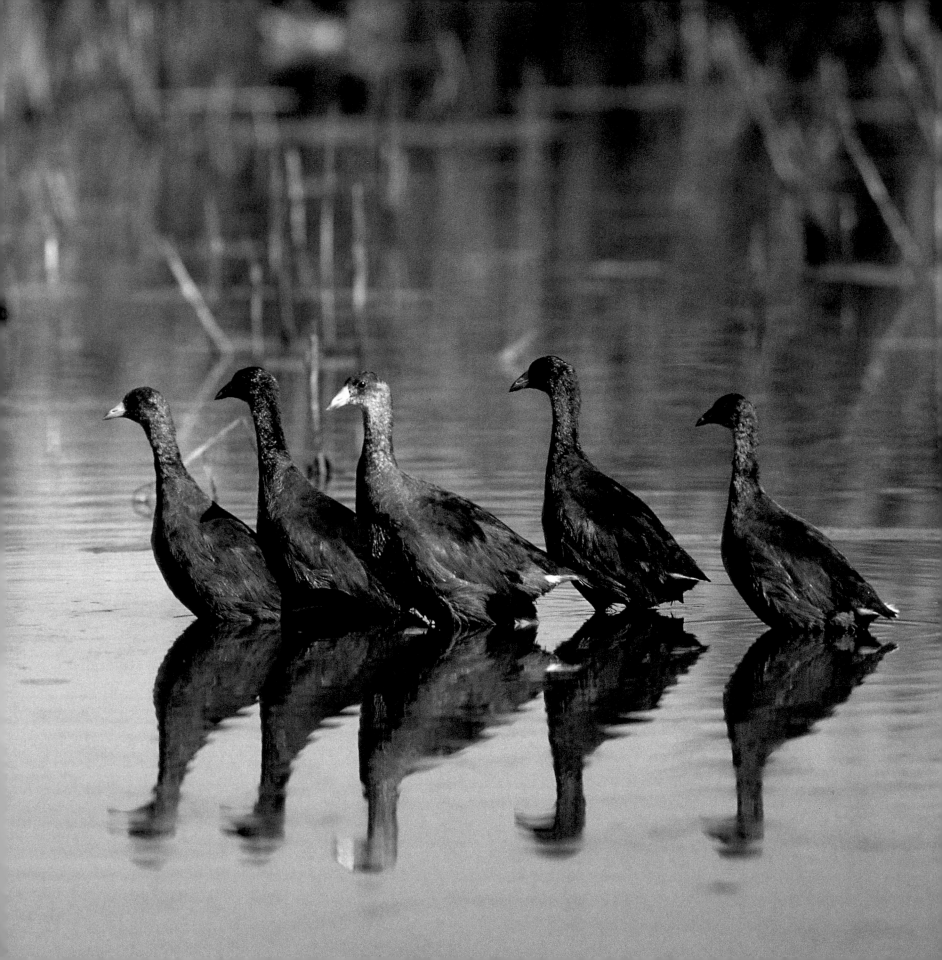

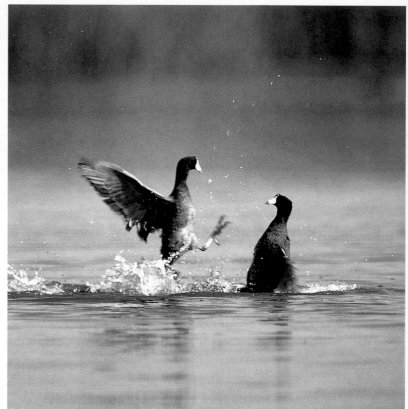

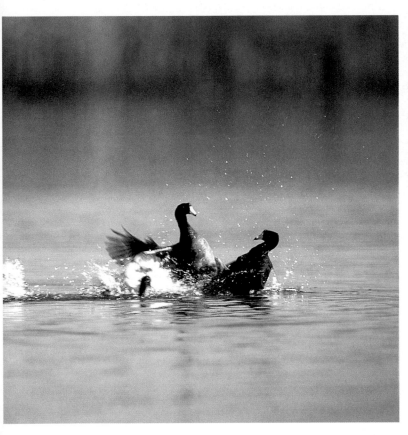
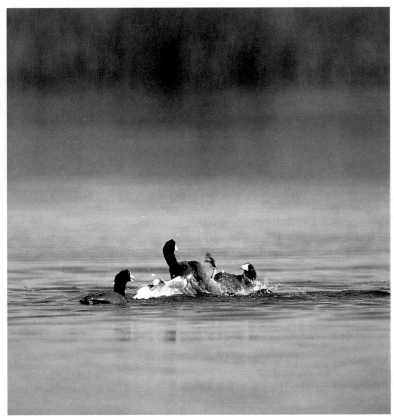

It was coot combat that first caught the eye of Michael Sewell. Coots fight like kangaroos, leaning back in the water and striking at each other with their oversized feet. They specialize in dirty tactics, like holding and hitting. The basic coot combination — the old mudhen one-two-three — is to grip the opponent with one foot, slap him silly with the free claw, slip the shiv of your beak in, then attempt to force him over onto his back and hold him underwater. A coot fight is spectacular — a small, local hurricane of beating wings and white water — and Sewell's telephoto lens provided him a ringside seat.

"These coots!" he complained to me, lamenting the amount of film he was burning on them.

One morning, donning my chest-waders, I helped Sewell push his aluminum skiff around the marsh. The skiff, covered in camouflage netting, served as gunship for his Nikon F-5 camera, which was mounted on a quick-swiveling tripod at the stern. His Nikon autofocus 500 F-4 S lens was designed to freeze fast-moving objects in flight. In front of the big strobe he had installed a Fresnell lens that quadrupled the output of the flash. Because the magnifying lens was a big reflective surface that tended to frighten birds, Sewell had rigged a trapdoor to hide it. At the last instant he pressed a button, the door dropped like a guillotine blade to dangle on a cord, and the sun's glint from the magnifier was nearly instantaneous with the flash. The photographer, in camouflage garb himself, wore three different duck calls on lanyards around his neck. He went loaded for duck, in other words, yet coots, everywhere, were what we encountered.

In nearly every stand of cattails, we found at least one coot nest. These structures, volcano-shaped cups woven of reeds, are often called "floating" nests, but this is misleading.

Each mound is firmly anchored, interwoven at waterline with the upright culms of a number of living cattails or bulrushes. In a single breeding season, a pair of coots will build as many as nine nests, but lays in only one, using the other dummy nests for displaying, mating, and brooding.

Setting the heel of his hand in one coot nest, Sewell pushed down hard, then commented on the surprising sturdiness. I followed suit. The nest was sturdy indeed. Horton the elephant could have incubated his egg on it. I asked Sewell how he explained the remarkable success of the coot. He gestured immediately at the nest between us, and he pointed out that where most ducks must nest on land, coots nest out in the relative safety of the cattails.

Perhaps the nest is indeed the answer. Maybe the success of the coot is architectural.

The female American coot does most of the building, with materials brought in by the male. There is a classic, almost Grecian sensibility to her eye for design. The "caldera" atop the volcano of the nest is a shallow, perfect basin. Coots seem to take great care to get the inner curvature just right, much as astronomers do in engineering the mirrors of their telescopes.

The pied-billed grebes of Sebastiani's marsh built a similar nest, but the design, to my way of thinking, was much inferior. Working with smaller fragments of reed, grebes fashion a much wider lip around the basin, cutting down on chick space inside. And grebe nests are always wet. The wider lip of the grebe nest may have some advantage — better chick retention, maybe — but it is hard to imagine any virtue to a damp nest. Water conducts heat away twenty times faster than air does. The grebe eggs I found were always warm, but they

*Coot nest*

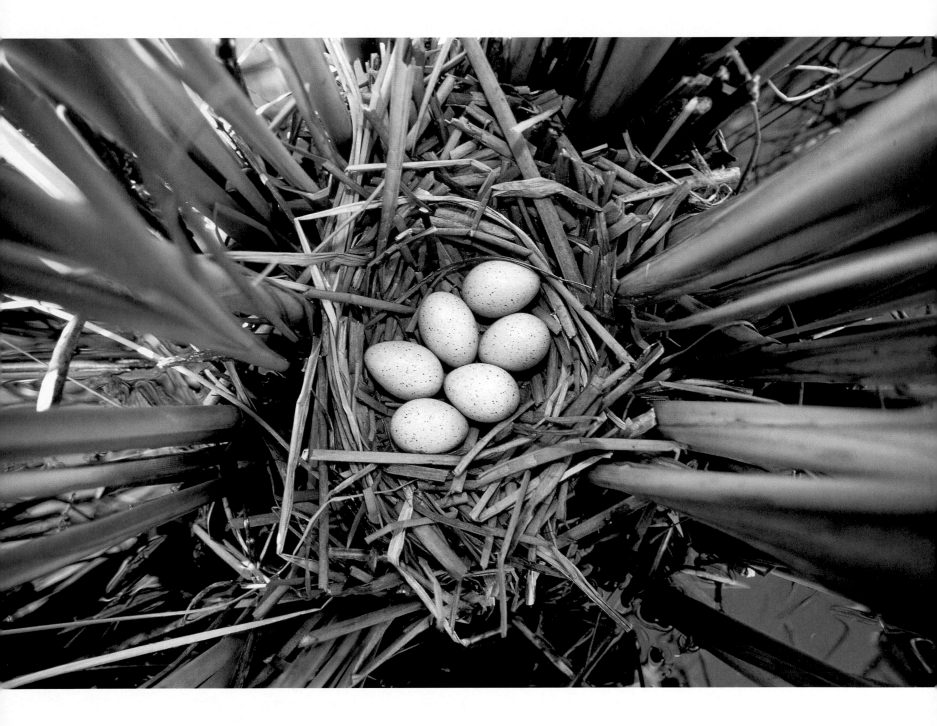

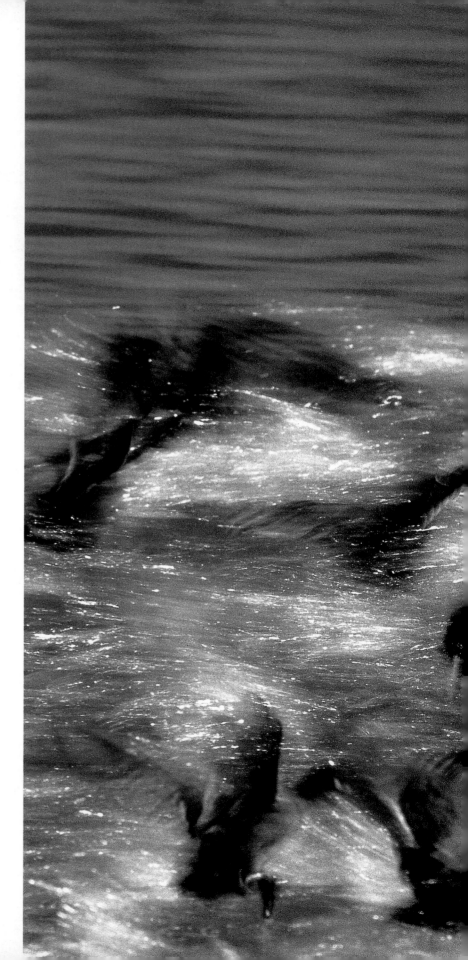

must have required nearly continuous brooding to keep them
that way. The pied-billed grebe lays a nice, elliptical, blue-
tinted white egg, but this immaculate creation soon becomes
nest-stained, darkening to a tannic, dirty buff-yellow, and
sometimes even to a harvest-moon red. None of this Easter-
egg effect for the coot. The weave of a coot nest drains nicely.
The basin is dry again soon after rain. Coot eggs — subellipti-
cal, from five to fifteen per nest, laid on consecutive days and
incubated by both parents — do not become nest-stained.
They remain, at hatching, the same semi-glossy, speckled,
pale-buff wonders they were when laid.

As we stood at the nest, Michael Sewell reflected on
the conundrum of the coot. He told me a story from his youth.
At the end of a fruitless duck hunt with his father, he and the
old man had turned their guns on coots. "We shot the limit,
which was twenty-one. In those days, the duck limit was
what? Three? We brought them home and cleaned them. It
was an experiment. Geez, they smelled just awful, like an open
sewer. They're bottom-feeders. I think one made it as far as
the pan. My dad was so stubborn! But in the end they all got
thrown out."

Sewell's coot experience — distaste early, a grudging admi-
ration late — paralleled my own. His implication that the success
of the coot might lie in its awful flavor had occurred to me, too.
As edible waterfowl are hunted out, the inedible figure to take
over the niche.

Or perhaps the success of this unappetizing bird is in its
appetite. The mudhen is a kind of vegetarian pond vulture. It will
eat tadpoles, insects, crayfish, and snails when it finds them, but
it subsists mainly on surface algae and moldering plant matter
from the bottom. Maybe the coot's secret is its cast-iron stomach.

*Coot stampede*

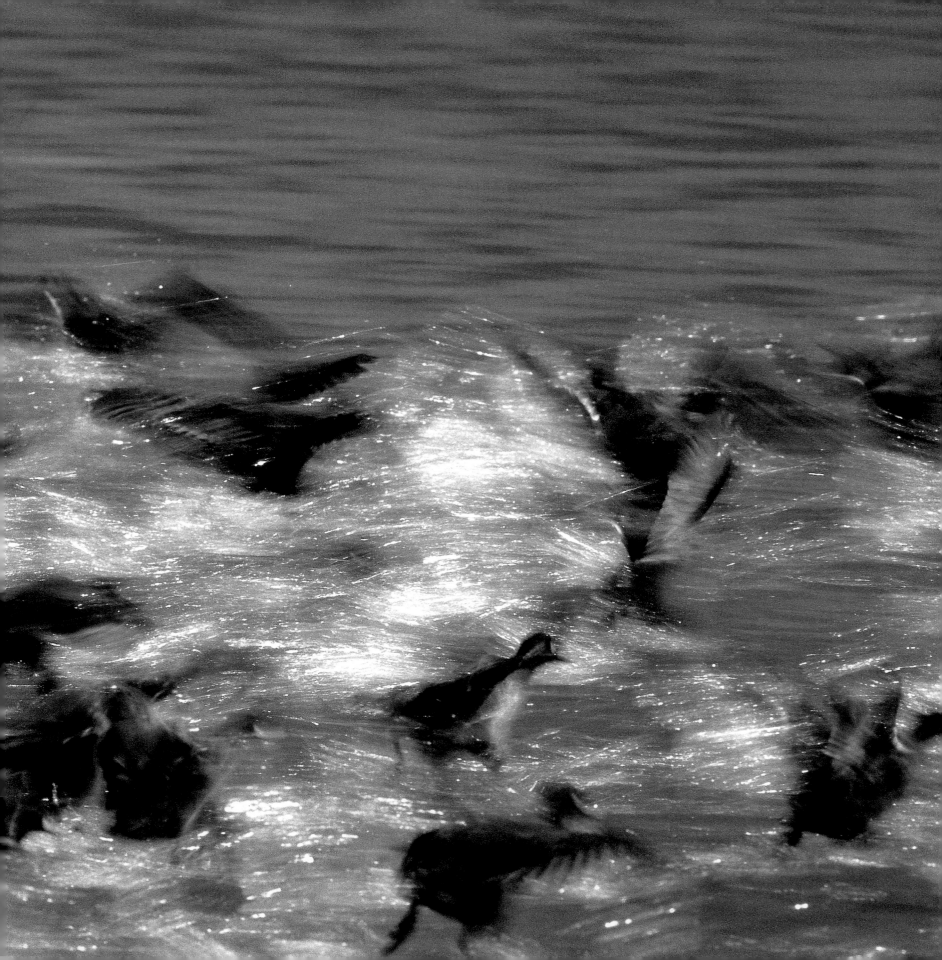

In the wet, gray weather of an El Niño spring, the warm eggs of coots, when your cold hands find them, feel positively hot. On discovering a nest, I would heft each egg briefly to steal a little of its warmth, then set it carefully down with the others. Sometimes I would roll an egg or two against my wind-chilled cheek. On a bleak day in the cattails, the cheering effect of egg against cheek is wonderful. It lasts long after the physical warmth is gone.

One afternoon the egg on my cheek cheeped at me. Startled, I set it back apologetically. The egg beside it cheeped, too, and from a small hole in the second egg, a tiny, red, dark-tipped beak protruded. I peered in. The cootling's black prenatal eye gazed back.

What emerges from the coot egg is the biggest surprise in the marsh. A coot, for all its grayness at maturity, pips out as gaudy and polychromatic as any tropical parrot. The hatchling has a bald, pink-purple pate, above which levitates a mist of nearly invisible down. The naked skin of the brow, in a semicircle above either orbit, is painted an iridescent lavender-purple. From the base of the red beak, stubby, orange, papilliform feathers spread backward across the face. The chick wears a frazzly cape, or poncho, of sparse, long, filamentous orange or yellow feathers over its dark underdown. In *Fulica americana*, the American coot, the parable of the Ugly Duckling is turned upside down.

Baby coots seem to venture out unsupervised very young. The biggest stretch of open water in the Viansa Wetlands was the embayment along the northern levee — the North Sea, as I called this body of water in my notes. I often saw the motes of solitary chicks disappear in the distance on the North Sea, boldly exploring the big two-inch

swells. Good parenting, I think, is not an explanation for the success of the coot.

Where other rail mothers perform distraction displays, the coot hen does not. The mother gadwalls of our marsh did a fine broken-wing act to protect their young. A whole epidemic of broken wings would spread among the marsh's black-necked stilts whenever we approached their nesting bar. The coots, for their part, would just swim away, clucking fretfully and leaving their young to fend for themselves. Coots are, it's true, one of the waterfowl species known to carry their young on their backs. And coot parents do work hard on the bottom, bringing up the swill that baby coots eat. But coots seem incapable of the tight discipline a duck hen maintains over her flotilla of ducklings. Occasionally, in a halfhearted and ineffectual way, a coot will try to herd its young. The cootlings pay little attention and continue to follow their impulses.

It may be, of course, that delinquency is good for coots. Cootlings soon become marshwise. Older cootlings sometimes help feed their younger siblings — a very rare phenomenon among birds. To an unusual extent, coots are reared by their peers, as often happens with latch-key children. By the time they are juveniles, gangs of young coots, four or five strong, have learned to mug ducks and pirate food from them. Perhaps the success of the coot is in the very negligence of their parents.

When danger presents, wayward cootlings generally take refuge in the nearest cattails or bulrushes. Coot chicks have a magical way of vanishing in the smallest, sparsest stand of reeds. The culms of cattails are green and vertical; the chicks are dark and squat, yet somehow the little birds dematerialize there. Occasionally I did succeed in wading up to a baby coot

taking refuge in Sam Sebastiani's reeds. The chick would try diving to escape me. Head and shoulders dove beautifully, but butt refused to follow. Coot survival strategy at the beginning of life seems heavily weighted — or unweighted, rather — in favor of buoyancy. Diving prowess can wait till later. Flailing at the surface, the chick seems to imagine it is plunging down into the cool, abyssal, eight-foot depths of the marsh. It seems convinced it is swimming an escape route through murky forests of pondweed. In truth it is going nowhere. When I scooped the chick up, it would attempt to swim off my hand once or twice, then resign itself and regard me calmly with a dark nictitating eye.

I would admire its many colors. I would delicately pat the monklike purple pate, under its saintly nimbus of down. I would test the sharpness of the claws on the huge feet. (The coot is one of those creatures that grow into their feet. The toes, disproportionate in adult coots, are even more so in babies. *Feet first!* is the coot survival strategy; the wings can grow in later. A half-grown chick has full-size feet, but is unable to fly until two months old.) Holding my coot, I would finger the meaty lobes, or flanges, that scalloped the toes.

When the coot's foot moves backward — the swimming stroke — the toes spread and the flanges fan outward to more efficiently cup and push the water. When the foot moves forward through the water — the recovery stroke — the toes close and the flanges fold back, decreasing resistance. Where a duck's feet are placed aft, like the screws of a vessel, to better propel it through the water, a coot's feet are placed more underneath. This is a trade-off. The webbed, stern-paddling feet of a duck make it faster and more graceful on the water. The flanged, centrally located feet of a coot make it faster and more graceful

on land. A coot divides its time between water, reeds, and mud, and the big flanged toes help it handle all three surfaces. This tridextrousness, maybe, underlies the coot's success. Coots are everywhere because they are generalists. They are birds of all mediums, as indicated by their feet.

The flanges have a secondary function as radiators, quickly cooling the bird down when it immerses the feet. Coots handle hot weather famously well. Perhaps some of coot success lies in thermoregulation.

When I had my fill of speculation on the riddle of the coot, I would give my chick a sniff — it smelled good, like any baby — then set it down on the water again.

Humans are amused by imprinting in waterfowl. We laugh at the deluded ducklings who follow the family spaniel around, having glimpsed the dog first of all things in Creation. We forget, in our merriment, how easily we are imprinted ourselves. It is possible for a human to fall in love with an infant marsh bird — and with the whole species it represents — merely by playing with the feet. A reasonable normal man can develop a powerful foot fetishism, just by fooling once or twice with the oversize feet of underage coots. Waterfowl, for all their programmability, are not imprintable until after hatching. A human is subject to a kind of reverse-imprinting in the egg stage, simply by rolling that warm, smooth ovoid against his cheek.

My heart, once hardened against the coot, softened. I became a cooter, or a cootie — or whatever the correct term for advocate of coot. The coot is garrulous, wordy, warlike, a builder, opportunistic and adaptable, by turns a good parent and bad; an animal whose young must grow into their feet. It is not so hard for *Homo sapiens* to empathize with a creature like that.

*Overleaf: Coot landing*

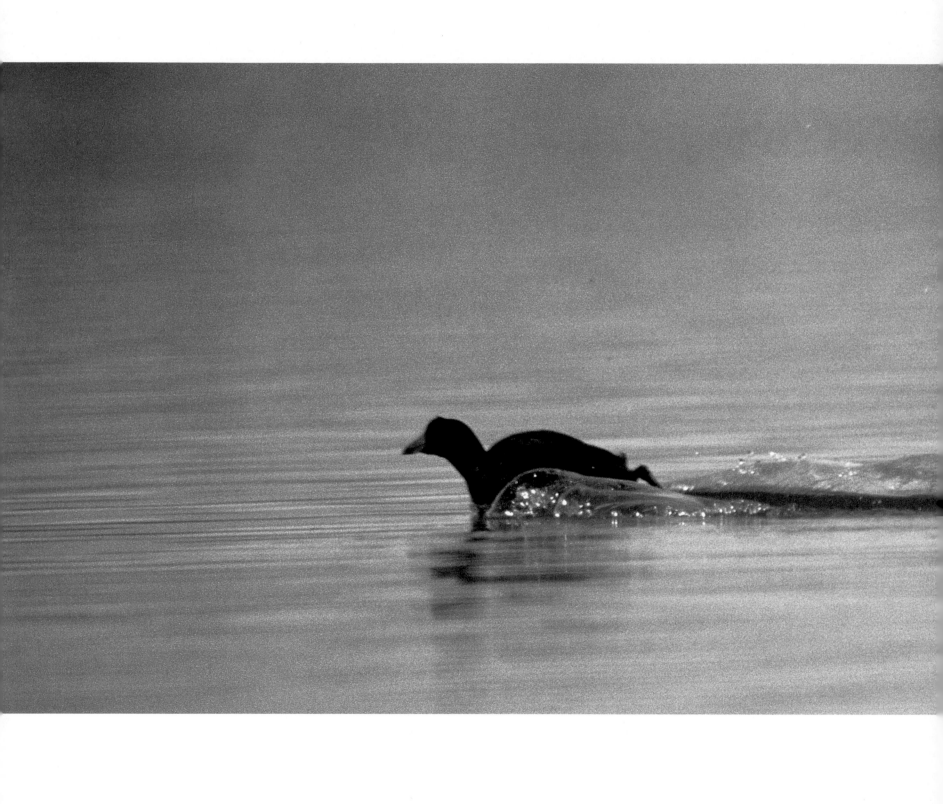

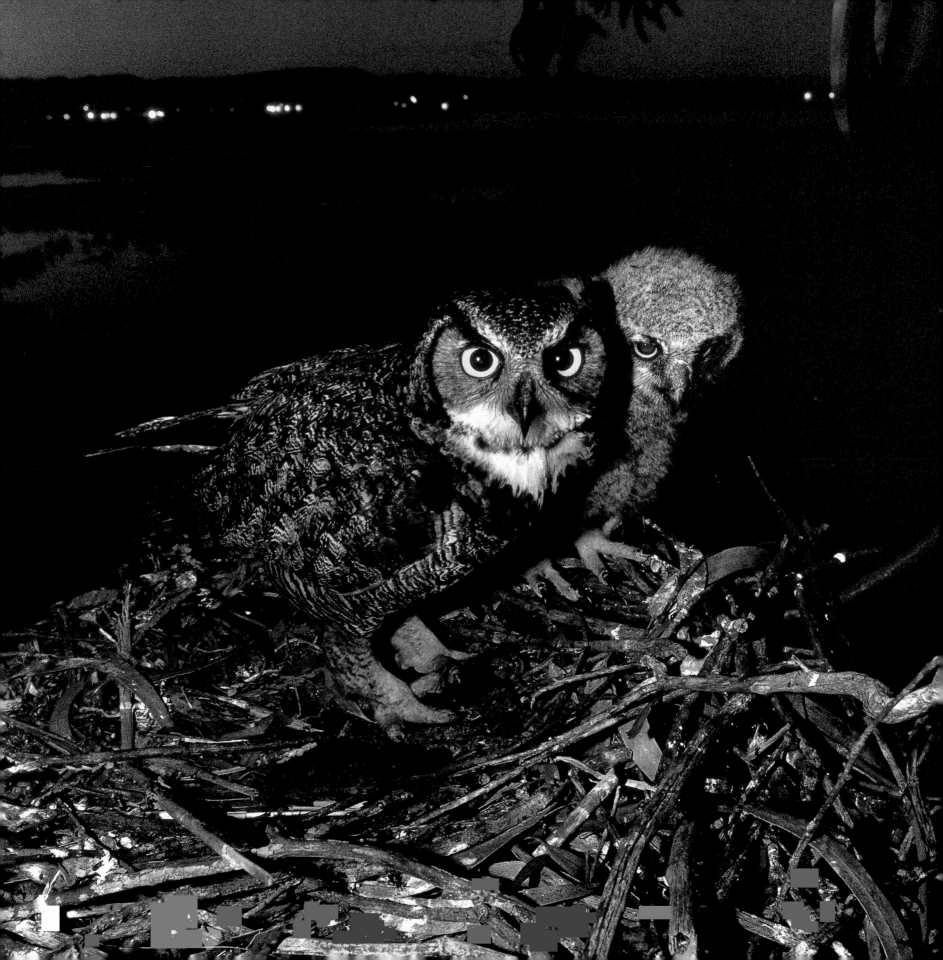

## Prince of Darkness

A pair of great horned owls appropriated an old hawk nest in a eucalyptus above the marsh. The tree stood with four smaller eucalypts in a tight, dark grove on the east levee, the only big trees for miles. The eucalyptus dominated the ninety-acre marsh just as Owl's tree, in *Winnie-the-Pooh*, dominates Hundred Acre Wood.

The male owl was smaller than his mate — a Thurberesque, Walter Mitty sort of husband. He puffed himself up for loud aerial courtship displays over the marsh. Alighting, he fed ritual meals to his giant wife. The female sat two feet tall in the nest. Staring out of the deep shade of the eucalyptus canopy, with her piercing yellow eyes and the dark horns of her ears, she looked like the Devil herself.

The eyes of the horned owl are huge, to better gather light. The eyeball is more tubular than spherical, an elongation that further aids night vision. The retina is packed with light-sensitive rods. The beak deflects downward so as not to impinge on the night view. After sundown, the bird sees two to three times better than humans do. The horned owl really is a prince of darkness. The tubular shape of the eyeball limits eye movement, reducing the bird's field of view — to about 110°, as compared to 180° in *Homo sapiens* and 340° in pigeons — but this only concentrates the satanic intensity of the gaze. The whole head must move to follow things. The amazing flexibility of the owl's neck is in service to this fixedness of eyes. The disconcerting force of the owl's attention arises from it. The owl is the most rapt of raptors. It is incapable of the sidelong glance. The stereoscopic eyes provide good depth perception on its main concern: what lies ahead. It worries less than other birds about what might be coming from the side.

The horned owls of the marsh bobbed, billed, clicked, called, responded, and finally mated. In the repossessed nest, assembled laboriously by red-tailed hawks over several seasons, the female owl laid two big, almost spherical, smooth, slightly glossy, dull-white eggs.

Confiscating hawk nests is standard procedure for horned owls. Adaptability and aggressiveness in nesting are virtues of the species. The horned owl will nest on the ledges or in the clefts of cliffs, in caves, in holes in the ground, in the forks of saguaro cactuses, in stumps, in tree hollows, in branches eighty feet up. In treeless country — the tundra at the northern limit of its range, for example, or the pampas at the southern limit — the owl will nest on open ground. The fiercest and most powerful of American owls, it nests wherever it wants. Horned owls are partial to the old nests of herons, ospreys, crows, and sometimes squirrels. They are particularly fond of the big, unruly nests of red-tailed hawks.

Horned owls are early nesters, setting up housekeeping so close on winter's last blizzards that sometimes they incubate covered with snow. Arriving early, horned owls get first choice, and once a pair has settled in they are nearly unevictable. Owls can defend their nest day or night, as other raptors cannot.

The dispossessed owners of the nest in Sebastiani's marsh — the two red-tails — continued to hang about the eucalyptus. One hawk or the other was usually perched on a white snag at the summit of the tree, surveying marsh and floodplain. From

*Male great horned owl and chick on nest*

its snag, the hawk would scream the red-tail scream. It was hard not to hear indignation in it. Until now, to my ear, the voice of the red-tail had always sounded like a cry of defiance. Now all I heard was outrage.

The female red-tail had been sitting on the nest when ousted by the owls. It was a fine nest. The hawks had built it at midpoint of a thick, nearly horizontal bough, along which chicks could take their first steps without fear of falling. The nest offered fine views of marsh in one direction, fallow field in the other. Westward through the eucalyptus foliage were fragmentary scenes of the Carneros hills. Directly below was the levee. The nest looked intimately down on any levee traffic: the occasional file of quail, or gopher snake sunning, or muskrat crossing to the other side. The red-tail and her mate seemed unable to give up on this site. It would have been wiser, I thought, had they simply got on with their lives.

In the first week of April, cracks appeared in the semi-glossy, smooth yet imperceptibly granulated surface of the owl eggs. The two owlets inside began to pip out.

From down on the levee, I was unable to witness this nativity — it happened in secret, hidden below the lip of the nest — but by calculating backward, from later stages of the chicks' development, I was able to approximate the date. The owlets entered the world asynchronously, hatching out over a period of several days, first one and then the other. Horned owl hatchlings are white, downy, gray-beaked, and "altricial," which is to say that they arrive immature and helpless, destined for a long period of care in the nest. For the first three weeks, they were brooded by the female, with the male bringing in all the food. After that, the parents took turns hunting.

In mid-April, more than a month after their eviction by the owls, the red-tailed hawks were still loitering about the eucalyptus. At intervals from atop the snag, one hawk or the other would cry for vengence. "*Kee-eee-er-er-er!*" screamed the bird, at the injustice of things. The owls paid no attention. One day, through binoculars, I was watching the vigorous jerking of tufted horns as the female owl groomed herself — her horns were all that showed of her — when the hawk screamed directly above. The owl did not miss a beat. She never bothered to pull her beak from the barbules she was reshaping.

Now and again she hooted.

In horned owls, the female voice is deeper than the male. The females have a little more to say: seven or eight syllables, usually, where the male contents himself with four or five. "*Hoo. Hoo-hoo-hoo. Hoo-oo. Hoo-oo,*" said this owl. The sentence was resonant and hypnotic and arresting. The hooting of the horned owl has an odd ambient quality, difficult to locate as to source. It was as if the whole eucalyptus grove had spoken. The hoots of horned owls are like short segments lifted from some profound, underlying drone of existence; some sort of sub-threshold vibration at the heart of things. On her stolen nest, hooting, the owl sounded as centered and mellow and content as the hawk sounded aggrieved.

On April 19, I noticed that the female owl was sitting higher in the nest. She was now horns, eyes, and beak above the rim. It seemed she was being pushed skyward by the pressures of motherhood, rising on the growth of her young.

In early March, when the nest was still unoccupied, my colleague Michael Sewell, with the aid of an arborist, had fixed ropes to the eucalyptus and climbed up on jumars to fix a dummy camera above the nest. Sewell was not sure the facsimile camera was necessary, but he installed it anyway, to make sure

the nesting birds would be habituated to the alien shape. The nesters, he assumed, would be red-tails. His domestic scenes and family portraits would be of hawks. By mid-March, what had appeared above the nest's jumble of sticks was not the profile of hawk. What appeared was the tips of horns.

Now, in the third week of May, Sewell prepared to replace the dummy camera with the real thing. The owlets were old enough that the risk of nest abandonment was small. The risk to photographer was another matter. Horned owls can be fierce defenders of their nests. Their talons are powerful enough to punch completely through the skull of jackrabbit or the wrist of human being. Ornithologists prying into the family life of *Bubo virginianus* have suffered some awful lacerations. After fixing ropes again in the tree, Sewell's arborist, John Schumacher, went up armored in leather, like an old Celt. Donning a motorcycle suit that Sam Sebastiani had borrowed for this purpose from Sear's Point Raceway, a few miles down the road, Schumacher strapped on a bicycle helmet, then clipped a Super Soaker squirtgun to his belt. A stream from this weapon, he hoped, would fend off the parent owls.

Sewell served as his spotter on the ground. The photographer was ready to sing out, "Bandit at two o'clock!" — or any other hour of attack — but the owls kept their distance. When it came Sewell's turn to climb, the photographer, reassured, went wearing only a heavy jacket. Jumaring up to the level of the nest, he looked in on the owlets and the remains of their last meal: gopher tartar and a pair of ducklings.

The ducklings were no great surprise. Horned owls eat a little bit of everything: shrews, mice, pack rats, Norway rats, showshoe hares, cottontail rabbits, tree squirrels, ground squirrels, chipmunks, minks, small weasels, woodchucks, opossums, bats, grouse, doves, snow buntings, juncos, sparrows, phalaropes, snakes, eels, dace, bullheads, perch, katydids, scorpions. They eat domestic cats, chickens, and turkeys. They consume porcupines, somehow. They seem to have a special taste for skunks, as their plumage and nests are often redolent of that animal. The owl's poor sense of smell has its advantages. Horned owls hunt day or night. They work mountains, forests, deserts. They are perfectly happy hunting marshes. They eat almost anything resident or migratory in Viansa Wetlands: grebes, ducks, geese, swans, bitterns, herons, coots, rails, pheasants, quail, flickers, blackbirds, muskrats, jackrabbits, frogs, crayfish, crickets, beetles, barn owls, marsh hawks, Cooper's hawks, red-shouldered hawks, and red-tails.

The red-tailed hawks built a new nest in the eucalyptus grove, on the side opposite the tree of the owls. They carefully lined it with twigs and bark, and the female laid three smooth, unglossy eggs, whitish with a faint buff wash and a sparse blotching of reddish brown. They were lovely eggs. Even the reddish blotching was attractive, like seas on a harvest moon.

We had little hope for these eggs. Nothing predicts disaster for nesting raptors like the presence of great horned owls. In *Hawks, Owls and Wildlife*, the Craighead brothers argue that the horned owl is, after man, the principal check on raptor and crow populations in America. The Craigheads discovered that for raptors the period of greatest vulnerability to horned owls begins in the nights shortly after the hatching of the owlets, when the owls are most active foraging. One would have expected, given the long, unhappy association of owls and red-tails, that a kind of cautionary oral literature might have sprung up among red-tailed hawks. One would have hoped that instinct might have whispered to our red-tails

*Overleaf: The night gallery — Coyote, raccoon, bittern, jackrabbit, opossum, otter, badger, and Sam Sebastiani's dog, Sprig*

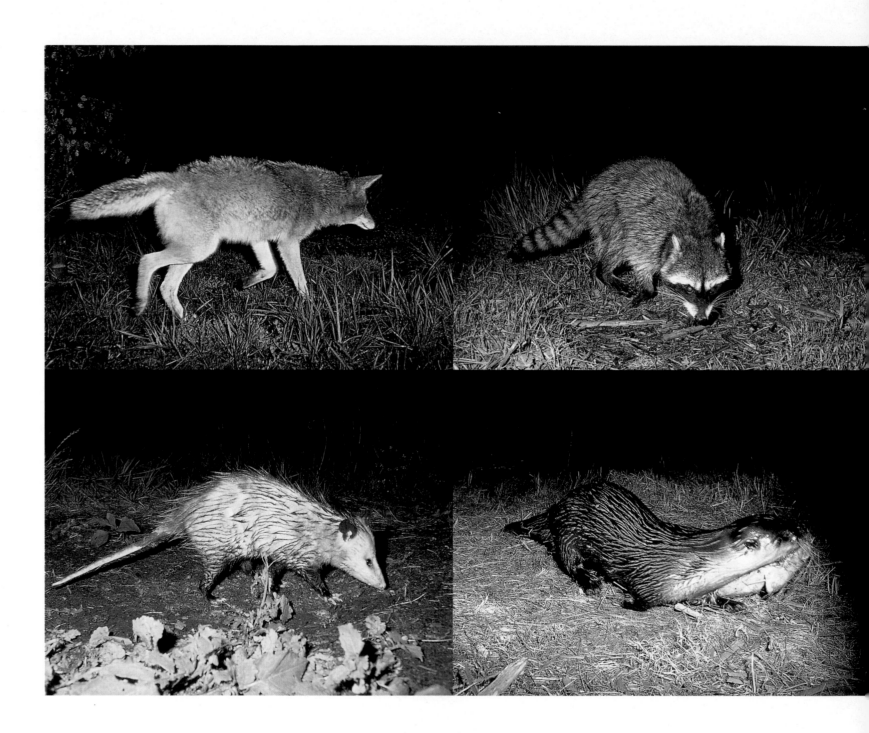

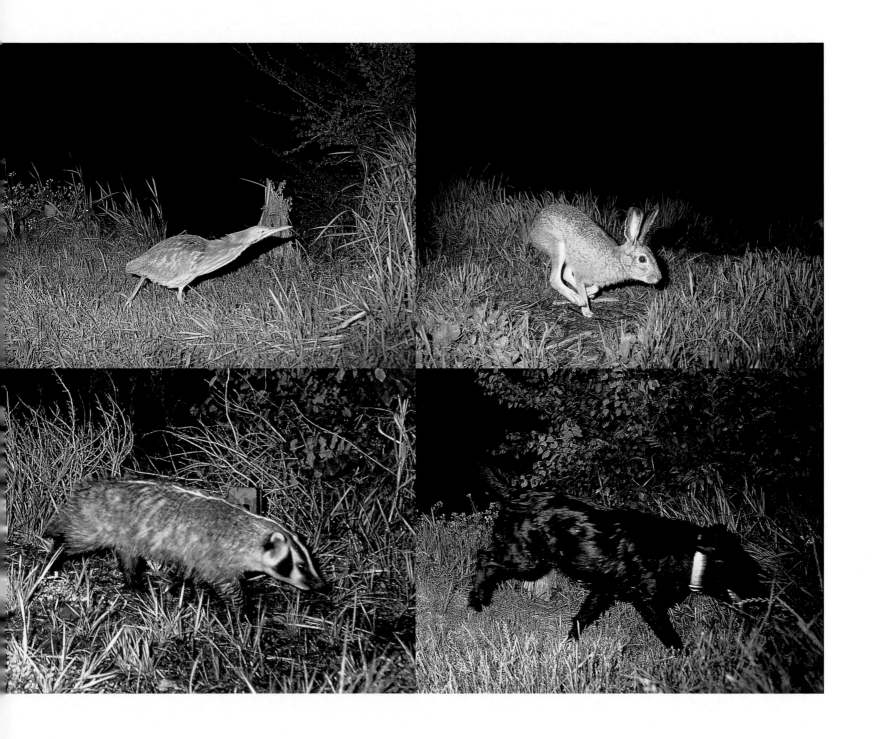

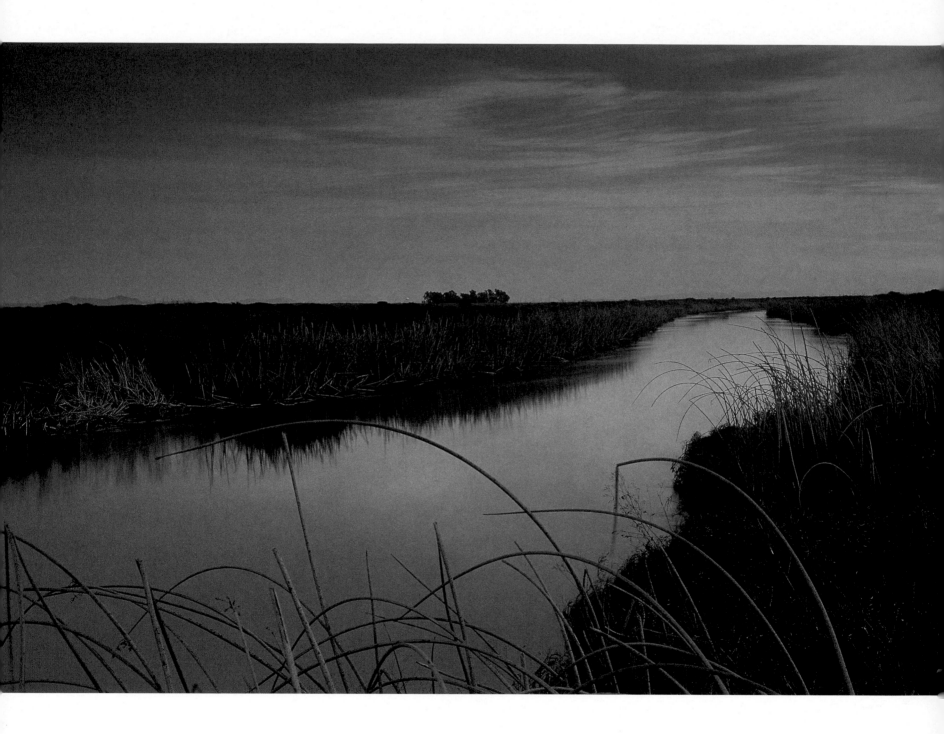

a little something about great horned owls as neighbors. Apparently instinct did not.

The red-tail chicks hatched. We watched from the hillside as they grew. They moulted their long, grayish first down for their woolier, whitish second down. It began to seem that the hawks had worked out some kind of truce with the owls. Then one night the horned owls destroyed the nest and ate everything in it.

By the end of May, the owlets were big enough to be left alone for long periods while both parents hunted. On June first, pausing on the east levee opposite the the eucalyptus of the owls, I raised binoculars and glassed the branches and the foliage of the tree. I could see no trace of either owl. Only the two owlets appeared to be at home. With the adult birds gone, I could visit the base of the tree with a minimum of disturbance. I did so, searching the ground beneath the nest for bones or owl pellets.

In their gizzards, horned owls and other raptors shape undigestable material — bones, beaks, claws, teeth, fur, feathers, the exoskeletons of beetles — into a bolus, or pellet, and vomit it up. The owl pellet is typically gray and sausage-shaped. The scouring action appears to be beneficial to the gullet, as captive raptors fed pure meat do not thrive. Owls and hawks seem to like retaining the pellet in the gullet. The sight of a living mouse or other prey stimulates the owl to disgorge the pellet, clearing the alimentary canal for action. Horned-owl chicks begin forming their first pellets at one week old. The owlets retch, lean forward, and proudly cast the pellet out. Break up owl pellets in your fingers, freeing the mouse ribs, muskrat molars, sparrow beaks, bluejay claws, and beetle wing-covers from their matrix of hair, and you get a good idea of what the owl has been eating. Sometimes your researches even reveal the individual identity of a victim — chickadee 65290, or some such number — as aluminum bird-bands show up frequently in owl pellets. Under the eucalyptus I found nothing but a few white droppings. The owls had digested all the evidence.

There was a small noise in the tree above, and I looked up. I saw the male owl in silent flight from a branch. He had been in the vicinity of the nest all along. An owl's first flight feathers have a soft, serrate leading edge, to reduce the vortex noise of the slipstream over its wings and make for quiet flying. He must have betrayed himself by the tick of a twig or the simple displacement of air.

He left the shadow of the eucalyptus for bright sunlight over the little field adjacent to the marsh. He had the odd, truncated look of an owl in flight. Owls have large heads, but in the air the dish-shaped face so scrunches in on the short neck that the bird gives an impression of headlessness. He flew east-by-northeast along the base of the levee, low over wild mustard, mobbed as he went by red-winged blackbirds. The birds were drawn to him like filings to a magnet. The flock materialized from nowhere. I would never have guessed, before their magnetization by the owl, that so many blackbirds lived in this corner of the marsh.

"The owl by day / If he arise, be mock'd and wond'red at," Shakespeare wrote in *Henry VI,* and so it is in Sam Sebastiani's marsh.

As June advanced, the owlets strayed on farther and farther from the nest. They were now grown nearly as large as their parents, though not so dark and horny. One day they had sidestepped five feet away from the nest, in opposite directions along the bough. The next day they were fifteen feet away.

*Sonoma Creek at high tide, dusk*

Soon they had hopped to smaller branches, then had climbed up forks of those. Before long they had migrated to such extreme ends of the canopy that it took me awhile to spot them.

On June 19, Joe Sebastiani, tending his father's vines on the west shore of the marsh, told me he had seen the owlets flying the day before. If I made a noise under the tree, he suggested, I might see an owlet take off in a practice flight. I tried that, but nothing stirred in the branches above. The owlets and owls had flown — for good, it turned out. The trial flights were over. The owlets were out in the wide world somewhere, chasing after their parents, screaming the godawful, blood-curdling entreaty cries of the subadult horned owl. For several more weeks, they would pursue their mother and father like banshees, dependent on the adult owls for food and instruction, but never back in the home grove. We would not see any of these owls again.

The empty nest was a little sad. It represented a triumph, of course; a successful nesting. The two chicks had fledged and flown. Both smooth, dull-white, slightly glossy eggs were now off mousing on muffled wings over farther fields. But still the nest depressed me. It was now just a jumbled bunch of sticks.

My own youngest was twelve. This surely had something to do with the sadness. My son had jumped instantaneously from infancy to adolescence. It had happened, coincidentally, just this season. Biologists talk glibly of the long juvenile dependency period in animals that must learn a lot — wolves, whales, owls, human beings — but the truth is that the offspring are gone before you know it. The nest is empty before you've even begun to feather it the way you wanted. I had watched these young owls grow up. I had not realized, until now, how much those yellow eyes — owlet and owl — had focused the eucalyptus grove. The eyes had animated this whole end of the marsh. Now the grove was just a bunch of trees. The departure of the owls, two days before the summer solstice, signaled the end of spring.

*Female horned owl and owlets above the levee*

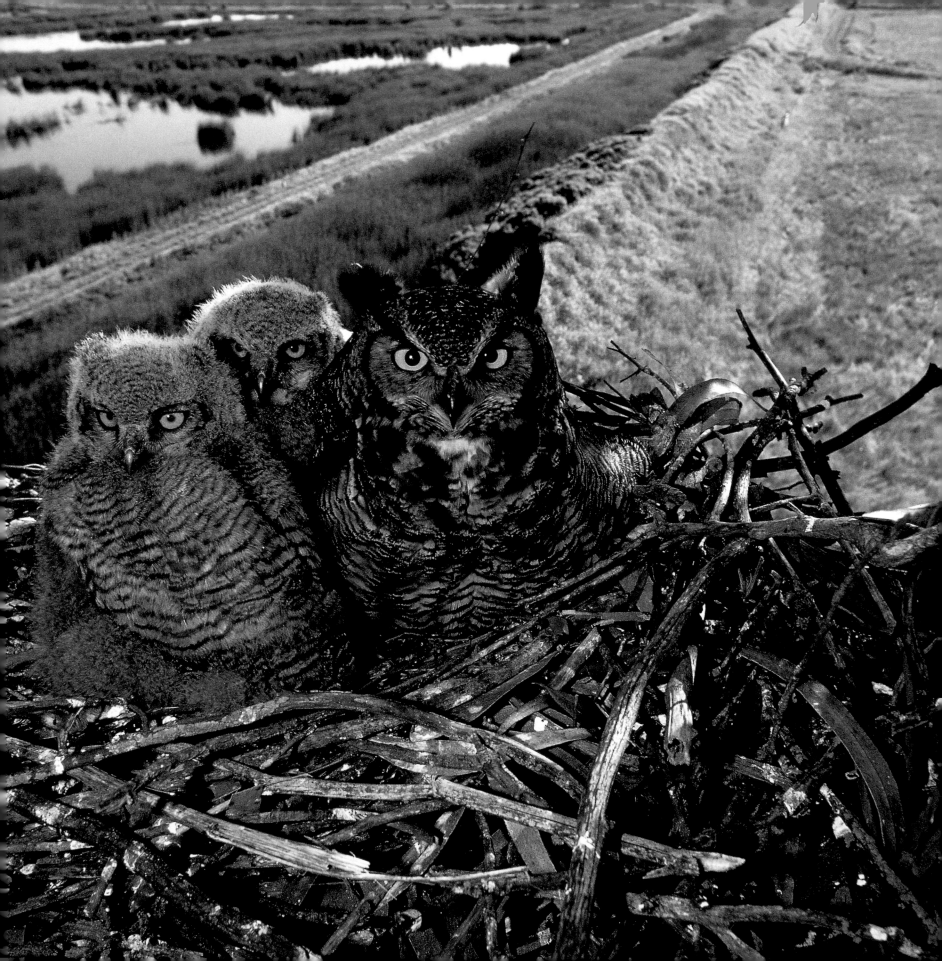

SUMMER

## Zugunruhe

In July the bulrushes began to lose starch. The proud, erect, fifteen-foot-tall culms of springtime commenced bending over on themselves. The cattails, too, lost their good posture. The reeds were fatiguing with age and the weight of perching egrets and herons. Marsh wrens, too, must have taken their toll. The long-billed marsh wren weighs almost nothing at all, but in its endless bulrushing up pairs of adjacent reeds, and its gleaning the culms at waterline for snails and dragonfly nymphs, and its launching itself from reedtops to hawk flying insects, and its binding reeds together as supports for dummy nests, each must have contributed to the decline of the reeds. The nemesis of the wrens, the red-winged blackbirds, weigh more and ride the reeds harder. Flashing red epaulets, singing *o-ka-lee-onk*, bobbing with the reed tip, the blackbirds stole the flex from the culms. The tules were worn out by song.

The curly dock on the levee turned scarlet-brown, the color of dried blood. A few late flowers of wild radish still bloomed, but they were lost in the general bristling of pointy radish seedpods and of star thistle.

A thickening soup of duckweed and pondweed stilled the surface of the marsh. Earlier, in the high water of springtime, the breeze had sent wavelets marching across the marsh, and gusts, racing one another to the other side, had stippled their traveling patterns there. Now the water jelled with vegetation. Light winds no longer left their mark. Each sort of waterplant calmed the surface in its own way. One species of pondweed, *Potamogeton nodosus*, floated its leathery, lanceolate leaves on the surface. Another species, *Potamogeton foliosus*,

floated its long, wiry, filamentous leaves. Water-starwort left its particular kind of dimpling, and marsh pennywort left its own. When you looked across the marsh into bright sun, you saw a complicated mosaic of textures. It was as if time had stopped, and sixty gusts of wind, each blowing in its own direction, had frozen on the surface.

Wading the marsh now was like striding through molasses. Your feet quickly became entwined and weighted with boots of pondweed. Sometimes by walking backward you could free them of these loads, but if you waited too long, and the pondweed boots grew too large, this technique ceased to work. You had to stop, stoop, grunt, rip the weed off by hand, fling it away in irritation.

The soup of the marsh was seasoned now with floating feathers — some pepper of wren and coot feathers, but mostly salt of egret. The white plumes and down of egrets drifted high and dry for a while, dazzling points of light, then became waterlogged and sank. As summer advanced, the proportions of feathers and flotsam increased: the shed skins of mosquito wigglers, dragonflies, and frogs; the floating corpses of minnows, tadpoles, crabs. The marsh collected the debris of its own fertility and grew a bit bedraggled. The once immaculate green of the reeds was now flecked and spattered everywhere with white guano.

The water was warm enough now that chest-waders were no longer necessary. I missed that tonic constriction of the waders under the pressure of the water — that feel of wearing hydraulic support socks — but for bare legs, on hot days, the cool embrace of the marsh was pleasant. Underwater tempera-

*Dragonfly nymph underwater*

tures varied. In a single step, you sometimes entered a zone that was almost cold. There was no predicting this underwater weather. The cold spots always came as a wonderful surprise.

The muskrats had broadened their diet to include spike-rushes, *Sagittaria*, water plantain, and assorted sedges, but they continued felling cattails. Their slash-and-eat agriculture left small clearings everywhere in the tules. As the season advanced, the clearings multiplied. Sometimes the felled culms of one clearing met those of the next, forming a T- or L-shaped raft. One day I found a whole muskrat city in the heart of a stand, an enormous floating platform of contiguous rafts. A single, industrious, stay-at-home muskrat might have been responsible, but more likely, I thought, was collabora-tion. It was as if the muskrats, solitary hunter-gatherers through winter and spring, had suddenly discovered society and civilization.

The season's first class of coot chicks was now in subadult plumage, gray with white bills. They were almost indistinguish-able from their parents, just a bit less noisy and opinionated. Flotillas of the first class of gadwall ducklings were on the verge of becoming ducks. They were as big as their mothers, and the cute little infantile bills of ducklinghood had grown out nearly to adult length. Even as the first classes of chicks graduated, new classes were matriculating. New families of baby coots, as colorful as parrots, and baby pied-billed grebes, filigreed like zebras, and baby mallards, cinnamon teal, and ruddy ducks con-tinued to make their appearances. The families of infants were always larger than the families of subadults, for attrition is high in the marsh.

Most of the migratory birds were long gone. The irritabil-ity that German ornithologists call *Zugunruhe*, "migration rest-lessness," had driven them on. The call of the North for birds is not a sound, but a sensation. It is a mood compounded of sun-light, starlight, and bird chemistry. A hormone produced by the pituitary gland, prolactin, in combination with corticosterone, their output regulated by photoperiod — the length of daytime and its light — stimulates fat buildup in migratory birds, enlarges gonads, and excites the itch to travel. The direction taken is guided by the stars. The constellations are full of mean-ing for migratory birds, a kind of signage across the night sky. Place captive migrants outside under the stars, they will face north in spring and south in fall. If clouds obscure the heavens, they will mill about randomly.

Two bay ducks that were common migrants through the marsh — the canvasback and greater scaup — were now up in the Yukon and the Seward Peninsula. The lesser scaup had traveled nearly as far. Two more bay ducks, the redhead and the ring-necked duck, had reached the high prairies of western Canada, where they breed. The sea ducks — common golden-eyes and buffleheads — were up in central Alaska. Barrow's goldeneye was working its way westward out the Aleutian Peninsula. The blue-winged teal had reached the British Columbia coast, the Yukon, and central Alaska. The wood ducks were up in Idaho and Montana and Vancouver Island. The shovelers had reached the northern plains and had spread through much of Alaska. The pintails were nesting throughout all Alaska and much of Canada.

Sunset in the marsh, for the birds left behind, now came at nine o'clock. Just before dusk, the red-winged blackbirds gathered to swoop in social clouds through the reeds — an ancient blackbird ritual celebrating the close of day. For the red-wings, seventeen hours of daylight was long

*Dragonfly nymph husk*

enough. For the long-distance migrants, it was insufficient. They had appointments at the top of the world, where summer days are endless.

The tundra swans were up in the tundra. The Caspian terns had reached Great Slave Lake and Lake Athabaska. The Canada geese were scattered throughout all Canada, save the highest islands of the Canadian Arctic. The brant had pushed farther still. Brant love high latitude and cannot seem to get far enough north. The western race had reached its nesting grounds along the northernmost margin of Alaska and the western islands of the Canadian Arctic. The eastern race was nesting along the northernmost margins of Greenland. If any land lay north of Greenland and Ellesmere Island, then brant would doubtless have tried nesting there.

Peninsulas tend to funnel migrating birds of prey. This is not because these fierce soarers *fear* open water, but because they save energy riding the thermals that occur over land. The Straits of Gibraltar make one such funnel, the Bosphorus another. The Golden Gate makes a third. Lofted along by thermals, merlins, kites, kestrels, peregrine falcons, bald and golden eagles, red-tailed, red-shouldered, broad-winged, rough-winged, rough-legged, and sharp-shinned hawks, and various other raptors have been crossing the Golden Gate since this strait opened. On reaching the other side — the Marin Headlands, in the case of the spring migration — the concentrated hawks disperse again as the birds fly northward toward their various destinations.

Most migrants through the marsh had gone untagged, nameless, numberless. The flocks of swallows, foraging on the wing and pausing hardly at all, had reached their destinations. The red-necked phalaropes were scattered across the Bering Sea and Chukchi Sea, converging on their tundra nesting grounds. The armies of shorebirds — greater and lesser yellowlegs, long-billed and short-billed dowitchers, willets, sandpipers, whimbrels, curlews, godwits, dunlin, snipe — foraging by day and traveling by night, had worked their way far to the north. Many had outdistanced the night, finally, reaching the latitudes of perpetual light and traveling the last miles, of necessity, by day. They were up with the snowy owls, caribou, and barrenground grizzlies. There had been a kind of metastasis of Sam Sebastiani's marsh. Its elements were scattered now across much of the Northern Hemisphere.

*Canada geese in night migration*

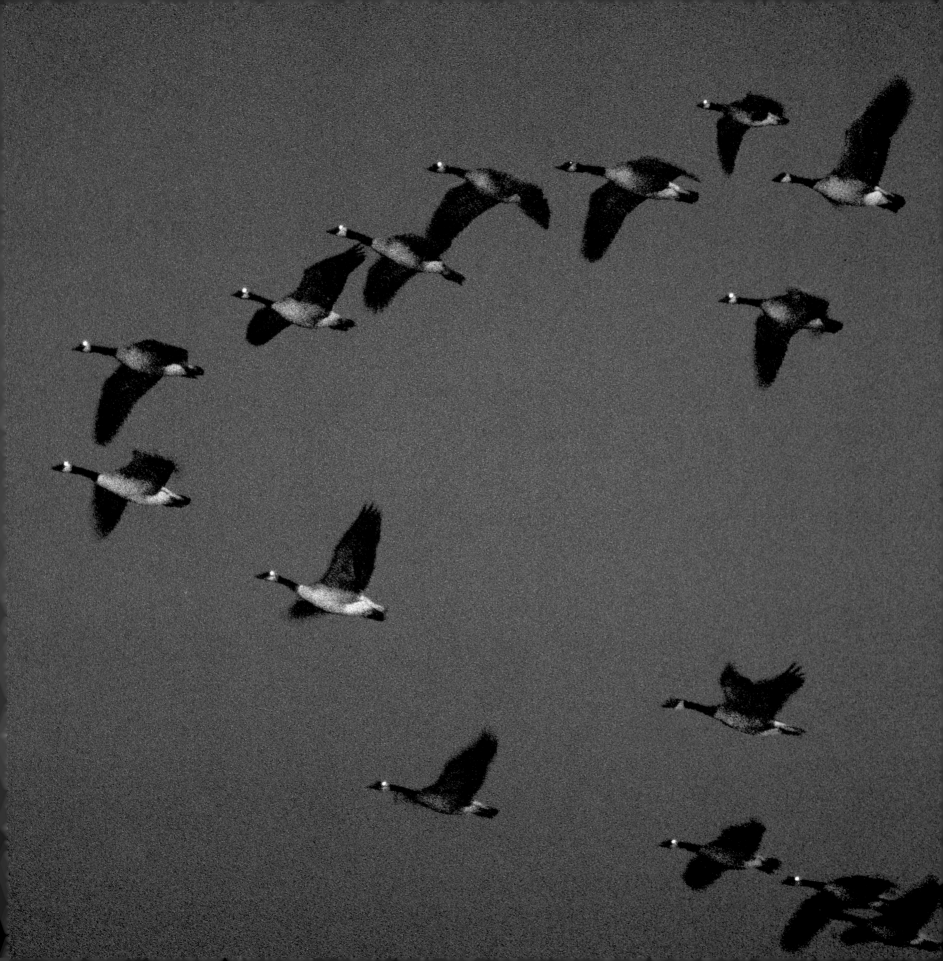

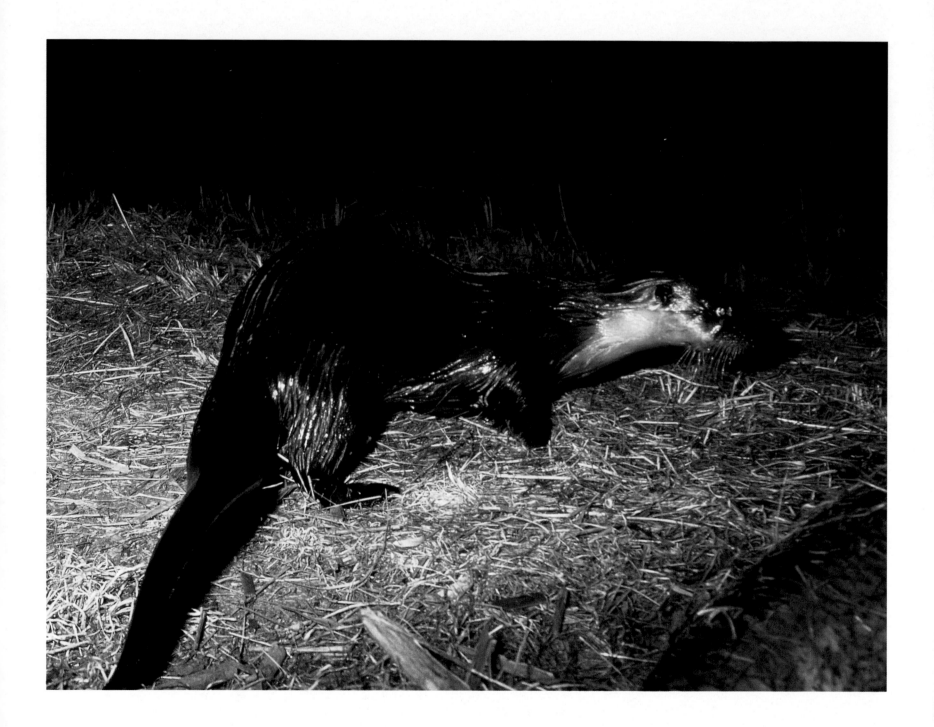

## Otter

Three otter appeared in the north. They were working southward down the channel that drains the eastern end of the Plain of Cline. Their sleek heads and backs broke the surface of the brown water, then curved back under. They were the first otter I had seen in the marsh — the only otter I would ever see here — and on first catching their motion out of the corner of my eye, I mistook them for the glistening fins of fish.

I was surprised by the otter. I knew they were here, of course. On visits to the marsh, my habit had been to scout the otter runs across the levee, following the narrow swaths of flattened grass their low-slung bellies had laid. I had studied the otter tracks. I had admired the faint tracery of webbing around the hind-toe prints in shoreline mud. I had regularly checked the chute of the otter slide into the Sonoma Creek slough for evidence of traffic. I had crumbled otter scat in my fingers and poked through the bones of otter kills. I had even seen photographic evidence of otter. The remote camera of my colleague, Michael Sewell, had captured flash portraits of otter at night. Yet until this moment I had never quite believed in them. These were *river* otter. Did they really belong in this marsh? And so close to civilization? In daytime?

These were otter, all right. Otter enter any scene with a kind of commotion impossible for fish. They swam my way with the élan that characterizes the Mustelidae, the great family of the weasels, as surely as broad skull, elongated body, and short legs characterize the group. The largest otter, surfacing opposite me, rose waist-high out of the water to look me over. In whales this is called "spy-hopping." In otter the spy-hop is hoppier, more expressive, thanks to lesser bulk and greater flexibility of spine.

The spy-hop of this particular otter was ambivalent. The otter was caught in a psychomachy, as the Greeks called it: a struggle between body and mind. Even as the otter's face turned toward me, full of curiosity, its body was twisting away with apprehension. Its whiskers were brought to a single point to either side, like watercolor brushes just lifted from the glass. I saw the blue, cataractlike glaze of its water-adapted eye. The otter's small weaselly ears, which lie streamlined alongside the head when it is swimming, had popped outward to catch any sound I might make. The otter hung for a moment at apogee, then sank back through the ring of bright water its spy-hop had made.

A smaller otter, having passed me underwater, swam back on the surface to examine me, very bold and unafraid. I made the mistake of speaking to it, at which it ducked back under. That was the last I saw of the three. The channel was a very confined body of water. I could see every inch of it, all the way back to its bend into the grass of the floodplain to the north. The otter must have resurfaced somewhere to breathe again, but they can do so very unobstrusively, and I missed it.

The otter is the most widespread carnivore on earth. The American river otter, *Lutra canadensis*, ranges virtually the whole of the New World, at home everywhere but the High Arctic and the the Sonoran and Chihuahuan deserts. In South America, the "Canadian" otter is comfortable everyplace, occupying the entire continent from the Mayan jungles to the tip

*River otter*

of Tierra del Fuego. The American otter's close cousin, the Eurasian otter, *Lutra lutra*, has an even wider historic range: from Ireland east to Japan and Korea; from the Scandinavian Arctic south to North Africa, Indochina, and Sumatra. A more distant cousin, the spotted-necked otter, ranges most of Africa south of the Sahara.

That sleek head spy-hopping above Viansa Wetlands, those sharp, wet mustaches, spy-hop above the marshes of Albania, the fiords of Norway, the black tannic waters of the Rio Negro in Brazil, the wadis of the Moroccan and Tunisian desert, the concrete irrigation channels of Israel, and the waters of the Amazon, Brahmaputra, Congo, Danube, Ganges, Mekong, Mississippi, Volga, Yukon, Zaire, and countless tributaries. It should have been no surprise to meet that face in Sam Sebastiani's marsh.

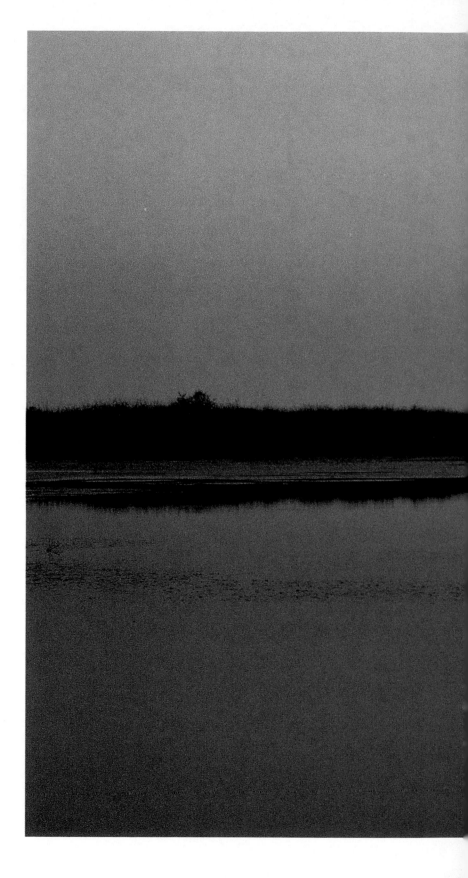

*Moon over Viansa Wetlands*

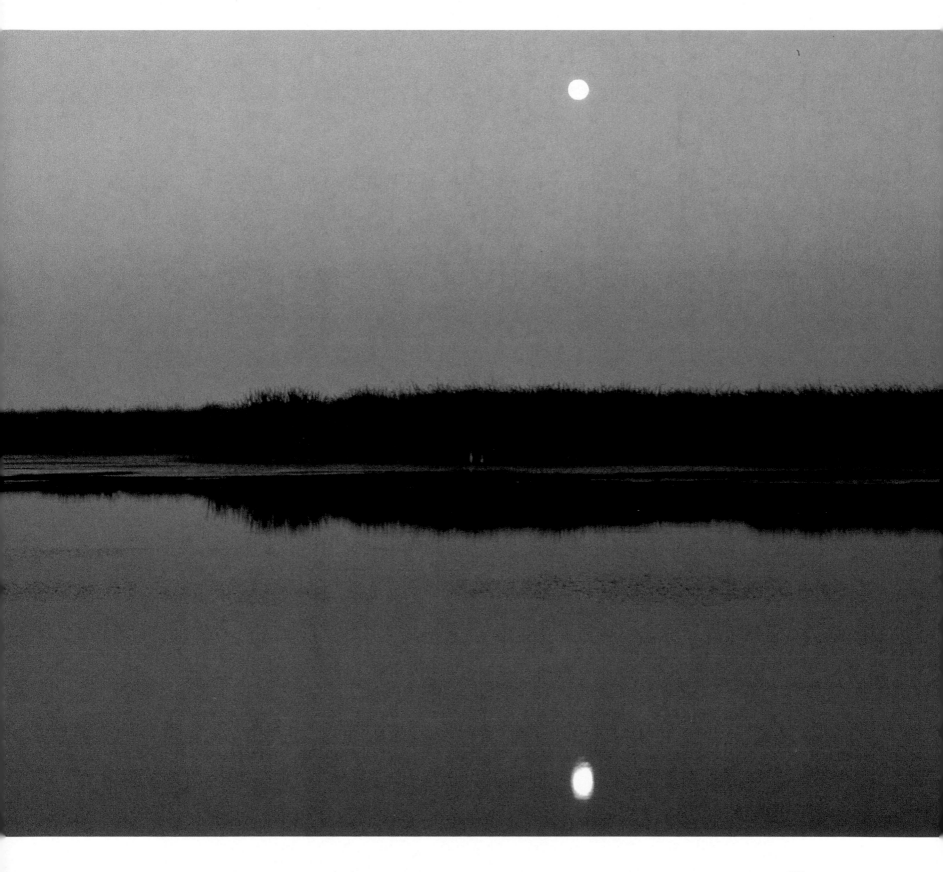

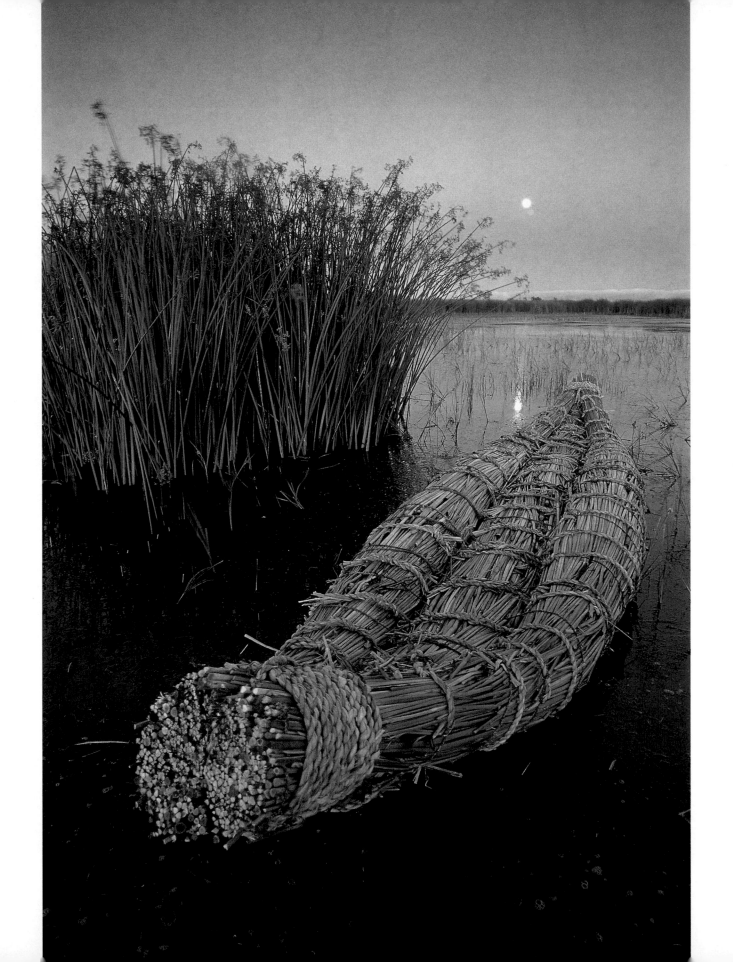

## Balsa

We lifted the tule balsa off the roof of the car and bore it regally, on its palahquin of two-by-fours, through the bulrushes of Viansa Wetlands. The local Indians who built these reed boats — the Ohlones and Coast Miwoks — did not design them to be dragged about. Unbuoyed, the balsa is vulnerable to gravitational stresses, like a whale out of water.

Portaging the balsa was no great chore. It was fifteen feet long and girthy, yet its dry weight was only 120 pounds. Across from me, sharing the load at the front of the pallet, was Charles Kennard, the transplanted Englishman who had harvested and built the vessel. Working from drawings of Ohlone canoes at the Bancroft Library, Kennard cut his tules — the California bulrush, *Scirpus acutus* — then dried them for a couple of months, along with enough cattails and California hemp to make 200 feet of cattail rope and 200 feet of hemp twine. With this cordage, Kennard bound his bulrushes into three bundles, then lashed the bundles together into a tripartite hull. He wet the bundles at either end to achieve the upcurved bow and stern that graced this design from Tule Lake to Titicaca.

The upturned prow parted the upright culms of the bulrushes. With a faint rubbery rasping, the dead, bundled bulrushes of the balsa slid past living bulrushes and into the water. We waded the boat out into Viansa Marsh, then withdrew the boards of the pallet from underneath. It was a double return: the balsa back to the domain it formerly ruled; these particular rushes back to the landscape where they germinated.

Before arrival of the galleons, the tule balsa was the commonest vessel in California. The canoe-made-of-rushes occurred not just where one might expect — in the marshy central valley and along the central coast — but also on the east side of the Sierra, among the Mono Paiutes and Shoshone, and up in the dry northeast corner of the state, among the Modoc and Northern Paiutes, and down in the parched hills of the extreme south, among the Kamia and Diegueño, and along the Colorado, among the Mohave, Yuma, and other desert bands. The ubiquitousness of the balsa testified to the vastness of California's old sea of reeds.

Charles Kennard and I waded his reed canoe out through the Viansa duckweed. The balsa was beautiful. It had the elegant simplicity of a Pomo basket or a Yurok basket-trap. I found it particularly lovely at its upcurved ends, where the cylinders of the bundles, their butts sheared off clean, showed the bulrush stems in cross section. I sat gently in the bow and lifted my legs in cautiously, expecting some tippiness. There was none. The balsa sat very stable in the water, as solid as one of those bulrush-woven "floating" nests of a coot or grebe. I felt a pleasant longitudinal flex in the bundles as the boat took my weight. The balsa felt alive, like some sort of steed. We poled out through the duckweed, then took up our paddles. The balsa was not very responsive. A certain lethargy in performance was the trade-off for its stability in the water. Eventually, though, the vessel obeyed our paddles. The Ohlones had no great interest in hot-rodding around their marshes, but they got where they needed to go. We set off across open water at the center of the marsh.

This was, it struck me, an auspicious voyage. This was a fine way to be paddling into the new millennium — in a resurrected tule balsa, across the waters of a resurrected marsh.

*Ohlone reed canoe*

# Bedlam

One of the cardboard boxes in the back of the pickup read "Please Handle with Care. Glass." The contents were no longer glass, in fact, but they remained fragile, and care in handling was still required. Another box read "Kunde Estate Winery" — an appellation deep in enemy territory, as the truck was easing down the gravel road through Viansa vineyard, toward the shore of the marsh. At the wheel was Stewart Young, a middle-aged, mustachioed Englishman who leads tours of Viansa Wetlands. In the back of the truck, seated on a side panel, was me. I gently hefted several of the boxes. The weight was negligible. No cheep or squawk emanated from within. The boxes were so light that I could not have testified with certainty that they contained anything at all.

We parked just inland of the western cattails. Nancy Summers, co-founder and director of the Wildlife Center for Disease and Toxin Investigation, pulled up and parked behind us. In caravan with her were two assistants, and behind them came Michael Sewell, who pulled his tripod and camera out of his car.

Under Summers's direction, Stewart Young and I carried the nearly weightless boxes down to within fifty feet of the water. Sewell set up his camera a short distance away, half-hidden by a small stand of cattails, and I took cover beside him. Stewart opened the first box and carefully unwrapped the young, towel-swaddled snowy egret inside. The bird spread its white crest in the sunlight, hopped from the box, and quick-stepped toward freedom in the marsh. Stewart opened the second box. In this one, the egret had already shrugged its towel. It wasted no time

flapping off, taking wing in the same direction the first bird had taken foot.

Nancy Summers is a small, slender woman built along heronlike lines herself. Her hair was in a pontytail, over which she had pulled a baseball cap. She regarded the marsh with bill forward and blond plume behind, like one of her birds. If you had to place her somewhere in the Ardeidae, the family of the herons, it would not be at the big end, with the great egret and great blue heron. She is assembled more on the modest scale of one of her snowy egrets. She suffers from maternal anxiety about the birds she has rehabilitated. As Stewart Young prepared to open a third box, Summers cautioned us about releasing her snowies too close to water.

I could not help but smile. Worrying about an egret in water is like worrying about a falcon in air.

The Wildlife Center for Disease and Toxin Investigation is a small Sonoma County nonprofit, founded by Summers in 1987, and funded by donations. None of the staff is paid. Summers has a degree in environmental design, not in veterinary medicine, but the rehabilitation work has pulled her in irrevocably, and she has become a species of bird doctor.

"Last year we released eighty-five snowy egrets and night herons here," she said, waving out at Viansa Wetlands. "We released a couple of green herons here, too, and a pair of harriers. Viansa Wetlands is a really good spot. You aren't too close to the road. There are wetland areas running from here clear out to the bay. No hunters. No dogs."

I suggested to Summers that this must be a difficult

*Snowy egret*

moment — each of these farewells to her patients. She denied it. "As soon as they're well, they're out the door," she claimed. The next class of sick and injured herons was waiting back at her center, along with a red-shouldered hawk in need of beak realignment and assorted other feathered patients. She could now concentrate her attentions on those.

The birds we were liberating today had all come from a rookery on the grounds of Napa State Hospital for the Criminally Insane. A chain-link fence, fourteen feet tall and topped with razor wire, surrounds this institution, but this has proved no obstacle to the birds. Hundreds of snowy egrets and black-crowned night herons nest above the hospital in tall pruned oaks. The snowies perch highest. In heron rookeries this seems to be their prerogative. The white egrets — the great egret and the snowy — routinely displace other herons from the top branches of roosting trees.

If there is some safety for herons behind the fences of Napa State Hospital, then that safety is only relative. A fledgling egret or night heron in the asylum cannot afford a single misstep in the high branches of those radically pruned trunks. A fall is likely to injure the bird, and, injured or not, it cannot climb to safety again. Each morning of the nesting season, the ground under the oaks is covered with guano and scattered with dead or damaged birds. The hospital protocol is to have all the fallen herons picked up each morning, dead or alive. The collectors of herons is usually a groundskeeper, Wanda Hudspeth, a hospital employee who always felt sorry for the birds, and who, on learning the aims of the Wildlife Center for Disease and Toxin Investigation, was immediately sympathetic. Anyone accompanying Wanda, or filling in for her, must go in a Napa State Hospital vehicle, and must avoid wearing brown.

"They don't want to confuse you with the criminally insane," Summers explained.

The asylum's big rookery, and the mysterious maladies afflicting it, have become Nancy Summers's principal concern. The failure rate of the nests is alarmingly high. The victims collected from beneath the nesting oaks suffer from aspergillosis, heavy parasite loads, folding fractures, salmonella, grossly enlarged livers, abnormal pancreatic function. Summers suspects environmental toxins must play a role, but she has been unable to determine which ones. With sick birds it is hard to find any smoking gun. Toxin damage often occurs in the egg, with no trace of the poison remaining in chick or adult. Summers has performed dozens of necropsies without solving the mystery. "We have a thick book of necropsy reports back at the Center," she said. Holding her thumb and forefinger five inches apart, she indicated the thickness of that grim tome. "Your first thought is, *Are we doing something wrong in caring for them?*" she said. She seemed to consider, afresh, this possibility — that the fault might lie with herself — then dismissed it for the hundredth time.

"Any intuitions?" I asked her. "Any guesses what the toxins might be? Where the birds are ingesting them?"

"Snowy egrets eat stickleback minnows here," she answered. "Night herons eat crayfish." She paused, stumped before she had really begun. Those two dietary items didn't seem to add up to anything. "The Napa River is grossly polluted . . ." she began again, but trailed off, leaving that idea, too, unfinished.

In nesting season at Napa State Hospital, the warden erects temporary fences around the rookery oaks to keep patients from contact with fallen herons. Some of the inmates

suffer from pica, the compulsion to put everything in the mouth. (All two-year-olds are victims of this malady, but by adulthood it is confined to the truly insane and places like Napa State Hospital.) Aspergillosis, salmonella, and assorted unidentified environmental toxins are not the sort of smorgasbord the warden wanted laid out under his asylum oaks. He was happy to see the birds go off to the Wildlife Center.

"The birds are lemons for the warden," said Summers. "We are able to help him make lemonade."

From a fourth box, Stewart Young lifted a juvenile black-crowned night heron. Chunkier and noisier than the egrets, it feinted, as if to spear Stewart's hand.

When it was gone, Stewart unswaddled another snowy egret. Uttering a small croak, the bird lifted off and flew to freedom.

I imagined the bedlam from which this egret had come: the low croak of individual birds in the asylum rookery; the burbling *wulla-wulla-wulla* that colonies of snowy egrets make in chorus; the *qwawk!* and *quark!* of black-crowned night herons; and the unhappy human laughter, muttered monologues, and wild cries of the deranged. *Madhouse herons*, I thought. The madhouse heron, maybe, was to be the new mineshaft canary. When your asylums fill up with the criminally insane, *and then herons begin dropping dead from the asylum trees*, something is rotten in your system.

Stewart liberated a fifth and final snowy egret. As he lifted away its towel, the egret spread the white feathers of its crest. That crest, along with the recurved plumes on the bird's back in breeding season, are the pride of the species, yet nearly were the end of it. The egret took a tentative step forward, in the stealthy way of egrets, then flattened its crest and dashed pell-mell for the marsh.

We carried the empty boxes back to the truck. Bringing up the rear, I followed the several lines of bootprints our little expedition had left in the mud. We crossed the trail of a raccoon, the big tracks of blue herons, the smaller tracks of black-necked stilts. As I studied this muddy calligraphy, I found myself wondering: Had Sam Sebastiani realized, in restoring his marsh, how many trails would converge here? Had the winemaker guessed what a rich place this would be? *Bird pond* had been his first thought. He had intended a wetlands for waterfowl, but it had quickly become more than that. Muskrats had come uninvited, as well as otter, turtles, and frogs. Coyotes, skunks, and racoons had come, arriving after dusk to hunt for duck nests along shore.

Badgers had come — or one badger had, at least — the animal caught one night in the flash of Michael Sewell's remote camera.

Sewell himself had come. Sebastiani cannot have guessed that his marsh would attract a resident photographer. Sewell, in camouflaging his camera blinds with wetland vegetation, and in disguising his person with those same reeds, and in quacking in various duck tongues through his assortment of duck calls, had worked himself into the very fabric of the marsh. Assuming the identities of the meek of the marsh, as he mimicked their distress cries to call in predators, he had blurred his boundaries with this piece of terrain. He had become a kind of marsh creature himself.

Stewart Young had come. Behind Stewart had followed the marsh tourists he leads along the shore each month. Joe Sebastiani had come. Joe's job was to maintain the levees and pumps, and he was better acquainted with these reeds than anyone. And I had come; me and my notebooks. And Andy

*Overleaf: Egrets over the marsh, hawks's-eye view*

163

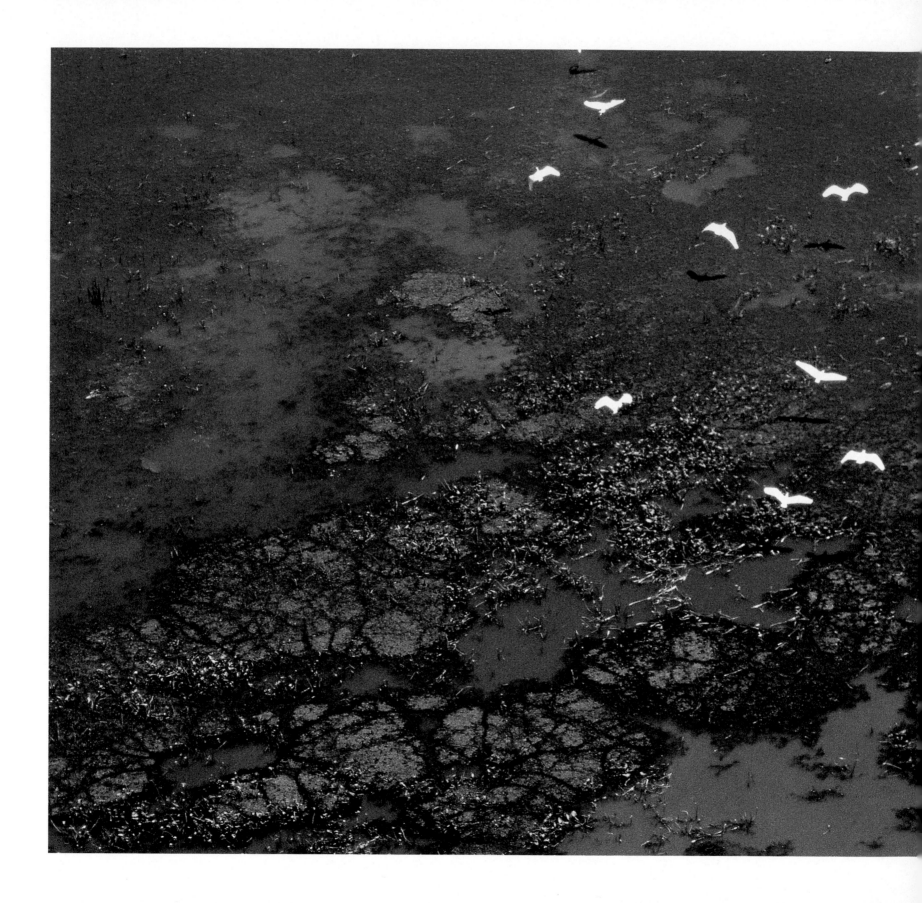

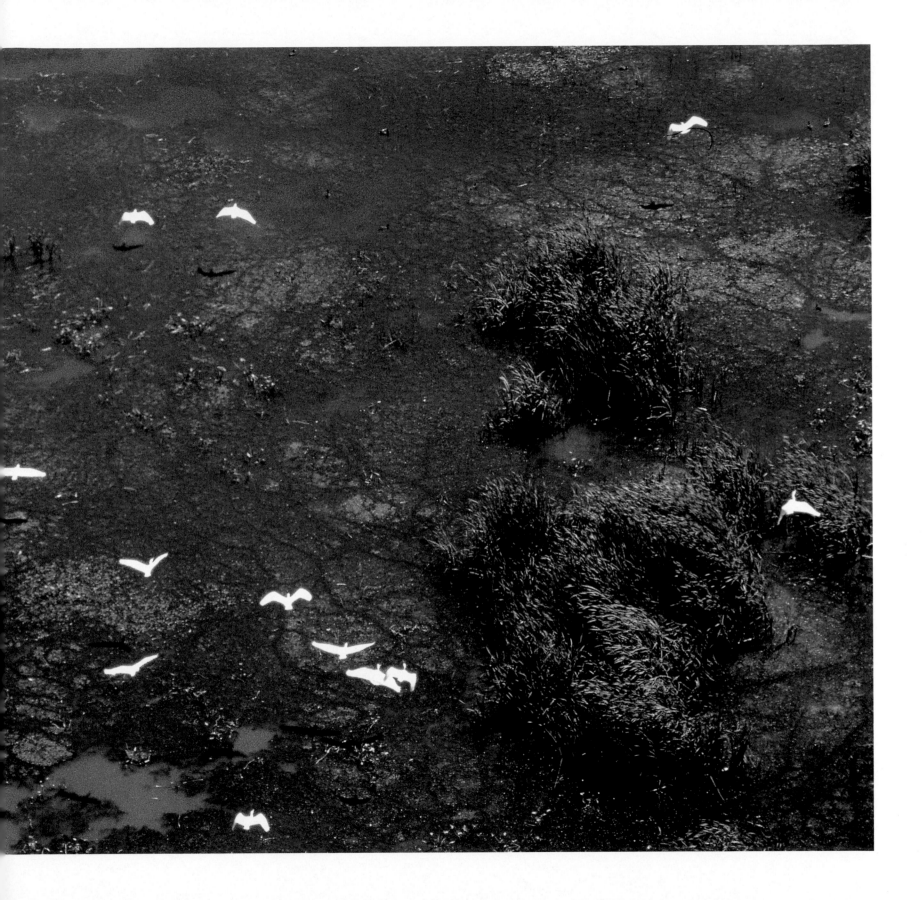

Engilis, the Ducks Unlimited biologist, along with *his* notebooks. For five years Engilis had monitored the marsh, documenting the return of diversity here. He was on a first-name basis with the flora, "swamp timothy, *Crypsis schoenoides*, at a frequency of 5.3%, water plantain, *Alisma triviale*, at 1.47%," and so on. A surprising number of humans drew sustenance, in one form or another, from Sam Sebastiani's marsh.

Nancy Summers had come, bringing her boxes of birds.

Can Sebastiani have foreseen that a Nancy Summers would show up in his wetlands? I doubted it. How could the winemaker have imagined that his marsh would become a halfway house for rehabilitated birds? He might have visualized the marsh as a kind of cornucopia out of which wildlife would tumble, but he cannot have foreseen that it would double as a funnel for the injection of wildlife back in.

*Snowy egret stretching*

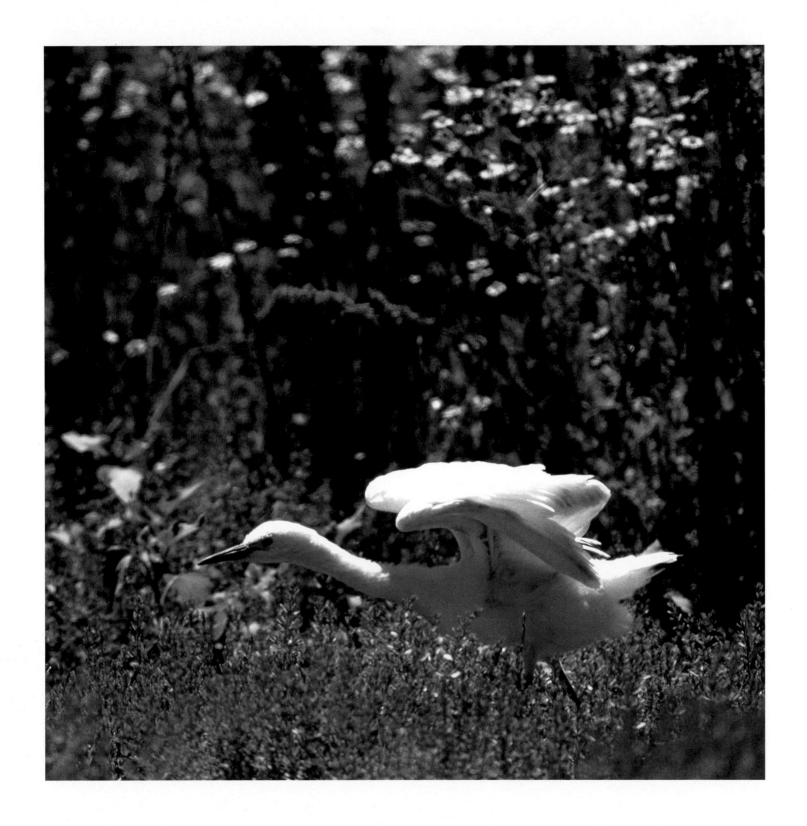

# AUTUMN

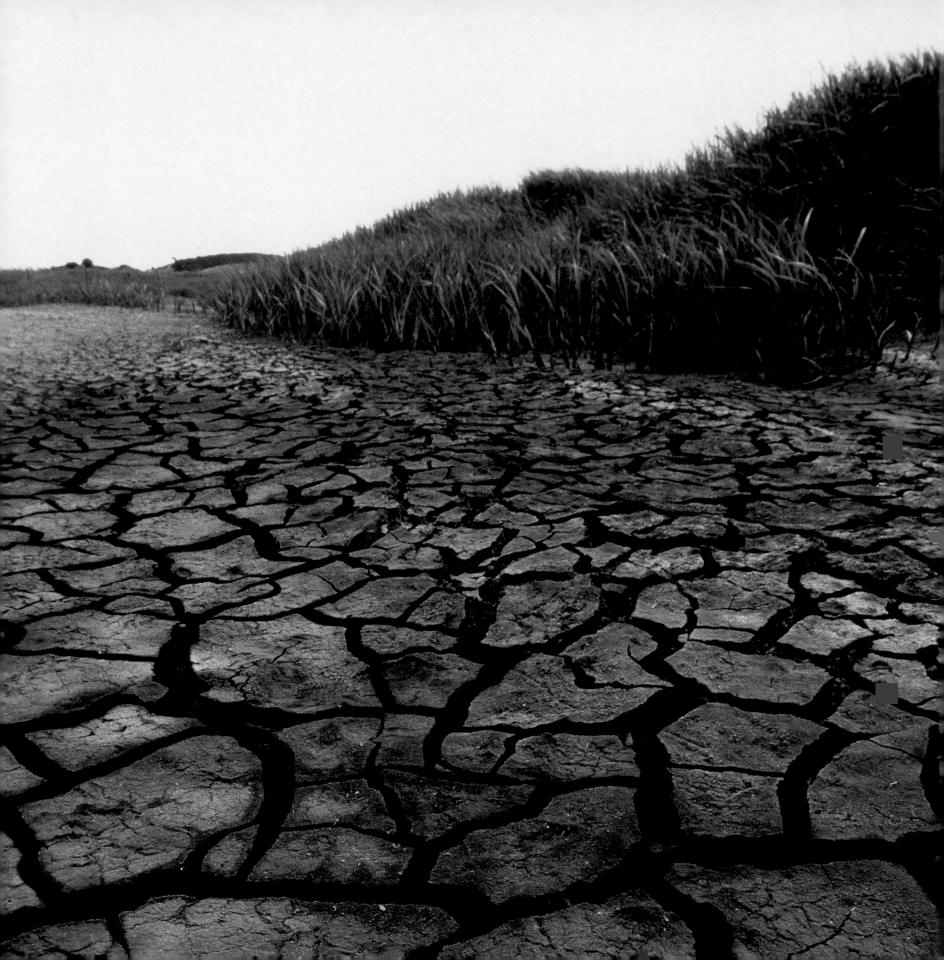

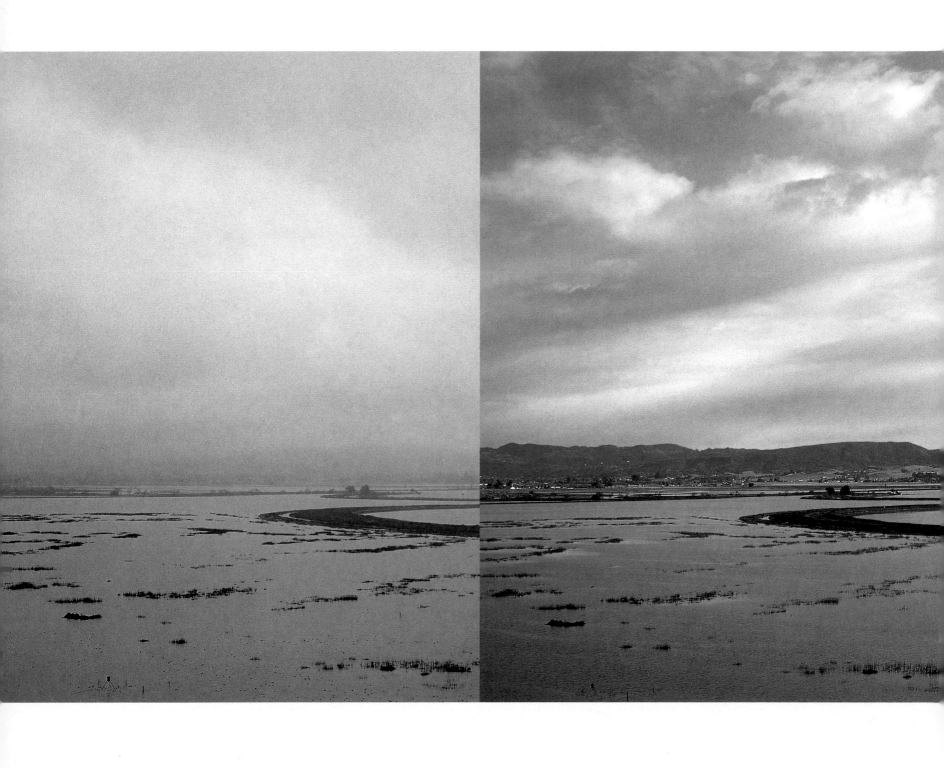

## Angel of the Marsh

By October, the marsh was dry except for its deep northern bay, a few small central pools, and the channel along the east levee. The meadows of pondweed and algae, as the water drained from under them, had come to rest on the bottom. The floating flora lost its third dimension. It dried and compressed to a kind of papier-mâché, a natural papyrus, that covered most of the shallow basin of the marsh. In the papyrus mat only the faintest hint of green remained, the same doubtful color you see in leaves pressed between the pages of a book. Back in summer, the living weed had formed heavy mukluks around a wader's feet, impeding progress. Now the papyrus — a thin, sunbaked crust of pondweed mâché — made a faint, resonant drumbeat under your shoes. With the edge of your sole you could scuff up a roll of it, exposing the mud beneath.

Receding water concentrated most of the marsh's frogs in the eastern channel. They bobbed up for air by the hundreds, each with a quick gulp — nose and eyes above the opaque water — then a plop back under. The plopping patterned the channel surface everywhere, like rebounding raindrops in the shape of frogs. The frogstorm pittered and pattered under cloudless skies, unnatural and ominous; an Egyptian plague on Sam Sebastiani's marsh.

One day an army of two hundred white herons — great egrets and snowies — appeared in the northern bay of the marsh. They worked their way along the bay's margins, then southward down the channel. White dress was required. There was not a single blue heron among them. Dazzling skirmish lines of egrets made easy pickings of the fish and frogs trapped in the shallows. They ended the Egyptian plague on the marsh. When I visited days later, only a few token frogs remained.

Here and there on the papyrus crust of the marsh bottom, wide-scattered, lay the skeletons of carp and empty carapaces of crabs. The crabs had ventured across the levee from the adjacent brackish universe of the Sonoma Creek slough. This had been a miscalculation. The tides in Sebastiani's marsh are seasonal, not diurnal, and the crabs were left high and dry.

As the marsh dried, some of the crayfish returned to Sonoma Creek, from which they had migrated into the wetlands. Others fled the sun downward, tunneling after the subsiding watertable until they reached moist mud in which to estivate.

Everywhere on the dry marsh bottom, in various stages of mummification by the sun, were the corpses of metamorphic tadpole-frogs. The tadpoles had hatched too late in the season. They had fed well enough — their unresorbed tails were thick and fat — but they had migrated in the wrong direction as the water vanished. It was surreal, like something out of Magritte or Escher: those rebounding raindrops in the shape of frogs; metamorphic tadpoles, caught and mummified halfway through the door to froghood.

In summer I had abandoned my chest-waders. Now I gave up shoes. The mud tended to suck shoes off, and the simplest thing was to go barefoot. When you crossed dry stretches of the bottom, the pondweed mâché was very pleasant under bare soles: a lightweight, papery tarmac. Your footfalls were faintly vibrant and tympanic there. Sometimes you broke

*Dry marsh bottom*
*Overleaf: Winter, spring, summer, autumn*

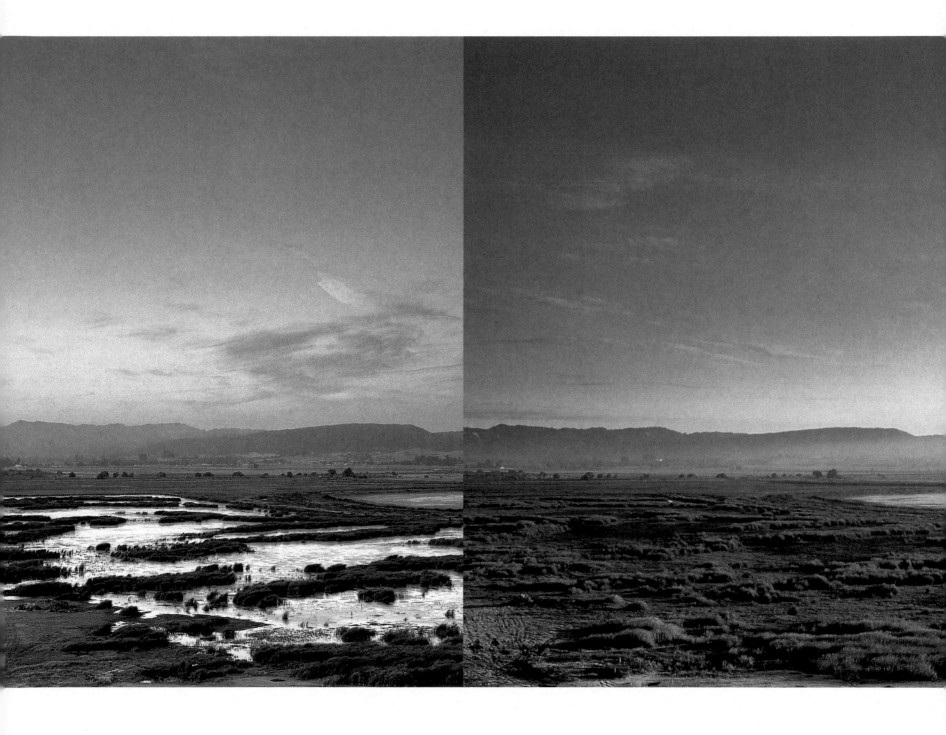

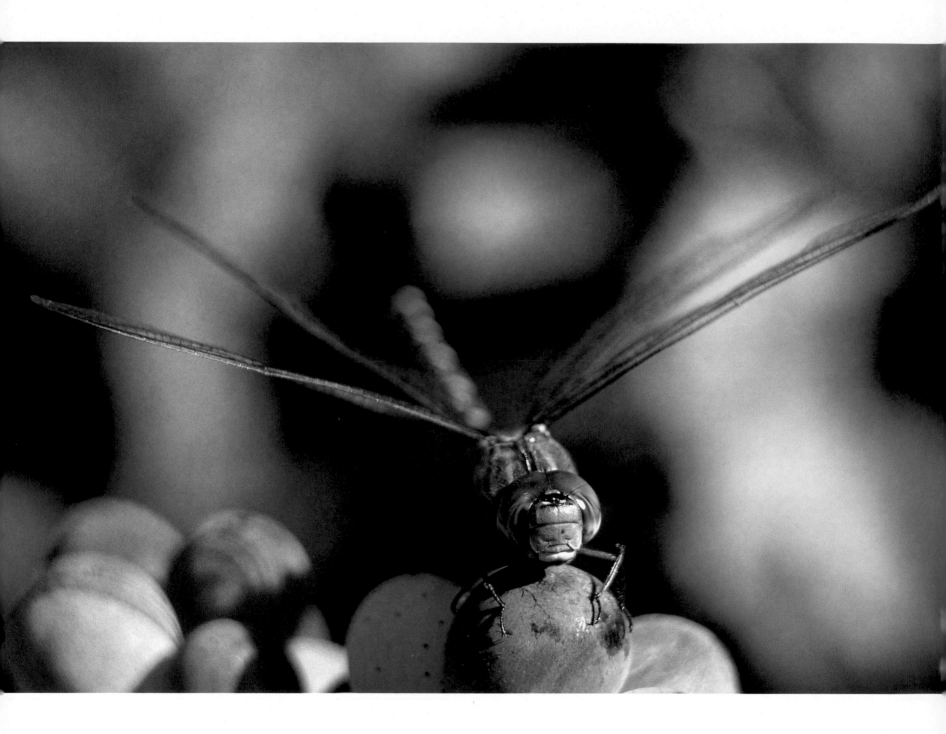

through the crust with a small satisfactory crunch and left a footprint behind. The zones of bare mud were agreeable between the toes. Generally you could walk lightly across the surface, slip-sliding a bit, but staying on top. The mud had a blue-gray patina of algae, marred behind you by the line of your slathery black footprints. Its consistency was unpredictable. Occasionally you plunged in knee-deep, or sank to mid-thigh. You struggled out wearing long, shiny-black, malodorous stockings. After ten minutes in the sun, the shininess of the stockings was gone. They still smelled — that good, noxious, mucky, anaerobic, almost fecal odor of marsh fertility — but they dried to a grayish black. Unless you renewed your black stockings by plunging in again, the smell faded a bit. At day's end, up in the vineyard by the toolshed, when you turned the hose on yourself to scrub the stockings off, the smell returned full strength; a powerful and evocative *essence de marais*.

The channel continued drying. Soon it was only an inch or two deep — a shallows of blue-gray water edged by ever-widening shores of blue-gray mud. It ceased to be a channel and became a row of linear ponds. Most of the surviving frogs had left, hopping away someplace else, or burrowing into mud banks to estivate. A few metamorphic tadpoles remained along the shore. Their frog foreparts — fingers and toes — were splayed on mud, their tadpole tailparts half submerged in opaque water. At the approach of a walker, they dove into what was left of the channel and shot away. Wispy black contrails of stirred-up mud marked the escape routes. Sometimes you missed the tadfrog itself, but you always saw its contrail. It was detectable, like one of those atomic particles that leave smoky trails in cloud chambers. The contrails hung for ten minutes, twelve, then finally settled out.

At the southern end of the marsh, mounds of pomace —

the residue of grape pressings — stood here and there on the dry bottom. Geese love pomace, Sam Sebastiani had discovered, and after harvest he dumps hillocks of it here. Red wine or white, Canada geese seem to have no preference. Some of the mounds included stems; others were pure fruit. The pomace smelled of spoiled grapes, or stale dregs in a bottle. That saturnalian, morning-after-the-party scent carried an amazing distance downwind, where it warred with the powerful, resinous fragrance of tarweed — a heady battle, for the human nose — before finally losing out to the weed. Yellowjackets loved the pomace as much as geese did. On catching its breath-of-Bacchus perfume, they followed it upwind to the mounds, where they aggregated by the dozens. Skimming the slopes with the wavery, bouncing flight of yellowjackets, they seemed to search for something and not to find.

In the vineyard above the marsh, the vines were bare of fruit. Except for a few stray bunches missed by the pickers, the grapes were now new wine in barrels underground.

One warm October day, a bunch of pilfered grapes in hand, I crossed dry, cracked mud at the southern end of the marsh. The grapes were good but very seedy. You had to eat them as a bear eats berries — shove in a whole cluster at a time, masticate, then spit out the wad of pomace. On the hilltop, outside the Viansa tasting room, the flagpole lanyard clanked in the breeze. I glanced up to the Tuscan villa of the winery; remembered the cool caves that Sam Sebastiani had dug underneath; recalled a lesson in oenology he had given me up there. The great barrels had stood in their rows. Under the dim, vaulted ceilings, Sebastiani's voice had a cavernous echo. The virtue of caves, he had said, is that their humidity keeps barrels tighter. This softens the wine,

*Dragonfly on grapes*

for all that escapes tight barrels is alcohol, what winemakers call the "angel of wine."

The marsh had an angel, too, it struck me. The volatile element here was not alcohol, but water. The drying mud underfoot was a *craquelure* of polygons, the edges of the cracks curling up. The angel of the marsh had flown.

"Six blue herons," I noted that day. "Couple of great egrets. Snowy egret. Three mallards. Two male ruddies. Gopher snake on levee. Black-shouldered kite. Two pheasants." And that was all. It was the shortest list I had ever compiled here.

The angel of the marsh had spread vaporous wings and departed, and with it most of the waterfowl.

The cattails had gone to seed. The tiny, tight-packed seeds covered each cigarlike spadix in firm brown velvet. In England, the cattail is called "reed-mace," which suits the shape, but not the texture. The velvet of cattail is one of the finest sensations in nature. A battering by such a mace would be delightful; a fine way not to die. Beneath the brown velvet of the seed capsules, a white kapok of cottony seed parachutes packs the core. Nearly weightless individually, the parachutes are folded in so cunningly and densely, in such vast numbers, that each mace has heft.

Strip an autumn cattail into the breeze, with the sun downwind, and half the sky fills with backlit parachutes. The cattail explodes like a supernova, emitting impossible volumes of matter and light. The disintegration comes in pulses, for the seeds never go all at once. Left to nature, the wind spalls them off in swatches. Left to human hands, it is the same. You cannot thumb away just one flight of seeds. The effect is too spectacular. You are compelled to follow that first flight with a second and a third. Great clouds of potential cattail — expanding nebulae of marsh-to-be — sail away on incandescent wings. A marsh is a biome just waiting to happen again. Whatever brutal reductions our wetlands have suffered in the past, the future of marshes always looks bright.

*Autumn cattails*

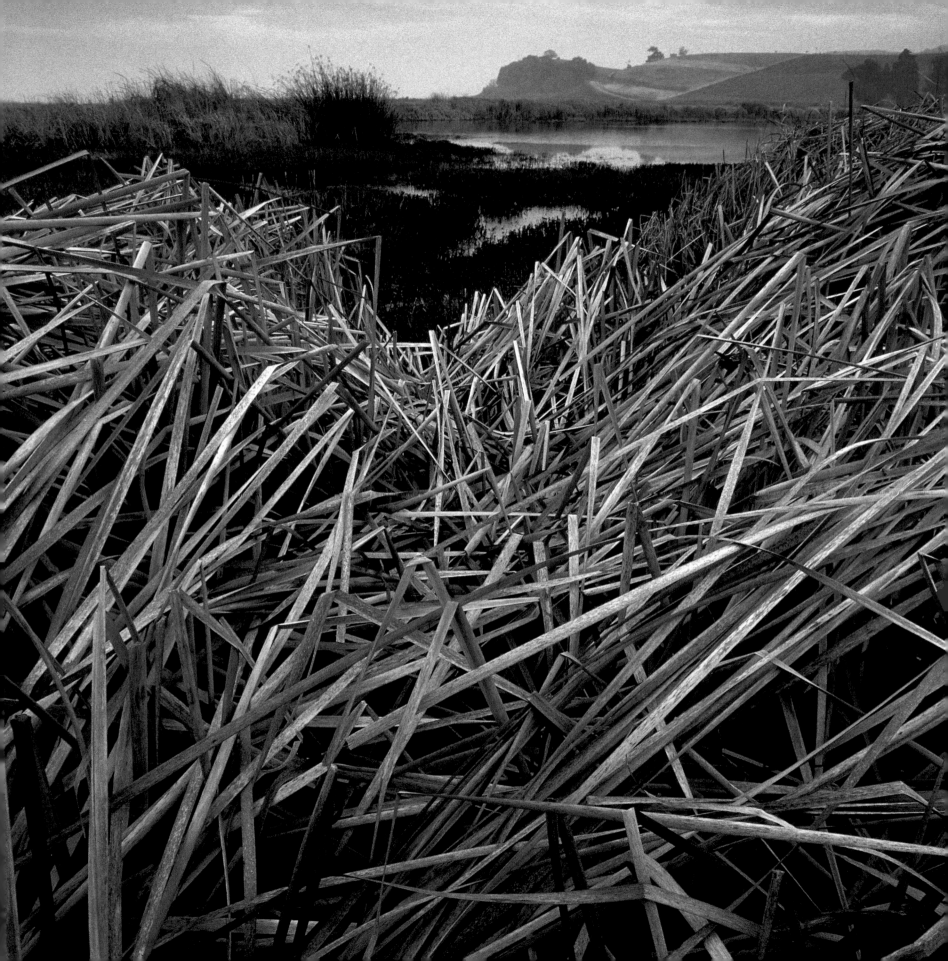

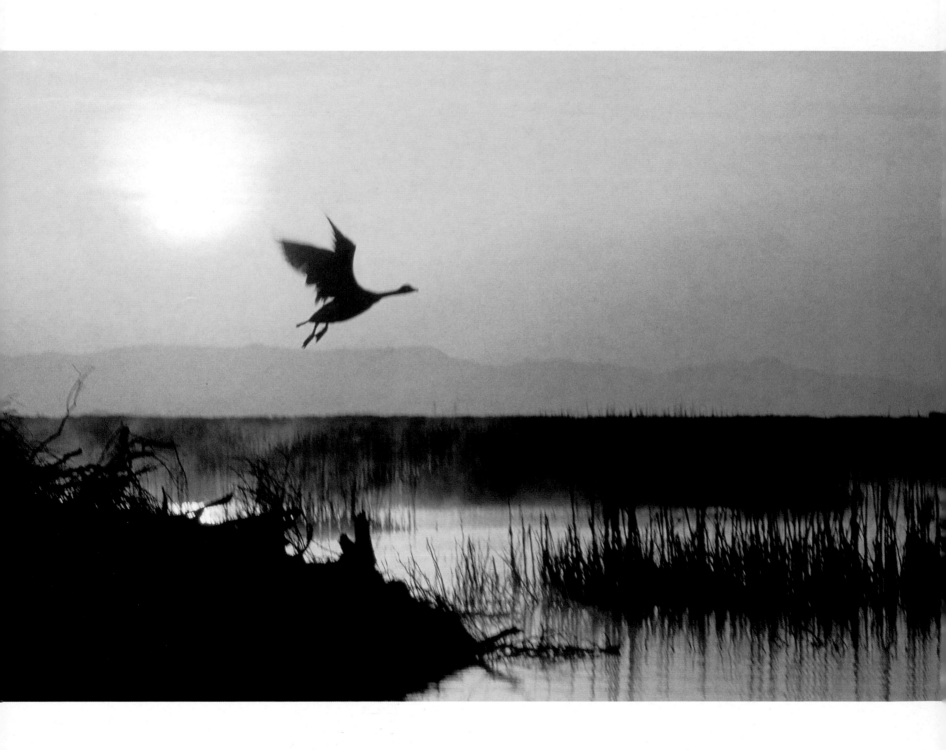

# *Archipelago*

The diesel shovel blew a puff of smoke and raised its big toothed bucket above the reeds, as if for a look around. The machine was long-necked, like some sort of robotic crane or heron. Migrating south from a grim cybernetic future, it had paused to feed in Sam Sebastiani's marsh. The long, articulated neck extended downward. The toothed bucket bit into the mud, retracted, dumped its load on the mound of tailings it had raised, then went back for more.

Sam Sebastiani, working from specifications provided by Ducks Unlimited, had hired the shovel and was building four nesting islands in the middle of his marsh. This one was Island No. 2. Island-making in a dry wetland has a nice symmetry to it. The shovel wasted no motion. The ditch from which it was extracting the island's material would serve as the moat around the finished shores. The bucket's bite made progress downward; its regurgitation made progress up.

The shovel left off digging. The operator cocked his bucket and, deft as any egret, snagged the loop of rope attached to a massive beam that lay nearby. Raising this beam, he dropped it again and again, tamping down the hilly crest of tailings, making a plateau of the island. Nesting waterfowl do not like hillocks. They prefer level ground.

The dry marsh bottom at the site was all tracked up, like a waterhole in the desert. The giant, metallic marsh bird of the diesel shovel, in clanking about, had patterned the slopes of the island and the shores of the moat with its prints — not the three-toed mark of the feathered sort of heron, but treadmarks. Every inch of mud was imprinted. Reading sign, you might have

deduced that a whole flock of cyborg herons had descended here. It fact it was just one persistent bird. In its ditching, the shovel had dug down to the watertable, and the moat was full of tannic water. A big crayfish rested stunned in the tea-colored shallows. Its estivation in the mud had been interrupted by the bucket. De-estivating as best it could, it tried to gather its wits and figure what to do next.

Island No. 2 had been laid out so that only one stand of cattails would be sacrificed — and just a portion of that clump. A single finger of the stand intruded inside the arc of stakes outlining the moat. The operator had saved this section for last. He had postponed the demoliton of cattails, as if in hope of some sort of last-second reprieve. Finally there was no avoiding it. The shovel swung toward the cattails; the bucket took a big bite. There was a bright explosion of seed. Great, luminous clouds of cotton sailed away on the wind. Losing this stand was unfortunate, but there was promise in the seed. These cattails were bailing out to become cattails somewhere else.

The ring of the moat was nearly complete. The operator, deftly working his levers, had closed the circle on himself. He seemed on the verge of painting himself into a corner, marooning his machine atop the island, inside the ditch.

Watching from the edge of the moat, I remembered *Mike Mulligan and His Steam Shovel*. That children's classic, now sixty years old, has fresher legs than anything by Joyce or Faulkner or Fitzgerald. At the end of the tale, Mike Mulligan and his steam shovel, Mary Anne, after a heroic day of digging the basement for a schoolhouse, realize they have miscalculated. Mary Anne

*Canada goose over marsh island*

finds herself at the bottom of the sheer-sided pit she has dug. She is converted, of necessity, to a furnace, and spends the rest of her days warming schoolchildren.

As the clouds of cattail cotton expanded and dispersed downwind, I pondered the fate of this diesel shovel. A marsh does not need a furnace, unfortunately. This marooned shovel could be converted to a — what? Converted to a pump, perhaps. It could spend the rest of its career draining the marsh of winter rain.

The shovel ceased digging. The last puff of cattail cotton thinned and vanished to the east. The operator had stopped in time. *Mike Mulligan and His Steam Shovel* must serve as cautionary tale for all shovel drivers, and this driver had heeded. He had left himself an isthmus for escape.

I made my rounds of the marsh. On the east levee, I broke stride to step over migrating caterpillars. Each one made its way resolutely westward across the levee crown. Each marched quick-time on its platoon of short legs. In dusty places, the caterpillars left faint treadmarks, like little diesel shovels. All the tracks were parallel. Due west had an allure, and each insect struck a true course of 270 degrees. To the north I saw a young male marsh hawk. It was the first harrier I had seen since spring. For some reason, harriers had been absent throughout the summer. It was good to see marsh hawks back in the marsh again.

On the papyrus crust of dry bottom, near a stand of tules, I found the skeleton of a muskrat. The size of the skull surprised me. Until this skeleton, distant, swimming muskrats had been the only kind I had known. Now, with the skull in hand for scale, I had a true measure of the muskrat and its giantism among the voles. A more normal vole — any rank-and-file field mouse — would have fit inside that cranium. The muskrat's incisors were big and beaverlike. The grinding surfaces of the cheek teeth showed the "loops and triangles" typical of voles.

When I returned to the diesel shovel, the operator was gone. He had quit for the day, or had broken for lunch or a cigarette. The glass bubble of his compartment — the eye of the metallic marsh bird — was empty. The long neck of the jib and its bucket were frozen in unnatural positions. With its brain on lunch break, the giant metal marsh bird might as well have been dead. The crayfish in the moat was gone. It had wandered away overland, or had burrowed deeper in the mud to resume its estivation.

Joe Sebastiani, keeper of the marsh, emerged from the reeds. Eyes downward, he was walking the lines of survey stakes marking future islands. When I joined him, he nodded toward Island No. 2.

"The water you see around the island is just a moat to keep the predators out," he said. "Right now, all the breeding ground we have for ground-nesting ducks is on the levee itself. The levee is exposed to all the racoons, coyotes, foxes, and we lose a lot of nests."

The virtue of the islands was not just their insularity, I learned, but their wind-shadow, too. "They make for a little indent of still water, downwind," Joe said. "It's a place where the ducks get to hang out, where they don't have to worry about big waves. Island No. 2 is a half-moon. It makes a little bay and a wave break, which will create calm water on the other side. The ducks don't have to worry about being blown all the way over to the east levee."

In a muddy spot, Joe drew for me the Ducks Unlimited plan. It showed a monotonous row of uniform islands.

"We consulted with the city and Ducks Unlimited in terms of how the islands should be constructed," he said. "The

*Black-necked stilt in distraction display*

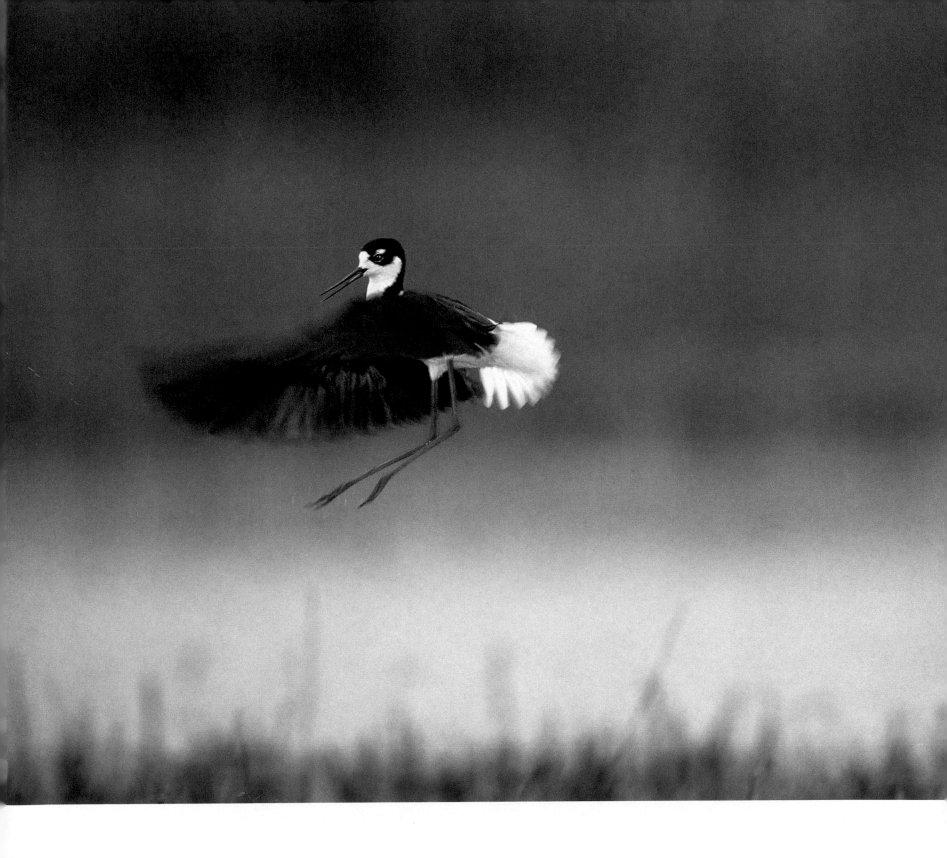

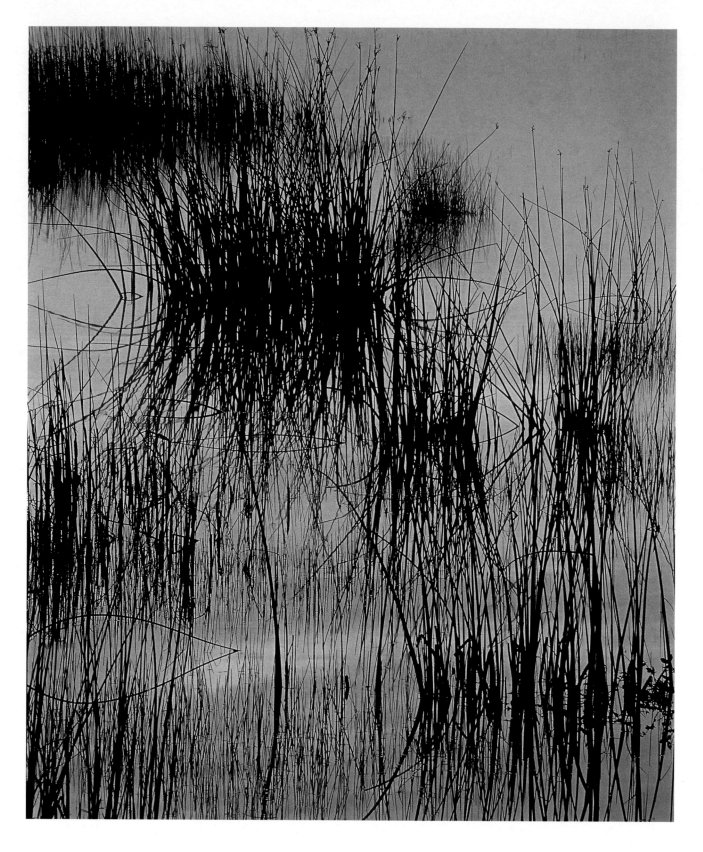

size of them and the height of them. But not the shape. Each one is a hundred feet long, except for Island No. 1, which we have at 206 feet long. We're just kind of creating our own shape. A different look for each one. Island No. 1 is going to be shaped like the boot of Italy."

For Aldo Leopold, the James Madison and the Aristotle of environmental restoration, the shovel was a symbolic tool. In his writing he returned to that instrument again and again.

"Acts of creation are ordinarily reserved for gods and poets, but humbler folk may circumvent this restriction if they know how," he wrote in *A Sand County Almanac*. "To plant a pine, for example, one need be neither god nor poet; one need only own a shovel. By virtue of this curious loophole in the rules, any clodhopper may say: Let there be a tree — and there will be one."

Not every clodhopper can afford a diesel shovel, but the average vintner can rent one of those machines. The vintner may say: Let there be an archipelago — and there will be one.

Joe resumed walking the survey stakes marking out the islands-to-be, and I lost him in the reeds.

If Sam Sebastiani was creator of the marsh, then Joe, who attended to the maintenance, was his Archangel Gabriel. I liked the approach the two had taken to their creation. Like the Creator Himself, or Herself — like the Genuine Article — they acknowledged no higher authority. When the Ducks Unlimited blueprints struck them as boring, they felt free to build an island in the shape of Italy. They had not been overly troubled with ecological correctness. Another family might have hired some specialist in native California plants to coordinate the revegetation. The Sebastianis had simply planted trees they liked. Along the gravel road down to the marsh, they had

planted a colonnade of Italian cypresses and olive trees — a touch of the old country. Along the marsh shores, at wide intervals, they had planted Russian olives. No more noxious exotic pest than the Russian olive has invaded the drylands of the West, unless it is the tamarisk. Yet I had grown fond of these particular Russian olives. I liked their sickly sweet fragrance. They had come to belong here. On the south shore, the Sebastianis had planted the sorriest little grove of redwoods you ever saw. The redwood is a fog-belt tree. It does not seem to prosper alongside grapes, on dry summer slopes above the shores of a marsh. But the Creator Himself experiments this way, too. He continually tests the seeds of his redwoods and Russian olives in various soils and climates, to see if they'll take. He likes a good surprise as much as anyone.

"If his back be strong and his shovel sharp, there may eventually be ten thousand," Aldo Leopold concluded, in his ode to trees and shovel. "And in the seventh year he may lean upon his shovel, and look upon his trees, and find them good."

On the new island, leaning back against the diesel shovel, I looked upon Sebastiani's trees and found them good myself.

What the winemaker had created was a whole world. As any complete world should be, Sam's was a rich and fecund place. Not once had I visited without finding some new bird or animal. For nearly a year, I had been investigating this marsh, yet had not exhausted its surprises. I had only begun learning about the place. The world of the marsh possessed, as any complete world should, its own terra incognita. The stream that contoured the bottom of Sebastiani's hill, as it straightened to flow under the eucalyptus of the owls, entered a long, fingerlike mini-marsh of bulrushes — a tidal inlet of Sonoma Creek — that I knew not at all. I had ventured once into those bulrushes.

*Spike rushes*

Sinking to my thighs in deep mud, I had struggled out, never to venture in again. I had seen one crab inside. Otherwise I had no idea what sort of life went on in there.

The universe of the marsh was conjoined, as any proper universe should be, by an alternate, adjacent universe: the Sonoma Creek slough, on the far side of the levee; a biome ruled by brackish principles, where the marsh was ruled by fresh. There were creatures with dual citizenship — the otter, crabs, and herons that crossed over to the marsh from the slough, and back again — but otherwise I knew nothing about that estuarine system.

When you waded into the marsh and the reeds closed around and overhead, the world of the marsh erased all others. There was nothing but water, reeds, and fragments of sky. You sometimes heard the staccato slapping of the lanyard against the Viansa flagpole on the hilltop, or some unintelligible announcement over the Viansa public-address system, or the distant, exciting, high-rpm whine of engines at Sear's Point Raceway. But these were like faint radio signals from other galaxies. They had no effect.

The reeds grew thickest at the southern end of the marsh. When I slipped into the marsh there, the deepest part, and the cattails and tules had closed around, I was as happy as a coot or a muskrat or a Marsh Arab. In the deepest marsh, I felt like Ali the Abominable. Ali led a ninth-century slave rebellion against the caliph of Baghdad, fighting a guerrilla war from hiding in Iraq's 6,000 square miles of marsh. I had no guerrilla army to camouflage, just myself, and ninety acres were sufficient. The marsh became a hideout from deadlines. "Wildlife Refuge. Please Keep Out" read the sign at the entrance to the gravel road. "Writer Refuge. No Editors" it might as well have said. The moment the cattails and tules closed around, I would find myself smiling a small, satisfied, Ali-esque smile. The caliph would never find me here.

The only problem was the calendar. It was nearly November, and my year in the marsh was almost done.

*Canada goose*

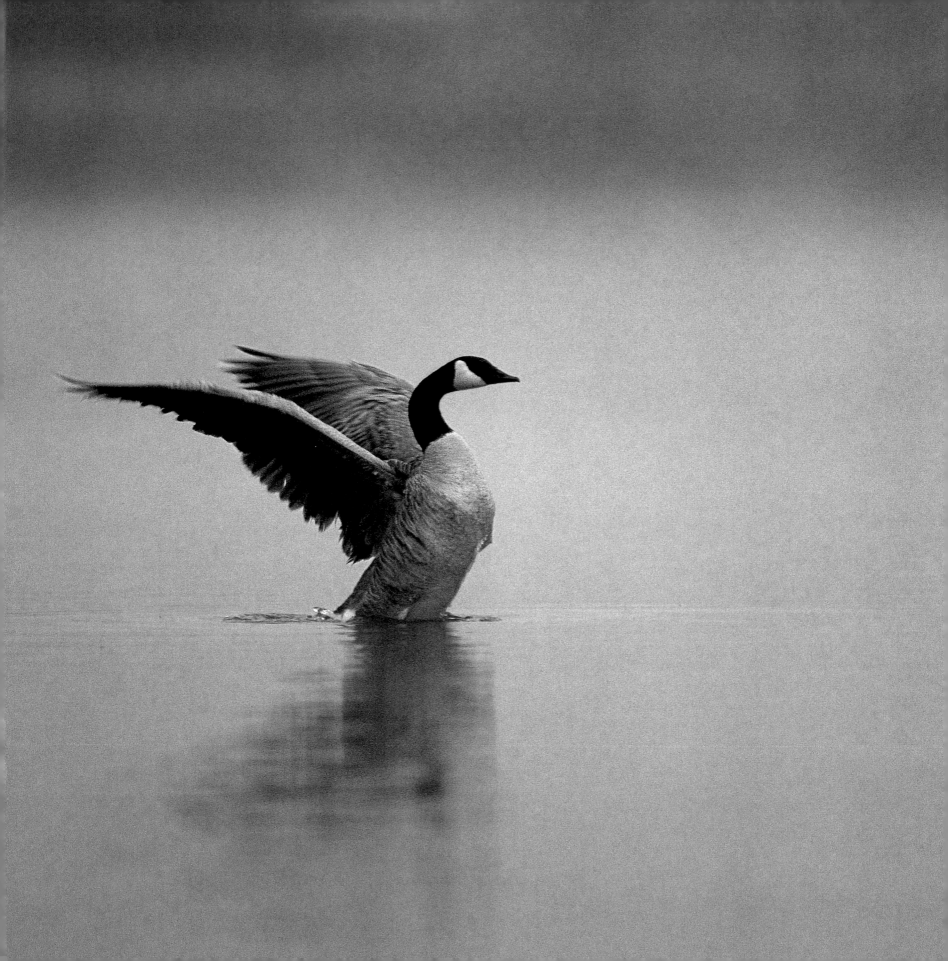

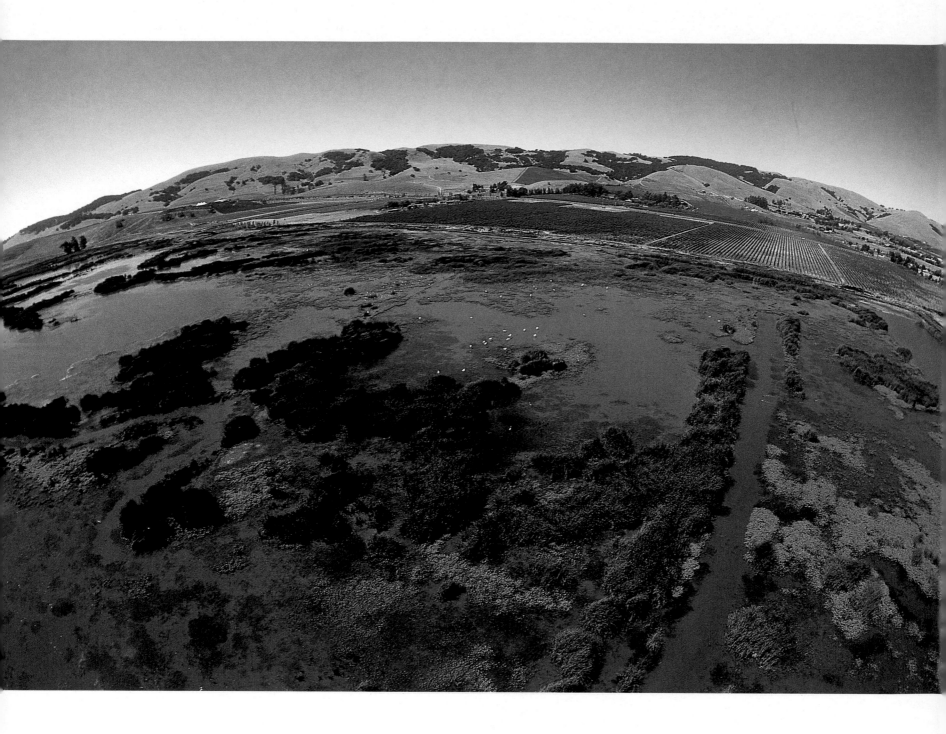

## Albatross

One day a Laysan albatross appeared above the Viansa cattails. It came in on a stiff wind, as albatrosses always do, its trim wings level with the body and perceptibly bowed, the tips flexed slightly backward at the carpal joints. The Laysan albatross, *Diomedea immutabilis,* is a dark-backed bird with a dazzling white head and underside. The genus name, *Diomedea,* derives from Diomedes, bravest of Greek warriors, a companion of the far-wandering Odysseus. Its species name, *immutabilis,* refers to the immutable colors of its plumage, which do not change with season, sex, or age. The various permutations of Laysan albatross — juvenile, adult, winter, summer, male, female — are nearly impossible to distinguish in the air.

The seven-foot wingspan dwarfed the spans of the biggest of the marsh's local soarers, the turkey vulture, golden eagle, and red-tailed hawk. Seen from below, its wings were as bright as vulture wings, and eagle wings are dark. The ornithologist who recorded the albatross was startled. For a moment he had trouble believing his eyes.

There are about 9,000 species of birds on Earth, but in a given locale all these boil down to just three kinds: breeding birds, which nest in that spot; regular visitors, which come as no surprise; and accidentals, which show up once in a blue moon. No visitor to Viansa Wetlands has been more accidental than the albatross.

The Laysan albatross is not your common marsh fowl. The Pacific Ocean, its rightful home, is vastly wider than Sam Sebastiani's ninety acres of water and reeds, yet something in the reflection of the marsh water caught the eye of that great, white, errant bird. The winds, and wanderlust, and its seven-foot wingspan, had carried it 6,000 miles from home.

The Laysan albatross is named for the raised atoll of Laysan, which lies at midpoint of Hawaii's Leeward Islands, a remote chain of bare rocks, shoals, atolls, and demi-atolls northwest of the main group. Laysan is the largest of the Leewards. Its 1,001 acres comprise roughly half the land area of the chain.

Raucous colonies of seabirds, in nesting here by the millions over millennia, had left a mother lode of guano. Humans came to mine the guano. They brought in exotic plants and animals. They grew tobacco, and a few sorry, stunted tobacco plants survive on the atoll today. The humans raised rabbits, which escaped from their hutches, multiplied, and grazed the atoll down to desert. In 1923, the *Tanager* Expedition, sent to the Leewards by Hawaii's Bishop Museum, found just four native plants left of the original twenty-five. The Laysan subspecies of loulu palm, and the Laysan sandalwood, and the Laysan millerbird, and the Laysan rail had not survived the plague of rabbits. All had gone extinct. The Laysan teal had been reduced to six birds. The scarlet Laysan honeyeater was down to three. The rabbits had eaten themselves out of sustenance, and their booming population had crashed. Expedition members succeeded in killing off the few gaunt rabbits remaining. One day, as the sky grew dark upwind and the barometer fell, the *Tanager* biologists glimpsed the last three Laysan honeyeaters. The birds were three scarlet sparks of life against the desolation. The next day the wind rose. A sandstorm blew

across a landscape denuded of any vegetation that might have held the sand in place. When the wind fell again, the honeyeaters had vanished. The subspecies *Himatione sanguinea freethii* was never seen again.

This disappearance of Pacific Island birds, repeated again and again on archipelagos scattered across that ocean, was what drove August Sebastiani into his captive breeding campaign. Pacific birds were his specialty. Had there been a Laysan dove, then the last specimens would likely have ended up in Sebastiani Vineyards, captive-bred in an aviary cleaned by August's son Sam. The demise of island birds had led to August Sebastiani's duck pond, which had been forerunner of Sam Sebastiani's marsh, over which the accidental Laysan albatross flew.

Today the largest colony of Laysan albatrosses on Earth nests on Midway Atoll, at the far end of the Leeward chain. As it happened, one of my overseas assignments, during the year I spent documenting the life of Viansa Wetlands, was a story on Midway. The atoll was about to pass from Navy administration to the control of the U.S. Fish and Wildlife Service. My mission was to cover the transition as Midway, after many decades as a military base, reverted to the birds.

In season, 430,000 Laysan albatrosses nest on Midway Atoll's sandy islets. The "goonies" stand everywhere, displaying, bickering, and fencing with their bills. The irony was that the nesting season was over when I arrived, and all the albatrosses were gone. The only bird remaining stood at the center of Sand Island, a giant statue of an albatross "sky-pointing" before a mural depicting scenes from the Battle of Midway — a statue of an albatross about twenty times actual size.

Contemplating the stone albatross, I considered birds I had encountered far afield: the osprey, which I have seen in Maine, Mexico, along the vast nipah-palm floodplain of the Rejang River in Borneo, and above the seasonally flooded rainforest of the Rio Negro in Amazonia. The great horned owl, which I have met in Patagonia and Yellowstone and several dozen other places. The kestrel, golden eagle, and great blue heron, all of which I have seen in the sandstone canyons of the American Southwest. The Canada goose, a skein of which flew low overhead in congratulatory formation — V for victory — just as two friends and I, after five weeks of walking across the Brooks Range of Alaska, set foot on the shore of the Arctic Ocean.

The truth, it struck me now, was that I needn't have walked all that way across the Brooks Range. I needn't have puttered up endless tributaries of the Amazon, or taken that tramp freighter to Borneo. I could have stayed home. I have seen each of those birds and more in Viansa Wetlands. Sooner or later, if one simply waits, everything shows up, an accidental visitor in Sam Sebastiani's marsh.

"You know, in business in America, or probably anywhere, you have to be tough sometimes," Sam Sebastiani told me one day, as we stood on his hilltop, surveying the marsh. "You have personnel problems, governmental problems. When you're all done fighting the governmental problem, all you get is to go ahead. Right? You solve the problem and you move on. Maybe you finally get your building permit, and you build your building. All you've done is build a building!

"I've thought about this a lot. There's a difference between going through hurdles in business, versus going through hurdles to get a wetlands in. The difference is that,

*Black-necked stilt chick in hiding*

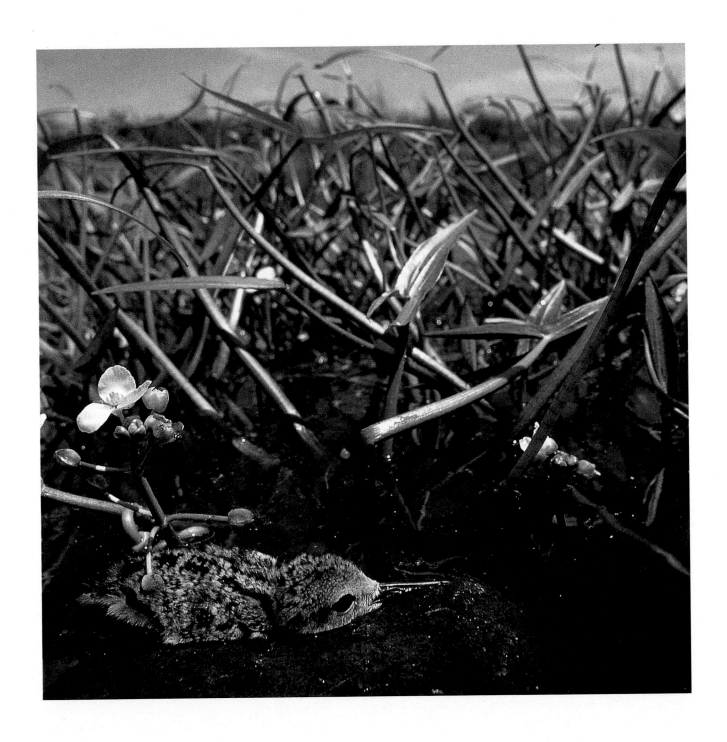

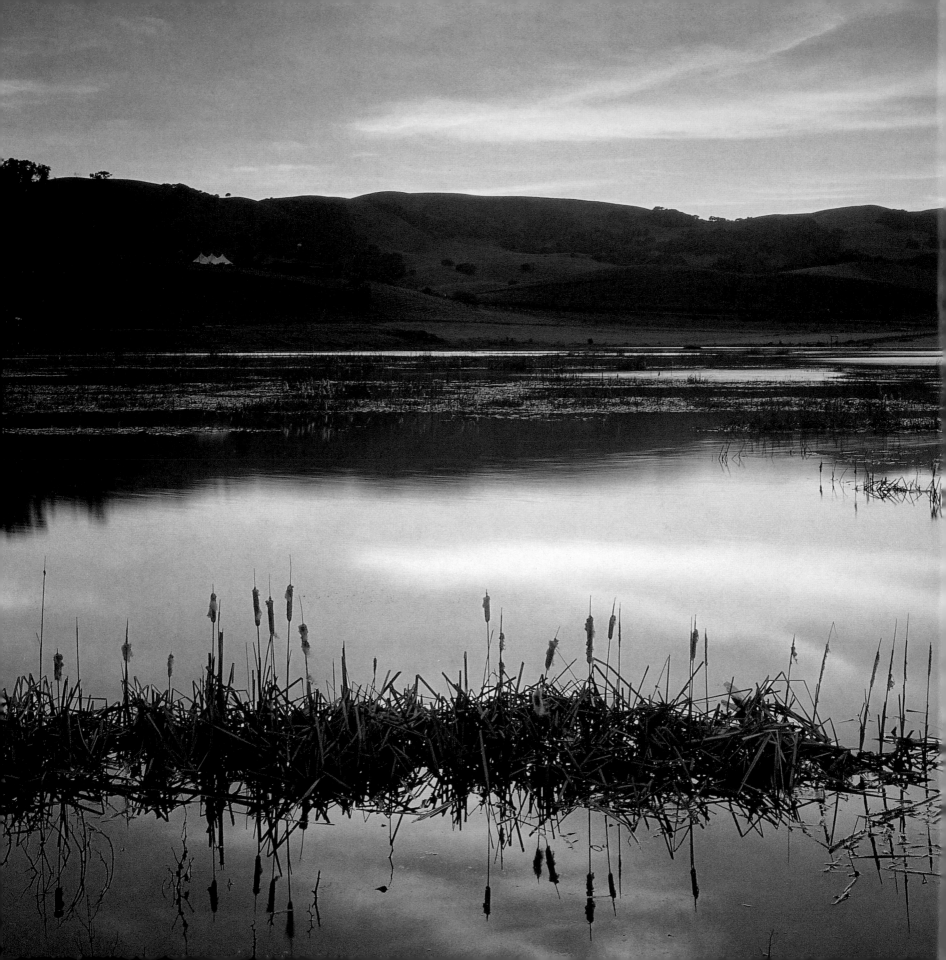

with a wetlands, you've created more life. I don't know that this was even conscious in my dad, when he built his duck pond, or conscious in me. But there's just this feeling about it. I go around the country, now, making my speech to people in wastewater management, growers, and so on. All these sorts of people do now is struggle with the government and then put up a tank farm to clean their water. I say to them, Jesus Christ, look at these photos of what we've come up with. If you're going to go to the trouble to fight the government, then fight to get yourself a wetlands. Because then when you get in your car, and go home, see a bird fly by, you might have put that bird on the planet."

In late November, back in the marsh again, I remembered the albatross. The first winter rains had fallen. The marsh was filling again, the cycle of the seasons nearly complete. The clouds passing overhead were not dark rain clouds — they were puffy and white — but soon skies would darken, big rains would fall, and my year in the marsh would be over. It was one of those reflective days when the mirror of the marsh seemed to hold the whole sky. It occurred to me, watching the reflected whiteness of the clouds, that this wetland made a kind of white hole.

Black holes, the better-known phenomenon, have been detected at the core of our own galaxy and elsewhere in the universe, their enormous gravity sucking in everything, even light. But for each sink of a black hole, physicists have suggested, there should be the spring of a white one. There should be an opening on the other side where everything comes out again.

By raising a levee on his property, any lowland landowner can make his own white hole. There is some sort of critical area required, but not a lot, around ninety acres, perhaps. On building his marsh, the owner need only sit back and wait till things start trooping out. In Viansa Wetlands I had seen every sort of duck, assorted herons, otters, dogs, coyotes, and rabbits emerge from the reeds. I had seen an aboriginal tule canoe come out, and a Humvee vehicle. I had met Italian-Americans on the levee, and Mexicans, and Germans, and a Russian, and two Englishmen. I had seen Marsh Arabs pole out in wooden *mashhufs* — had witnessed that in my imagination, at least. (My year in the marsh included trips to the library, which opened up the long history of Iraq's marshes to me.) I had seen the *totora*-reed balsas of Lake Titicaca's Uru Indians emerge, and the giant reed-woven ark of Uta-Napishtim, the original Noah. Sit long enough by the white hole of your marsh, and eventually all Creation will emerge from it, even the luminous white wings of albatross.

*Sunset, Viansa Wetlands*